Camera Orientalis

Camera Orientalis

Reflections on Photography of the Middle East

Ali Behdad

The University of Chicago Press
Chicago and London

Ali Behdad is the John Charles Hillis Professor of Literature
at the University of California, Los Angeles.

The University of Chicago Press, Chicago 60637
The University of Chicago Press, Ltd., London
© 2016 by The University of Chicago
All rights reserved. Published 2016.
Printed and bound by CPI Group (UK) Ltd, Croydon, CR0 4YY

25 24 23 22 21 20 19 18 17 16 1 2 3 4 5

ISBN-13: 978-0-226-35637-2 (cloth)
ISBN-13: 978-0-226-35640-2 (paper)
ISBN-13: 978-0-226-35654-9 (e-book)
DOI: 10.7208/chicago/9780226356549.001.0001

The University of Chicago Press gratefully acknowledges the generous
support of the John Charles Hillis Endowment at the University of
California, Los Angeles, toward the publication of this book.

Library of Congress Cataloging-in-Publication Data

Names: Behdad, Ali, 1961– author.
Title: Camera Orientalis : reflections on photography of the Middle East / Ali Behdad.
Description: Chicago ; London : University of Chicago Press, 2016. |
Includes bibliographical references and index.
Identifiers: LCCN 2015039772 | ISBN 9780226356372 (cloth : alkaline paper) |
ISBN 9780226356402 (paperback : alkaline paper) | ISBN 9780226356549 (e-book)
Subjects: LCSH: Photography—Middle East—History—19th century. | Photography—
Political aspects—Middle East. | Orientalism in art.
Classification: LCC TR114 .B44 2016 | DDC 770.956—dc23
LC record available at http://lccn.loc.gov/2015039772

In memory of my maternal grandfather,
Mahmood, an early and avid photographer,
and my own father, Hassan, who never
took a single photograph in his entire life.

Contents

CONTENTS

Illustrations

Acknowledgments

This book treats photography of the Middle East as a phenomenon of contact and travel, and like its subject matter, *Camera Orientalis* is the product of many welcome opportunities to connect with and learn from brilliant scholars and rich photographic archives. Above all, this book would have been impossible to write had I not had the privilege of immersing myself in the rich photographic archives of the Getty Research Institute (GRI) alongside the extraordinary group of international scholars assembled during my year of residency. While the generous institutional support of the GRI allowed me to delve deeply into its extensive archival holdings of Orientalist and Middle Eastern photography, my cohort of research fellows has offered insightful interlocutions at every step along the way, always pushing me to press beyond my own critical orthodoxies. I am especially grateful to the participants in the Orientalist photography workshop at the GRI: Esra Akcan, Susan Babaie, Hannah Feldman, Talinn Griogor, Rob Linrothe, Nancy Micklewright, Nabila Oulebsir, Mary Roberts, and Frances Terpak, who all attended our meetings, selected photographs for our viewing, and shared thoughtful observations. Comments offered by participants in the conference on Orientalist photography held a year later at the GRI, particularly those by Christopher Pinney, Luke Gartlan, Darcy Grimaldo Grisby, and John Tagg, helped me further nuance my discussion of Orientalist photography.

The ideas presented in this book have greatly benefited from conversations with many other scholars as well. I wish to express my special thanks to colleagues throughout the United States, Europe, and the Middle East whose invitations to present parts of this book as lectures or conference papers enabled me to engage in productive dialogue with them and other scholars I met during my visits: Wendy Belcher, the late Irene Bierman, Sheila Blair, Jonathan Bloom, Frederick Bohrer, Joseph Boone, Brian Edwards, Ahmad Ersoy, Elahe Helbig, Marianne Hirsch, Chandra Khan, Pedram Khosronejad, Gesa Mackenthun, Nancy Micklewright, Issam Nassar, Nasrin Rahimieh, Jennifer Robertson, Lucie Ryzova, Silvia Spitta, and Shamoon Zamir. Stimulating conversations with the following stellar scholars have left an indelible mark on this book, and I extend my thanks to them: Anjali Arondekar, Julia Ballerini, Zeynep Çelik, Zahid Chaudhary, Jorge Coronado, Elizabeth Edwards, Carmen Pérez González, Joan Schwartz, Stacie Scheiwiller, Stephen Sheehi, Corien Vuurman, and Michelle Woodward. Many other colleagues and their work have played a critical role in sparking my imagination as I was writing this book, including George Baker, Homi Bhabha, Thierry de Duve, David Eng, D. A. Miller, Hamid Naficy, and Kaja Silverman.

Researching this book entailed a great deal of archival trawl, and I am indebted to several institutions and many curators, librarians, and staff who facilitated my search, most especially: Beth Guynn, Sabine Schlosser, Tracy Shuster, and Ted Walbye (GRI); Jacklyn Burns and Anne Lacoste (Getty Museum); Akram Ali-Babaie, Helen Assadian, Sodabeh Kaardel, and Seyed Javad Hasti (Golestan Palace Museum); Massumeh Farhad, David Hogge, and Besty Kohut (Arthur M. Sackler Gallery and Freer Gallery of Art, Smithsonian Institution); Başak Kilerci (Atatürk Library of Istanbul); Simon Elliott and Robert Montoya (UCLA Special Collections); Mozgan Taraghi and Leyli Zandi (City Photo Museum of Tehran); Meredith Reiss (Metropolitan Museum of Art, New York); Linda Komaroff, Sandra Williams, and Piper Severance (Los Angeles County Museum of Art); Lauren Smith and Alexandra Hays (Gladstone Gallery Archive); and Alexis Hager (Taymour Grahne Gallery). I also wish to thank Mohammad Tahmasbpour and Parisa Damandan for generously allowing me to use images from their private collections and for sharing so unsparingly their immense knowledge of the history of Iranian photography. Rana Javadi kindly gave me permission to use the works of her late husband, Bahman Jalali. My mother, Fatemeh Oskoui, lovingly guarded and passed along to me my grandfather's entire gelatin silver plate collection; needless to say, I owe her a great deal more than this simple acknowledgment. Finally, I wish to thank the artists who graciously provided me with permission to use images of their extraordinary photographs in this book: Lalla Essaydi, Hassan Hajjaj, Shadi Ghadirian, and Shirin Neshat.

I cannot thank enough my students in three graduate seminars who indulged

me with open-mindedness and good humor as I tried out my half-baked ideas, while thoughtfully nudging me to refine my thinking through engaging dialogue. The participants of the consortium seminar on photography of the Middle East at the GRI, the seminar on Orientalism in art and literature at the University of California, Los Angeles (UCLA), and the team-taught seminar (with Ahmet Ersoy and Chris Pinney) on the history of photography in the non-Western world at Boğaziçi University have all left critical imprints on this book. The completion of this book was greatly enabled by the assiduous research assistance of Adrienne Posner. Adrienne's knowledge of photography and her illuminating observations helped me immensely as I labored to chisel my critical arguments, and I am truly indebted to her. Thanks as well to Nahrain Al-Mousawi and Sarah-Neel Smith for their research assistance at an earlier stage of this undertaking. I am most grateful to Ross Chambers, whose attentive and supportive reading of the entire manuscript gave me the courage to part with it at the end. Ross's exemplary scholarship and intellectual integrity have been a major source of inspiration for me from the beginning of my academic career, and he continues to offer me invaluable mentorship to this very day. I am fortunate to find myself amidst a most remarkable community of colleagues and students at UCLA whose support has been vital in completing this project. Special thanks to John Agnew, Nasia Anam, Nezar Andary, King-Kok Cheung, Liz DeLoughrey, Helen Deutsch, Sandro Durante, Lowell Gallagher, Nouri Gana, Yogita Goyal, Jonathan Grossman, Akhil Gupta, Ursula Heise, Gil Hochberg, Neetu Khanna, Efrain Kristal, Michelle Lee, Francoise Lionnet, David Wong Louie, Saree Makdisi, Amy Malek, Kirstie McClure, John McCumber, Kathleen McHugh, Anne and Ron Mellor, Aamir Mufti, David Myers, Jon Naito, Sianne Ngai, Michael North, Felicity Nussbaum, Elinor Ochs, Teo Ruiz, David Schaberg, Mark Seltzer, Shu-mei Shih, Susan Slyomovics, Erin Suzuki, Jenny Sharpe, Richard Yarborough, and Maite Zubiaurre. I am also grateful to the staff of the English Department at UCLA, most especially to Bronson Tran for his assistance in preparing the digital images for publication, and to Janet Bishop, Rick Fagin, and Nicole Liang for their help with processing reproduction fees and permissions for the images.

I also owe special thanks to Alan Thomas at the University of Chicago Press for his perspicuous comments and generous support of this project, to Randolph Petilos for his thoughtful assistance with the publication of this book, to India Cooper for her great editorial work on the manuscript, and to the two anonymous readers for their valuable comments and helpful suggestions.

The unwavering support of friends and family has played a crucial role in making the writing of this book possible. I offer warm thanks to Wendy Belcher, Jeff Decker, Nezam Emtiaz, Masoud Ghandehari, Masood Jelokhani, Nicolas Mellen, Houman Mortazavi, Morteza Mostafavi, and Jenny Sharpe for their nourishing friendships,

and for always being there to support me, personally and professionally. I am deeply grateful to my brothers, Amir, Hamid, Hossein, Saied, and Vahid, for their encouragement and subtle gestures of affection, and to my wonderful children, David and Roxana, for their humor and everyday expressions of love that have given me sustenance as I have undertaken this journey. Leslie Bogart, Kyra Haglund, Vinnie Marino, Maeve McCaffrey, Victor Morton, and Julian Walker kept me centered, physically, mentally, and spiritually, as I was writing this book, and I extend my heartfelt gratitude to them.

Last but certainly not least, I owe my greatest debt to Juliet Williams, who has been the most insightful and patient interlocutor and the most loving and caring partner one could wish for. Her incisive comments and writerly contributions, offered as she read and re-read the entire manuscript, made both the writing process and the book itself a whole lot better than going it alone. Without her, this book would not exist, and I am forever indebted to her.

Camera Orientalis

At the origin of photography is "the Orient." And yet art historians have generally assigned only marginal importance to the works of the many European photographers who traveled to or resided in the Middle East after the introduction of photography in 1839, while also overlooking the many resident and local professional studios established in the region during the second half of the nineteenth century. I have titled this book *Camera Orientalis* to call attention to the centrality of "the Orient" in the photographic imagination and to the intertwined history of photography and Orientalism. In the pages that follow, I contend that the Middle East ("the Orient") played a crucial role in the development of photography both as a new technology deployed in the service of empire and as a commercialized, mass medium that perpetuated the Euro-imperial desire for adventure and the exotic in the region. Photography transformed Europe's distinctly Orientalist vision of the Middle East into images received as objective fact, a transformation that proved central to the project of European involvement in the region during the nineteenth century. As one of the early advocates of photography for its expeditionary use in the Middle East remarked, "Perhaps for the first time we will have truth in place of fiction."[1] Although photography of

"the Orient" was indebted to the earlier literary and painterly representations of the region and was deeply invested in the discourse of exoticism, the indexical quality of these photographs made them factual and truthful representations in the minds of European audiences, who voraciously consumed them.[2] The invention and development of photography as a seemingly objective mode of representation thus enabled the rise of a scientific form of Orientalism in the nineteenth century that claimed to offer definitive and comprehensive understanding of "the Orient." In a telling example, the same commentator in another article described the works of early expeditionary photographers to the region as a "charming and complete book" (*livre charmant et complet*), comparing them to "God's creations" (*comme les œuvres de Dieu*).[3]

A Brief History of Photography in the Middle East

A crucial link between photography and Europe's knowledge about the Middle East has existed since the invention of the daguerreotype in 1839. In his introduction of Louis-Jacques-Mandé Daguerre's invention to the Chamber of Deputies, Dominique François Arago commented on the great advantages of the new medium as a means of reproduction and documentation for Egyptologists and Orientalists, and recommended that the French government immediately equip institutions of knowledge-gathering about the Middle East such as the Institut d'Égypte with the new technology to further the projects of archaeology and Orientalism. Taking a cue from Daguerre himself, Arago also underscored the technical fact that the daguerreotype process could fruitfully be put to work in Egypt and the Middle East, where light was more intense than in Europe. From the very moment of its invention, in other words, photography was understood to be portable and a process well suited to travel in the Middle East, where the quality of light made photographs easier and faster to produce. As well, photography provided the ideal mechanical tool to scientifically document historical monuments and catalogue the people of the region, rendering the Middle East visually and epistemologically transparent.[4]

It should come as no surprise, then, that in subsequent decades, many early European traveling photographers followed Arago's suggestion and went to the Middle East to photograph various locations and monuments, making the region one of the original sites for the practice of photography.[5] Inspired by Napoleon's expedition to Egypt and the publication of *Description de L'Égypte*, many French amateur photographers and Orientalists began photographing Egyptian antiquities in the early 1840s.[6] Girault de Prangey, for example, produced numerous daguerreotype plates of historical monuments and panoramic landscapes during his journey to the Middle East in 1842–45.[7] The introduction of William Henry Fox Talbot's calotype process and Gustave Le Gray's paper negative process, in addition to the in-

vention of Frederick Scott Archer's collodion wet plate process in the 1850s, enabled other French amateur photographers like Maxime du Camp, Auguste Salzmann, and Félix Teynard[8] to produce a huge photographic inventory of archaeological sites for both French government and Orientalist institutions as well as wealthy individuals and dignitaries. As a reviewer of du Camp's photographs of Egypt remarked, these "exactly reproduced" images allowed European audiences to

> survey with an assured eye (*d'un œil sûr*) the interiors of its temples, its pyramids, its palaces; plunge at night into its hypogea, read the half-erased chronology of its Pharaohs, understand its strange architecture, trace the rites of its priests on the friezes of its monuments, and grasp the thought of its dark and marvelous cult.[9]

The "mysteries" of Egyptian theocracy, art, and architecture, he argued, could be decoded with the aid of the camera, exhibiting it all as a "complete encyclopedia." In other words, photography, understood as "light-drawing," promised to shed light on the "dark" region.

Across the Channel, British Orientalism's concern with the "Eastern Question" and the interest in the Holy Land engendered by the Protestant revival created a huge market for photographic images of the Middle East, especially Palestine. In the mid-nineteenth century, professional photographers including Francis Frith, John Cramb,[10] Francis Bedford,[11] and James Graham[12] catered to the lucrative demand for realistic images of religious sites throughout the Holy Land, producing large inventories of such photographs for European tourists to the region as well as armchair travelers at home. Frith's 1876 catalogue, for example, lists over four thousand photographs of the Middle East.[13] Moreover, in light of the cultural hunger for visual accounts of the biblical landscape, as early as 1864, photographers working for the Royal Engineers began a comprehensive photographic survey of the Holy Land.[14] In contrast to their French counterparts, whose artistic aspirations, interest in architecture, and colonial relations with North Africa made them mostly focus on Egyptian antiquity and "Oriental" types and exotic scenes (e.g., *scènes et types* photography), the British photographers used their cameras not only for the purpose of colonial documentation but also to depict the biblical landscape for the middle class. Unlike their French counterparts, who displayed a sense of playfulness and superficiality in their representations of the region, as exemplified in their obsessive depictions of harem scenes and eroticized women, the British photographers maintained a more serious and purposeful style marked by a nostalgic religiosity and a quest for visual mastery. Their evocative and austere photographs of sites and landscapes of the Holy Land, for example, are either close-ups of monuments in a state of decay or panoramic views of biblical landscapes shot from summits to help the viewer engage in

religious contemplation or romantic reverie.[15] Not surprisingly, some of the early British photographic missions to Palestine, such as those of Bedford in the early 1860s and Graham in the 1850s, were associated with the Anglican Church and aimed to produce a visual narrative of the journey to the Holy Land for their audiences at home who did not have the luxury of embarking on such an arduous and expensive journey. Indeed, several British photographers of Palestine were Protestant clergymen, and many others had direct connections with the Anglican Church, which led them to use the camera to validate or prove elements from the Bible.[16]

As the versatility of photography was enhanced through new technologies of reproduction such as albumen prints and other techniques including gelatin-based photographs, traveling and resident photographers were able to produce en masse images of every kind, depicting the Middle East, its people, and their everyday practices to satisfy the demands of both the burgeoning tourist industry in the region as well as the bourgeois clientele in Europe whose desire for exoticism transformed them into collectors of Orientalist photographs. While the mid-nineteenth-century expeditionary and traveling photographers, such as Frith, Cramb, du Camp, Wilhelm Hammerschmidt,[17] and Teynard, mostly captured the ruins and remains of the Middle East's past in their photographs, late nineteenth-century European and resident/local photographers like Émile Béchard,[18] Félix and Adrien Bonfils,[19] the Abdullah brothers,[20] Lehnert & Landrock,[21] Félix Jacques-Antoine Moulin,[22] and Pascal Sébah[23] furnished European tourists and travelers to the region with pictures of Islamic architecture, Egyptian antiquity, ethnic and professional types, erotically staged photographs of harem women, and exotic images of street scenes. The works of these photographers were also widely exhibited in various world expositions throughout Europe and the United States in the second half of the nineteenth century. Sébah's photographs, for example, were successfully exhibited at the Société Française de Photographie in 1869 and 1870 as well as the Vienna International Exhibition of 1873. In contrast to the early photography of the Middle East that captured its disappearing past, representing it as a deteriorated and decadent civilization in need of European intervention for historical preservation and cultural renewal, with the rise of permanent professional studios in major cities, local and foreign photographers began to produce a large archive of topographic images of people, their professions, costumes, and customs, further pandering to tourists' and European audiences' demand for exoticism. If archaeology and Judeo-Christian mythology informed the expeditionary tradition of Orientalist photography, ethnology and secular temporality circumscribed the iconography of the images of people produced by the professional studios in the region. In making this broad claim, I am not arguing that every image produced by the professional studios—say, Maison Bonfils in Beirut or Abdullah Frères in Istanbul—falls within the purviews of

ethnic or professional typecasting; as the official photographers to Sultan Abdülaziz, the Abdullah brothers, for example, photographed Ottoman dignitaries and official ceremonies in a respectful and dignified fashion. As well, local photographic studios, such as Abdullah Frères and Sébah & Joaillier, also catered to the local middle classes who wished to have their portraits taken. Nor would I suggest that there were no individual stylistic differences between various photographers in the Middle East, though these stylistic differences are often difficult to determine given the fact that professional studios regularly employed other photographers to take images, often sold their negative inventories to other studios, and occasionally rephotographed other artists' images and sold them as their own. The Abdullah Frères studio, for example, was sold to Sébah & Joaillier in 1899, which allowed the latter to use the former's negative plates and sell them as their own. Similarly, upon his retirement as a photographer in 1863, Roger Fenton sold his negative plates and photographic equipment to Frith, who relabeled them and sold them as his own. My aim here is to highlight the fact that representations of Middle Eastern people and their cultures, *especially* those that circulated in the European market, were inscribed in an ethnological system of differentiation and classification that made them both legible and desirable as images of cultural alterity. The major consumers of Orientalist photographs were European tourists, whose desires for exoticism and "Oriental" eroticism were catered to by local studios.

As in the expeditionary tradition of Orientalist photography, these images too were at once enabled by and participated in a network of aesthetic, economic, and political relationships between Western Europe and the Middle East. Art historians and curators have generally treated these images in terms of their aesthetic or documentary value and as unique expressions of a particular artist or professional studio.[24] What these approaches overlook, however, is the overlapping systems of representation that historically created the fertile conditions for the production and consumption of these exotic photographs. Their focus on a particular photographer or studio preempts a broader understanding of the visual vocabulary that informs Orientalist photography and the tropes linking its thematic and topical concerns. As I will elaborate in the first two chapters, these photographic representations belong to the genre of the picturesque and exude an aura of exoticism. These images, collected as exotic mementos, not only came to be identified with tourism in the region but also informed the experiences and expectations of tourists there. In this way, the development of modern techniques of photography extended the desire for Orientalist exoticism by rendering the Middle East visually accessible. Put otherwise, through the practice of accumulating Orientalist photographs, the tourist and the armchair traveler could not only metonymically possess "the Orient" but also remember nostalgically their real or imaginary *voyage en Orient*.

The albums of late nineteenth-century European tourists and travelers to Turkey, for example, provide representative examples of the visual consistency of cultural alterity in late Orientalist photography. Whether assembled by French or English travelers to the region or by the local professional studios themselves, these albums invariably begin with panoramic views of Constantinople, especially the Bosphorus, followed by images of historical monuments, such as the Mosque of St. Sophia and the Mosque of Sultan Ahmed, and end with several images of Turkish women, street vendors, and ethnic types. Often photographed by the local studios of Sébah & Joaillier and Abdullah Frères, the multitude of street types and harem images and the visual consistency in the narratives of these albums not only reveal the fact that the photographic styles of commercial studios in the region adapted European pictorial conventions but also demonstrate the ways in which the discourse of exoticism, the practice of photography, and the business of tourism overlapped, producing a distinct style of representation that froze people and cultures in a static and picturesque manner. Produced generally for European consumption, these images transform a typological perception of the world into exotic mementos; they aestheticize the penchant for classification and satisfy the touristic desire for the exotic and the picturesque.

Alongside the European Orientalist archive of photography, there are also various indigenous archives throughout the Middle East holding images of the region and people produced by amateur and professional photographers, such as those of Agha Reza Khan and Abdullah Qajar in Tehran, Yüzbaşi Hüsnü and Ali Sami Bey in Istanbul, Garabed Krikorian and Khalil Raad in Jerusalem, and Sirjis Sabunji and the Sarrafian brothers in Beirut.[25] As Issam Nassar has elaborated in the context of early local photography in Jerusalem, the history of local photography in the Middle East has been utterly neglected in art-historical discussions of the medium.[26] Contrary to the inaccurate claim of some Orientalist art historians that Muslims in the Middle East have historically viewed photographic representations of human beings as a sin,[27] the elite classes in Iran and throughout the Ottoman Empire embraced the new medium soon after its invention in Europe. Indeed, following its introduction in the West, the art and technology of photography was taken up almost immediately by the wealthy and the powerful in the region, who represented themselves in honorific poses, local monuments in a monumental fashion, and people of lower classes and their practices in an often simultaneously exoticizing and eroticizing manner. In the final three chapters of the book, I explore the relation between Orientalist photography and local photographic representations in the Middle East to consider the cultural and political implications of the emergence of photography as a modern technology for the region. The images produced by local photographers in the Middle East do not simply maintain a mimetic relationship with their European

counterparts, and it would be a mistake to conflate these representational practices. However, it is equally problematic to consider indigenous traditions of photography in the region either as utterly distinct from or as oppositional with respect to their Western traveling and resident counterparts. Although in the late nineteenth century and the early twentieth, many local photographers produced portrait photography and family portraits of members of the indigenous bourgeoisie, as some critics have elaborated,[28] locally produced images, as products of contact zones, were nonetheless in dialogue with European photography of the region and as such both informed and were informed by formal concerns and thematic choices of Orientalist photography in Europe. Orientalist photography, in other words, is not a unilateral visual regime produced solely by Europeans, but rather one that must be understood as a mode of representation produced through cultural contact between the West and the East. To cite an example, the production and publication of *Les costumes populaires de la Turquie en 1873*, which was conceived by the Ottoman Orientalist painter Osman Hamdi Bey, comprising seventy-four phototype images of folk costumes produced by the local photographer Sébah, and accompanied by explanatory texts written by Victor Marie de Launay, a writer for the French-language *Journal de Constantinople*, is clearly in dialogue with European photographic representations of Ottoman Turkey as it combines the ethnological penchant for racial categorization with the exoticist desire for Oriental costumes. Similarly, Qajar-era photographers such as Abdullah Qajar and Agha Reza Khan, like their Ottoman counterparts, amassed a large collection of images of monuments as well as of rural people and lower classes for the court that are firmly embedded in the monumental and exoticist traditions of Orientalist photography.

Orientalism Matters

As I have suggested, the enormous archive of what I term "Orientalist photography" as well as indigenous photography of the Middle East has been mostly marginalized in art-historical debates. That such an authoritative and wide-ranging work as the *New History of Photography* by Michel Frizot devotes only a few pages to expeditionary and tourist photography from across the entire world, and just a single page to photography of "the old world of the Mediterranean," speaks not only to the generally Eurocentric tendency of photography criticism that disavows other histories of photography across the globe but also to the dismissive way in which art historians have traditionally treated photographic representations of and in other worlds as merely derivative of their Western counterparts, viewing these images as minor works produced in the periphery either by curious scholars of exotic cultures or local commercial photographic studios in the region.[29] Even when some of these

photographs have been shown in museum exhibitions or galleries,[30] there has been a nostalgic tendency and recuperative urge in curatorial literature to reposition and redefine European Orientalist photographs as aesthetic objects. As Rosalind Krauss has aptly observed, recent scholars of photography generally have uncritically assumed that "the genres of aesthetic discourse are applicable" to these images and have problematically "decided that the art-historical model will map nicely onto this material." Having belatedly determined that nineteenth-century Orientalist photography should be exhibited in art museums, curators and art historians apply the concepts of "artist" and "oeuvre" to this visual archive, concepts that, as Krauss argues, obscure "the set of practices, institutions, and relationships to which nineteenth-century photography originally belonged."[31] More symptomatically, in the case of exhibiting Orientalist photography as aesthetic objects, museum curators' formalistic and aestheticized approaches to photographic representations of the Middle East disavow the political aims and cultural implications of how the new medium of representation was enmeshed in and developed along modern colonial rule in the region. The following introductory statement by the curators of the "Sight-seeing" exhibition at Harvard provides a symptomatic example of what one may call curatorial Orientalism:

> Littered with remains of great civilizations, witness to events of the Bible, and governed by fierce Muslim warriors who kept their women secluded in harems, the Middle East has enthralled the imagination of the West since the Crusades.[32]

In recent years, there have emerged some postcolonial approaches to the Orientalist archive that aim to expose the workings of power and the entanglement of photography in the politics of exoticism. Inspired by Edward Said's seminal book *Orientalism*, several scholars have critically studied European photographs of the Middle East as signifiers of the unequal gaze between the European colonizer and the colonized. In *The Colonial Harem*, for example, Malek Alloula exposes the "ideology of colonialism" and the repressed sexual phantasm that accompanied it in his study of the eroticized representations of Algerian women in postcard form in the early twentieth century. Alloula's critical aim is both "to uncover the nature and the meaning of the colonialist gaze" and "to subvert the stereotype that is so tenaciously attached to the bodies of women."[33] His postcolonial model of the gaze posits a binary opposition between the European colonizer as the producer and consumer of the eroticized images of women and the colonized woman as the victimized object of voyeuristic vision. Similarly, James Ryan's *Picturing Empire: Photography and the Visualization of the British Empire* thoughtfully explores how photography became an integral tool for British colonial rule as it was deployed to visually represent Britain's mastery and

hegemonic power over its colonized subjects. Considering the large photographic archive of the Royal Geographical Society he studies to be "a form of collective colonial memory," Ryan argues cogently that "the process of photography exemplified the grammar of observation and depiction at the heart of geographic science's quest to expose the unknown." Photography, Ryan shows, "played a significant role within the construction of the imaginative geography of Empire, creating a parallel Empire within a range of discourses including science, art, commerce and government."[34] As examples of postcolonial anamnesis, these works attempt "to return this immense postcard to its sender" to use the words of Alloula.[35] In other words, claiming that the Orientalist archive of photography offered a one-way vision for its European audiences, these critics belatedly engage in a confrontation of antagonistic gazes.

My study of this archive aims to expose the formalistic silences and to critique the Orientalist tendencies of the conventional art-historical approach, while offering a corrective to postcolonial counterclaims by mapping the various ways in which the Orientalist archive was the product of visual contact between the West and the East, a contact that, though marked by enormously uneven relations of domination and cultural hegemony, did not merely engender a unidirectional gaze. In fact, local photographers also participated in Orientalist representations of the region, albeit in a transcultured fashion that attended to the taste of the local elite. Local photographic practices in Iran and Ottoman Turkey grafted into their local productions certain visual and literary tropes from Orientalism, a process that sometimes changed the meaning and connotation, not to mention application and function, of these tropes, but nonetheless perpetuated perceptions of exoticism and eroticism associated with the region. The use of the camera in the Middle East, however, was not limited to a discourse of exoticism, for the elite also took advantage of the medium to reaffirm their patriarchal values and to consolidate their power. In the final chapter, I discuss portrait photography in the region by way of attending to its productive function in the construction and consolidation of a local form of power. More specifically, by focusing on royal portraiture in Qajar-era Iran, I show how photography functioned not merely as a means of self-expression or an inscription of monarchical and patriarchal order but as a powerful tool that enabled and perpetuated traditional values and unequal relations of power in the region. In short, local photographic practices were often not on the side of resistance, as some postcolonial readers have suggested, but on the side of power.

The critical motivation behind *Camera Orientalis* is threefold. First, I am interested in the ways that photography, as a tool of representation, contributed to Orientalism by providing it with a kind of indexical truthfulness through which it could lay claim to (pseudo)scientific knowledge about "the Orient." From its inception, photography proved to be a highly valuable and efficient technology for Orientalists,

equipping them with a rapid and seemingly objective means of documentation. Various survey missions offered panoramic views of the Oriental landscape, while professional photographers produced detailed and accurate records of archaeological sites and exotic types. The seemingly objective quality of photography was deployed to fix and stabilize the subject of Orientalist representation. As such, photography transformed the Orientalist system of knowledge by furnishing it with an efficient technological apparatus for gathering presumptively reliable, nonsubjective data about the Middle East. The camera thus gave Orientalism a scientific gloss, investing it with an aura of objectivity and accuracy even as photographers continued to exoticize people and cultures of the Middle East through their careful staging and selection of images.

Second, I hope to elaborate the ways in which Orientalism in turn informed photographic representations of the East. If the camera was useful to Orientalism, so was Europe's knowledge of "the Orient" helpful to photographers of the Middle East, for it determined how they captured its "exotic" culture in their images for Western audiences. It is not insignificant that many early photographers of the Middle East, like du Camp, Louis de Clercq,[36] and Bedford were part of official missions or archaeological expeditions associated with Orientalist institutions. Even those who initially photographed the region independently, like Frith, were informed by Orientalist ideas and consciously referenced them as they represented the region. The early photographic collections of Frith, for example, are interleaved with descriptive texts that cite the works of earlier Orientalist travelers. European photographers' careful staging and selection of images reveal an exoticist consciousness that assumed "an ontological and epistemological distinction made between 'the Orient' and (most of the time) 'the Occident,'" to use Said's words.[37] As well, early photographic images of the Middle East are aesthetically indebted to the works of Orientalist painters such as Eugène Delacroix, Jean-Auguste-Dominique Ingres, John Frederick Lewis, Jean-Léon Gérôme, and other artists, both in the photographs' subject matter and in the formal concerns they embody.

From Camera Lucida to Camera Orientalis

This project offers a critical counterpoint to the Euro-American biases of photography theory that have marginalized, if not completely disavowed, the history of the medium in the Middle East. My title, *Camera Orientalis*, signals two theoretical debts, to Roland Barthes's *Camera Lucida* and to Christopher Pinney's *Camera Indica*, and underscores my critical engagements with them. To elaborate how these theoretical precursors serve as points of *departure*—understood as both a starting point and an act of divergence—for this study, a brief discussion of their respective theoretical contributions is in order. Barthes titles his book *Camera Lucida* to dis-

entangle the problematic association of photography, "by reason of its technical origins, with the notion of a dark passage (*camera obscura*)," for, according to him, "it is *camera lucida* that we should say (such was the name of that apparatus, anterior to Photography, which permitted drawing an object through a prism, one eye on the model, the other on the paper)."[38] Rejecting the conventional art-historical approach to the medium, which positions the *camera obscura* as the technological innovation that gave rise to photography, Barthes argues that there is nothing obscure or hidden about a photograph, which according to him is at once wholly visible and utterly impenetrable. "The Photograph is *flat*, platitudinous in the true sense of the word," he maintains, and for this reason "it cannot be penetrated" (106). For Barthes, there is nothing hidden or vague in a photograph that disallows interpretation: "In the image … the object yields itself wholly, and our vision of it is *certain*—contrary to the text or to other perceptions which give me the object in a vague, arguable manner, and therefore incite me to suspicion as to what I think I am seeing" (106). The evidentiary quality of photography discourages the critic from reading or uncovering anything beyond what is visible on the surface of an image: "It is precisely in this arrest of interpretation that the Photograph's certainty resides: I exhaust myself realizing that *this-has-been*" (107). Although Barthes rejects the idea of photographic objectivity, he nonetheless considers the photograph as evidence of a presence in the past.

In light of the evidentiary quality of photography, Barthes explicitly rejects any social or political reading of a photograph and provides instead a "personal" (not to be confused with "subjective") reading of photography. Put otherwise, in order to understand the *eidos* of photography, Barthes explains, he "would have to descend deeper into [himself] to find the evidence of photography, that thing which is seen by anyone looking at a photograph and which distinguishes it in his eyes from any other image" (60). In the second part of his book, Barthes investigates one central photograph: the Winter Garden Photograph of his mother, which he does not reproduce because, though it illuminates everything for him about the ontology of photography, "it would be nothing but an indifferent picture, one of the thousand manifestations of the 'ordinary'" to anyone else (73). Through his reading of this photograph, Barthes elaborates his conceptual distinction between a photograph's "*studium*," or the coded "field of cultural interest," and its "*punctum*," the "unexpected flash which sometimes crosses this field" and "pricks" the viewer (94–95). What interests Barthes, and what he privileges in his study of photography, is the *punctum*, the "subtle *beyond*," the element that launches one's desire beyond what the photograph permits us to see through its *studium* (59). While the *studium* presents some information or background about what is being photographed, the *punctum* is the affective element whose "incapacity to name" is precisely what disturbs or holds the viewer (51).

Jacques Rancière has observed that *Camera Lucida* stands as an act of criti-

cal repentance for the late Barthes, who, as the former semiologist and the author of *Mythologies*, tries to expiate his "sin of having wished to strip the visible world of its glories, of having transformed its spectacles and pleasures into a great web of symptoms and a seedy exchange of signs." Rancière astutely observes that in *Camera Lucida*, Barthes "bends the stick in the other direction by valorizing, under the title of *punctum*, the utter self-evidence of the photograph, consigning the decoding of messages to the platitude of the *studium*." What animates his interest in photography is not the social but the personal, and what allows him as a viewer to speak of the photograph is its potential for an introverted meditation rather than its worldliness as a cultural object. Whereas Barthes the semiologist "demonstrated that the image was in fact a vehicle for a silent discourse which he endeavored to translate into sentences," Barthes "the theoretician of the *punctum*" claims that the photographic "image speaks to us precisely when it is silent, when it no longer transmits any message to us."[39]

My study of Orientalist photography attempts to problematize what Rancière correctly diagnoses as the Barthesian "principle of reversible equivalence between the silence of images and what they say."[40] *Camera Orientalis* attends to the dialectical relationship in a photograph between the indexical and the historical, on the one hand, and the iconic and latent, on the other. Such an engagement with photography neither compartmentalizes nor hierarchizes what Barthes calls "the rhetoric of the image" and the sociohistorical understanding of its production, dissemination, and reception. Nor does this approach dichotomize its formalistic and political concerns, calling into question the arbitrary separation and contrast between the *studium* and the *punctum*. By privileging *punctum* and marginalizing *studium*, Barthes not only erases the historical contingency of a photograph and the practice of photography in general, but he also disavows the performative nature of photographic representation. Barthes's singular focus on the indexical nature of a photograph fails to account for the ways in which both the photographer and the subject construct an identity or an event. In the case of Orientalist photography, its practitioners carefully arranged the setting and props to create an aura of exoticism. The sitters, often the same models the studios employed, were to perform various activities associated with "exotic" cultures of "the Orient." Even when photographing historical monuments, photographers depopulated the sites to make their images enact a sense of melancholic abandonment. Whereas Barthes's theory of photography "dispels all the mediations between the reality of mechanical imprinting and the reality of the affect that make this affect open to being experienced, named, expressed," as Rancière observes, my discussion of Orientalist photography is attentive to how every image is a visual performance, providing the viewer with a coded field of image-repertoires that can, indeed should, be named and interpreted.[41] The coded field of the photo-

graphic imaginary does not merely concern what is being represented in a photograph, for technical and formal elements such as the lighting, detail, framing, and vantage point also play a performative function in producing certain cultural and political meanings.

To the extent my analysis of Orientalist photography focuses mostly on the *studium*, *Camera Orientalis* is more indebted conceptually and politically to Pinney's *Camera Indica*. Pinney begins his book with a comment on its title, stating that it is "an allusion to *Camera Lucida* … which plays an important role in the latter part of this book."[42] Deferential to Barthes though Pinney appears at certain points, *Camera Indica* attempts "to extend Barthes' concerns into an ethnographic realm where what matters is not the personal and private readings of the analyst but photography's impact on the everyday life of the society" (8). While Pinney pays tribute to Euro-American theorists of photography, he nonetheless critiques Eurocentric accounts of photography by offering a more "complex changing ecology of photography" (8). Unlike Barthes, who foregrounds personal and private readings of photography, Pinney, on the one hand, elaborates how the new medium came to be deployed "in new spaces of power and knowledge" in which photography's unique "indexicality was increasingly stressed and individual faces were largely displaced by generic masks rendered visible to the state" (23). On the other hand, he focuses on local practices of photography to demonstrate how Indian photographic portraiture does not seek to "impose a category of identity plucked from a preexisting structure but emerges rather as a creative space in which new aspirant identities and personae can be conjured" (85). Photography in the Indian context, he further demonstrates, is not viewed as an indexical medium that duplicates the everyday world, but rather is prized for its capacity to "construct the world in a more perfect form" (149). Against the Barthesian understanding of photography as primarily indexical, Pinney contends that Indian portraiture may be either a public icon of remembrance or an idealized representation of the sitter. Pinney's account of photography in India thus calls into question Barthes's private readings of photography and his ontology of photography as impenetrable to the viewer by demonstrating how context indeed matters to both the production and consumption of a photograph. Geographical, historical, and social contexts in which the medium operates and in which a photograph is produced, consumed, and read, he suggests, govern the workings of power as well as the entanglement of photographs and the practice of photography in different systems of meaning.

In the context of the history and practice of photography in the Middle East, cultural contact and the discourse of Orientalism are essential to understanding nineteenth-century European and local photographic representations of the region. Whereas Pinney's *Camera Indica* relies on the concept of nation-state to frame its

study of Indian photography, *Camera Orientalis* employs a more conceptual and transcultural approach to photography. The archive of Orientalist photography was not the product of a unidirectional relation but of contact between Western and Middle Eastern cultures, nations, and people. Put otherwise, photography, which in its materiality is a product of actual contact between light, chemicals, and paper, was a phenomenon whose historical development also was catalyzed by cultural contact. The aim of this study is not only to consider the implications of a particular form of cultural contact but also to call into question a broader theoretical claim about the productive function of transculturation itself. Mary Louise Pratt coined the term "contact zone" in *Imperial Eyes* to designate "social spaces where disparate cultures meet, clash, and grapple with each other, often in highly asymmetrical relations of domination and subordination."[43] Many postcolonial critics subsequently have adopted this term to argue that colonial encounters between "the West and the rest" have been marked by the "spatial and temporal copresence of subjects" and comprised of "interactive" and "improvisational dimensions," to use Pratt's own terms.[44] The notion of "contact zone" and the idea of "transculturation" as a phenomenon of contact have been adopted, on the one hand, to problematize the unidirectional relation of power between European colonizers and the non-European colonized, and, on the other hand, to account for the agency and resistance of the non-European colonized. Some art historians of non-Western cultures have recently attempted to critique the unidirectional model of colonial encounters by theorizing indigenous artistic representations in terms of a transcultural resistance to the West and imperialism. Mary Roberts, Nancy Micklewright, and Zeynep Çelik, for example, have figured late nineteenth-century Ottoman photography as an attempt by indigenous artists and elites to challenge Orientalist constructions of Ottoman society and as a revision of their collective self-image in the West.

In the pages that follow, however, I hope to complicate such celebratory claims about the productive function of transculturation at the colonial frontier, and the commonly accepted view that the indigenous and their modes of representation, as phenomena of contact zones, are always already on the side of resistance. My discussion of indigenous photography in nineteenth-century Iran, for example, aims to demonstrate that claims about the oppositional nature of indigenous representations are problematic in perpetuating a Manichean structure in which the West is always on the side of power and its others are inherently endowed with oppositional agency. Such celebratory claims fail to account for the inequalities of power and unequal access to (photographic) representation that characterize non-Western societies as they do anywhere else. Indeed, throughout the Middle East, the elite classes utilized what Allan Sekula calls photography's "double system," one "capable of functioning both *honorifically* and *repressively*."[45]

Moreover, in the following I make the case that a new understanding of Orientalism as a complex network of aesthetic, cultural, economic, and political relationships that is transnational and transcultural in nature is crucial to how the Middle East is represented by both European and indigenous photographers. Art historians have often used the notion of "Orientalism" either as a neutral art-historical term (as in nineteenth-century Orientalist genre painting) or as a purely ideological term—which some have embraced as a useful notion in unpacking the political implications of Orientalist representations of the Middle East, while others have rejected it as an applicable concept in understanding nineteenth-century visual art and photography. My notion of Orientalism implies a more nuanced understanding of the term that does not dichotomize the aesthetic and the political and is attentive to the nodes and ties that bind photographers, consumers, and collectors of exotic images, and later museums and curators across national boundaries. Such a complex web of relations is what supplies the silent indexicality of photographic representations with political meaning as well as aesthetic value. Whether we study these images in the historical context of their production and consumption or in their afterlives as art objects or visual archives, photographic representations of the Middle East contain meanings only accessible when we attend to geopolitical distinctions and cultural assumptions about "the Orient." A nuanced reading of these images, in other words, has to map their affinities with Orientalist discourses and colonial practices that parallel them. My approach is therefore critical both of art-historical attempts that reposition the photography of the Middle East within conceptual paradigms that are constituted only by aesthetic and formal concerns and of ideological critiques that reduce the photographic archive to mere colonial distortion. *Camera Orientalis* offers a historically informed examination of Orientalism's photographic archive that attends to the specific practices, institutions, and relationships in which it is inscribed. What enabled the actual production of, and historical interest in, early expeditionary photography of the Middle East, and what renders such images legible today, is an elaborate set of relations, ranging from cultural vogues such as Egyptomania and academic institutions such as the Institut d'Égypte to the economic and political interests of European colonialism in the region. In this way, Orientalism can be said to harness photographs of the Middle East to particular representational tasks such as exoticism, preservation, and possession. It is these dynamics to which I now turn.

1

The Orientalist Photograph

To speak of *the* Orientalist photograph is not to assume the fixed nature of either the notion of Orientalism as a discourse of power or photography as a medium of representation, but rather to interrogate the conventional and dominant criteria used to define these terms and their entangled histories, interrelations, and legacies. To speak of the Orientalist photograph is not to privilege photography's role in Orientalist cultural production either; nor is it to dismiss its particular characteristics as a visual and material object. Rather it is to elaborate the historical and theoretical nature of the relationship between photography and Orientalism. More specifically, my aim is to bring into dialogue the iconography of the Orientalist image with an historical understanding of its emergence in the mid-nineteenth century. This chapter sketches an approach to the Orientalist photograph that engages its form as much as its politics; what follows is at once a historically informed account and a formal elaboration of a particular form of photographic representation. Without attempting an exhaustive inventory of the features of Orientalist photography, my goal is to provide a general description of some of its formal characteristics, situating them specifically in the historical context of their formation. An Orientalist photograph is an imaginary

construct, though always historically and formalistically contingent; it is marked by iconic fractures and ideological fissures, yet nonetheless regulated by a visual regime that naturalizes its particular mode of representation. The photographic representations of "the Orient" and its people, in other words, are linked and actualized through a web of practices and institutions that figure it as the exotic other.

What has motivated my description of what one might call the "visual regularities"[1] of Orientalist photography are recent claims by some art historians and literary scholars that Orientalism no longer provides a viable conceptual framework for engaging nineteenth-century representations of the Middle East by European writers, travelers, and photographers. In light of the wide-ranging influence of Edward Said's *Orientalism*, it is remarkable how much critical energy has been expended in recent years to demonstrate that his path-breaking book misrepresents or inadequately delineates the project of Orientalism. To be sure, *Orientalism* has always attracted more than its fair share of critics. Just a few years after its publication, scholars such as Aijaz Ahmad and James Clifford indicted *Orientalism*'s "high humanism," took issue with its use of Michel Foucault's theory of knowledge-power, and questioned its omission of German and Russian Orientalism.[2] What distinguishes recent criticism of *Orientalism*, however, is that it emanates from a broader rejection of the field of postcolonialism itself, and indeed of the project of political critique of literary and artistic expressions altogether. Recent art-historical discussions of nineteenth-century photographic representations of the Middle East provide an exemplary case of this recent anti-Saidian tendency.

"In contemporary writing about nineteenth-century photography of the Middle East," writes Michelle L. Woodward, "it has become almost a cliché to describe many of these images as 'Orientalist'—that is, reflecting or propagating a system of representation that creates an essentialized difference between the 'Orient' and the 'West.'"[3] This claim aptly captures the predominant sentiment among art historians and curators who work on representations of the Middle East created by both European and indigenous painters and photographers. To be sure, responses to Said's discussion of Orientalism as a discourse of colonial power among art historians and museum curators span the critical spectrum, from more rigorous and subtle critiques articulated from the left to the sometimes facile and reactionary stances adopted by those of an opposing political orientation. On one side are art historians such as Zeynep Çelik, Christopher Pinney, Mary Roberts, and Woodward who argue that "the trend to extend Said's analysis to apply equally to visual representations has ... been used too broadly, obscuring nuances and inconsistencies, not only between different photographers' bodies of work but also within them."[4] These scholars typically aim to constructively revise Orientalism to encompass "a disparate and disputed set of discursive constructions," while at the same time acknowledging "Orientals" as "par-

ticipants in the production of counternarratives or resistant images."[5] On the other side are writers, including John MacKenzie and Ken Jacobson, who betray a marked suspicion of "theory" and seek to return the term "Orientalism" to its prior usage as an art-historical term that could be deployed without suggestion of a broader political or ideological critique. In *Orientalism: History, Theory and the Arts*, MacKenzie argues against Linda Nochlin that "there is little evidence of a necessary coherence between the imposition of direct imperial rule and the visual arts," claiming in laudatory terms that "Orientalism celebrates cultural proximity, historical parallelism and religious familiarity [with the Middle East and North Africa] rather than true 'Otherness.'"[6] Given such perceived "misconceptions inherent in postcolonialist analysis," Jacobson similarly suggests that "a return to more traditional methods is desirable for the study of 19th- and early 20th-century photography in North Africa and the Near East," urging commentators to focus more single-mindedly on the "notable aesthetic, as well as documentary and historical merit" when analyzing visual representations.[7] Despite their ideological differences, art historians in both camps share the claim that the genres and concepts of aesthetic theory are applicable to Orientalist photography, and focus on its artistic aspect instead of its topographical characteristics. While critics on the left have attended primarily to the aesthetic and stylistic differences of Orientalist photography, those on the right have been more apt to dismiss altogether the characterization of the practices and institutions to which this archive originally belonged as ideological.

The recent tendency of photographic historians to elide the politics of Orientalist representation in favor of a return to business-as-usual aesthetic analysis underscores the critical necessity to assert the photograph's status as both illustrative and constitutive of notions of "the Orient." More specifically, if Orientalism is understood neither as a merely ideological discourse of power nor as a neutral art-historical term, but instead as a network of aesthetic, economic, and political relationships that cross national and historical boundaries, then it is indispensable to the understanding of nineteenth-century photography of the Middle East. Whether considered in the context of their production and dissemination in the nineteenth century or in relation to their present status as collectable objects or historical archives, photographs of "the Orient" become meaningful and legible only if they are considered in context, understood broadly to encompass not just geographical regions but histories and social imaginaries. While insisting that Orientalism offers a crucial perspective from which to comprehend the meaning and significance of photographic representations of the Middle East, I do not mean to suggest that such images should be understood merely as a reflection of Europeans' racial prejudice against "Orientals," nor that these images simply transmit or validate European, imperial dominance over the region. Nor it is the case that Orientalist photography entails a binary visual structure

between the Europeans as active agents and "Orientals" as passive objects of representation. Rather, I hope to advance an alternative view of Orientalist photography that carefully attends to the interplay of a multiplicity of operations that generate a distinctly exotic vision of the Middle East—operations ranging from those of the photographers who staged and produced the images to the curatorial practices that have packaged them as collections and archives. It bears noting here that such an exotic vision of the region was generally embraced and often perpetuated by the elite in the Middle East. Given this, it is evident that indigenous photography in and of itself does not represent an oppositional locus or resistant iconography; rather, photography as a general practice was enmeshed in the kind of operations that rendered its vocabulary and thematics of representation equally exoticist.[8] A network theory of Orientalism, therefore, concerns itself neither with the motivations of individual photographers nor with the attributes of art objects, but instead studies the symmetric and asymmetric relations between discrete images, specific individuals, and concrete practices.

Network

The history of photography has been intimately connected with Europe's knowledge about the Middle East since the invention of the medium in 1839. Significantly, at the very meeting in which Daguerre's invention was introduced to the Chamber of Deputies, the presenter, Arago, commented upon "the extraordinary advantages that could have been derived from so exact and rapid a means of reproduction during the expedition to Egypt."[9] He then recommended that the French government immediately furnish various institutions of knowledge-gathering about the Middle East, such as the Institut d'Égypte, with the new technology to further the project of Orientalism. It is not a coincidence that only eighty days after this meeting, a group of French painters and scholars led by Horace Vernet, an Orientalist genre painter who had traveled to Algeria with the French Army in 1833, and the daguerreotypist Frédéric Goupil-Fesquet went to Egypt to photograph Egyptian antiquity, or that as early as 1846, Daguerre's British counterpart, William Henry Fox Talbot, published a pamphlet titled "The Talbotype Applied to Hieroglyphics," which was distributed among archaeologists and Orientalists.[10] Indeed, in subsequent decades, many early European traveling and expeditionary photographers followed Arago's suggestion and went to the Middle East to photograph various places and monuments, making the Middle East one of the original and most popular sites for the practice of photography.

Art historians and museum curators generally have treated early amateur and expeditionary images of the Middle East either as distinct artistic expressions of indi-

vidual photographers or as documentary projects to provide European audiences, in particular archaeologists and Egyptologists, with verisimilar images of the Holy Land and Egyptian antiquity.[11] What these approaches fail to acknowledge is the network of practices, institutions, and relations that made possible the production of these images in the first place, as well as the politico-cultural context that led them to be so rapaciously consumed as visual and exotic objects. That representations of "the Orient" figured so prominently in the early history of photography, specifically in England and France, speaks to the complex web of cultural, economic, and political relations between Western Europe and the Middle East, relations that provided the logistical means and conceptual paradigms for various photographic projects. Indeed, the photographic undertakings of du Camp, Teynard, or Salzmann would never have been realized were it not for the great interest in Middle Eastern antiquity generated by Napoleon's 1798 expedition to Egypt and the subsequent establishment of the Institut d'Égypte, the intellectual and discursive contributions of earlier Orientalist scholars, painters, and travelers, and the sponsorship of the French government and institutions. Du Camp, for instance, belonged to the Orientalist institution Société Orientale, had a government commission from the Ministry of Agriculture and Commerce to photograph historic monuments in Egypt, Palestine, and Syria, was trained prior to his journey by Gustave Le Gray and Alexis de Lagrange to produce good negatives, was accompanied by Gustave Flaubert, who fancifully documented their trip, and was finally able to publish his photographs in 1851 using the printing process developed by Louis Désiré Blanquart-Évrard—photographs that became immediately known because of the popular and scholarly interest in Orientalism. Far from being the result of a manic obsession with photography, as Flaubert claimed, du Camp's images are products of a network of individual and institutional relationships that not only determined the content of his photographs but also provided the technical knowledge and logistical support to execute them (figure 1.1). Du Camp's *Égypte, Nubie, Palestine et Syrie* thus contains an intricate interplay of textual and visual traces that inscribe it within the iconography of Orientalism. As in Frith's *Egypt and Palestine* (figure 1.2), his photographs in the book, which became an instant success in spite of its costliness, are accompanied by texts containing verbatim extracts from eighteenth- and early nineteenth-century Orientalist travel narratives in order to make these images meaningful and legible.[12] These textual precursors not only function as explications for photographic representations of "the Orient" but also circumscribe what is considered worthy of photography in the Middle East. Put otherwise, the earlier travel narratives play a crucial role in the practice of Orientalist photography by providing it with the knowledge, the framework of classification, and the formal concerns of its representations.

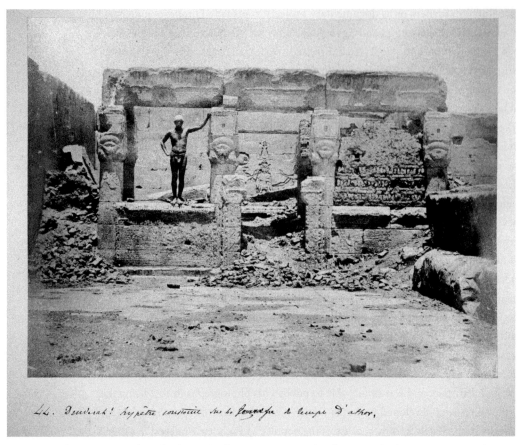

1.1 Maxime du Camp, ruins of Denderah (1849). Albumen print. Special Collections, Charles E. Young Research Library, University of California, Los Angeles.

Sun-Picture

That a photograph, technologically speaking, was understood as a "sun-picture" or "sun-drawing" offers a materialist explanation for why "the Orient" as the land of sunshine was one of the first sites for the practice of the new medium. Light was not only the basis of the invention but also a necessary element in the very process of photographic production, and so the abundance of sunlight in the Middle East made the region an ideal location for the execution of early photography. As Daguerre, the inventor of the first form of photography, acknowledged, "The imprint of nature would reproduce itself still more rapidly in the countries where the light is more intense than in Paris."[13] This point was underscored by Arago, who specifically referenced Egypt as an ideal location for photography in his introduction of the medium to the Academy of Sciences on January 9, 1939:

Now how long a time does the light require to execute this operation? In our climate, and in ordinary weather, eight or ten minutes, but, under a pure sky, like that of Egypt, two, perhaps, one minute, might suffice to execute the most complex design.[14]

The plentiful sunshine in the Middle East was not merely a technical necessity but also a crucial factor in giving the photographer an artistic edge over the Orientalist painter. If Orientalist genre painters such as William Henry Bartlett had difficulty "express[ing] the oriental light—which without the accidents of light and shade usual in the north—is sufficient to produce the most brilliant relief combined with a softness and harmony equally beautiful,"[15] the Orientalist photographer not only needed the bright light to take a photograph and to develop his negative plates but also was able to capture the remarkable contrasts produced by the brilliant sun to

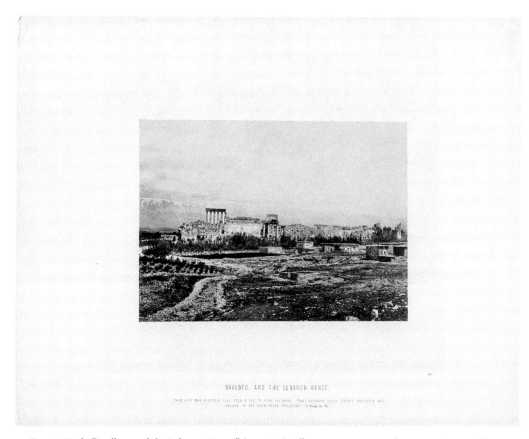

1.2 Francis Frith, "Baalbec, and the Lebanon Range" (ca. 1860s). Albumen print. Ken and Jenny Jacobson Collection of Orientalist Photography. The Getty Research Institute, Los Angeles.

1.3 Sébah & Joaillier Studio, "Intèrieur du Grand Bazar" (ca. 1890s). Albumen print. Pierre de Gigord Collection. The Getty Research Institute, Los Angeles.

make his image compositionally more complex. Indeed, one of the most prominent features of the Orientalist photograph is its deployment and contrasting of light and shadow (figure 1.3). The manipulation of light and shadow allowed the photographer to synthesize photographic documentation and artistic symbolism. To make their images into what was considered *photographie artistique* at the time, photographers often produced shadows by retouching negative plates when there was no contrast

in lighting. The contrast of light and shadow enhanced the quality of the image, for while the translucent blaze of sunshine conferred upon the subject of the photograph a preternatural aura of aliveness, the ever-present shadows furnished it with a sense of mystery and sublime terror. The interplay of sunshine and shadow made the composition of the image at once beautiful, through brilliant and harmonious relief, and sublime, by infusing it with a sense of mysterious disorientation.

Circularity

The relation between Orientalist painting and photography is not that of a linear influence but that of a circular reciprocity. Even a cursory glance at early Orientalist photography reveals its indebtedness to the conventions of Orientalist romantic paintings: Moulin's erotic and ethnographic photographs of the Orient explicitly borrow from the works of romantic painters such as Delacroix, just as Hammerschmidt's and Frith's photographs of Egyptian antiquity and the monuments of the Holy Land relied on the topographical works of English painters such as David Roberts. Like their precursors, the Orientalist photographers were preoccupied with the past, sentimentalized ruins, turned to the religious and mystical, focused on the mysterious and the exotic, and fetishized the erotic. That Orientalist photography's subject matters and formal concerns were mediated by a particular painterly tradition should come as no surprise since some of the early photographers of the Orient, such as Fenton, Salzmann, and Vernet, were accomplished painters, or began their careers as (Orientalist) painters but switched to photography as the new medium provided them with a more efficient means of realistic representation. More surprising, however, are the ways in which photography altered Orientalist genre painting, transforming its techniques and turning its romantic reveries into realist fantasies. As was predicted by Daguerre in 1839, beginning in the mid-nineteenth century, Orientalist painters such as Ludwig Deutsch, Jean-Léon Gérôme, and William Holman Hunt became increasingly dependent on the works of amateur and professional photographers of the Orient such as Henri Béchard, G. Lékégian, the Abdullah brothers, and Sébah to create what was considered documentary realism. That Théophile Gautier compared the new documentary realism and its precise techniques to the objective precision of photography points to the crucial mediating role of the Orientalist photograph.[16]

The circular relation between Orientalist painting and photography at once complicates notions of artistic influence, originality, and origin, compelling us to consider Orientalist representation as the interplay of formalistic and discursive relations. The sometimes suspicious attitude among art historians and museum curators toward Said's discussion of Orientalism as a discourse of colonial power has obscured the

crucial links between painters, photographers, archaeologists, writers, and travelers, and how their practices and discourse have influenced each other. Frith's *Egypt and Palestine* provides an early example of the interplay of the discursive and the visual. The juxtaposition of his photographs with their descriptions after each image points to the supplementarity of textuality and visuality in the field of Orientalism. Frith's texts are peppered with references to the works of other travelers, archaeologists, and Orientalists. Consider the following quotation from Albert Smith, an accomplished traveler at the time, which Frith offers by way of describing the role of photography in providing truthful images of other worlds:

> Artists and writers will study effect, rather than graphic truth. The florid description of some modern book of travel is as different from the actual impressions of ninety-nine people out of a hundred, allowing all these persons to possess average education, perception, and intellect, when painting in their minds the same subject, as the artfully tinted lithograph, or picturesque engraving of the portfolio, or annual, is from the faithful photograph.

Frith responds to this claim by pointing out:

> Yet it does not follow, O Albert Smith, that a photograph, because it is not "over-coloured," is therefore *faithful*. I am all too deeply enamoured of the gorgeous, sunny East, to feign that my insipid, colourless pictures are by any means *just* to her spiritual charms. But indeed, I hold it to be impossible, by any means, fully and truthfully to inform the mind of scenes which are wholly foreign to the eye. There is no effectual substitute for actual travel, but it is my ambition to provide for those to whom circumstances forbid that luxury, *faithful* representations of the scenes I have witnessed, and I shall endeavour to make the simple truthfulness of the Camera, a guide for my Pen.[17]

Frith's palpably defensive commentary on Smith provides an example of how early photographic projects were in dialogue with travel writing and other Orientalist representations. Although Frith underscores the camera's claim to objectivity and truthfulness, his response nonetheless speaks to the complementary relationship between the camera and the pen, photography and witnessing. On the one hand, the supplementary relation between the photographer, archaeologists, and earlier travelers to the region suggests that what became worthy of photographing in "the Orient" was mediated through earlier descriptions and painterly depictions of holy sites and antiquity. On the other hand, by photographically re-presenting these sites, Frith pro-

vides further evidence for their studies while at the same time popularizing Orientalism as a discourse. Reaffirming the value of travel and firsthand observation, Frith nonetheless points to the value of photography as a substitute for the Orientalist journey. For him, the Orientalist photograph has a supplementary function, providing the viewer with a visually objective experience of "the Orient," otherwise unavailable to most people. Orientalist photography, therefore, neither displaced its painterly counterpart nor outdated its textual precursor, but rather joined them to further the project of Orientalism as a dominant mode of representation.

Mediation

If early and mid-nineteenth century European travelogues and Orientalist genre paintings defined what was worthy of photographing in "the Orient," the Orientalist photograph in turn powerfully informed the vision of every traveler who went to "the Orient." Evelyn Waugh's description of the scene of his arrival to Constantinople offers a telling example of this mediation:

> It was getting dark by the time that we came back to the mouth of the Golden Horn. A low sea mist was hanging about the town, drifting and mingling with the smoke from the chimneys. The domes and towers stood out indistinctly, but even in their obscurity formed a tremendous prospect; just as the sun was on the horizon, it broke through the clouds, and, in the most dramatic way, possible, threw out a great splash of golden light over the minarets of St. Sophia. At least, I think it was St. Sophia. It is one of the delights of one's first arrival by sea at Constantinople to attempt to identify this great church from the photographs among which we have all been nurtured.[18]

Like other travelers to the region, Waugh seems already familiar with what he would see in Istanbul before his arrival thanks to many photographs of the city and its attractions disseminated throughout the West. Indeed, European travelers were "nurtured" as early as the 1850s by images of Constantinople, Jerusalem, and Egypt by pioneer photographers such as James Robertson, du Camp, Teynard, and Salzmann. Orientalist photography as a mass medium democratized the access to Orientalist representation by liberating it from its elite confinement in the Salon. The common display of photographs of the Middle East in the world exhibitions of the second half of the nineteenth century and their circulation in photographic studios provided almost everyone a glimpse of "the Orient."[19] The Orientalist photograph was therefore not merely an expression of a European desire for "the Orient"[20] but was *productive*

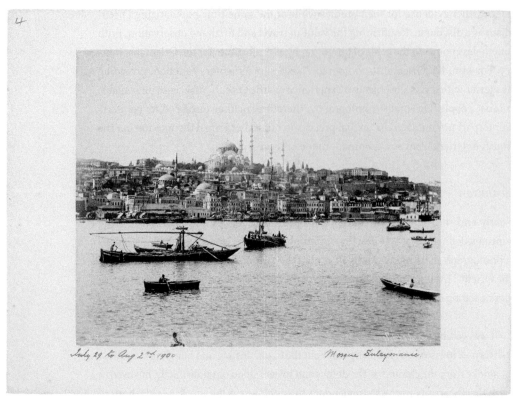

1.4 Sébah & Joaillier Studio, "Mosquée Suleymanie" (ca. 1890s). Albumen print. Pierre de Gigord Collection. The Getty Research Institute, Los Angeles.

of the lure of the East. Unlike the phantasmagoric image repertoire of the *Arabian Nights* that had defined and then disillusioned earlier travelers like Gérard de Nerval and Flaubert, the Orientalist photograph was constitutive of the "Oriental" real that made the traveler's encounter with the reality of "the Orient" more meaningful, albeit somewhat déjà vu. Unlike the intertext of the *Arabian Nights* or the romantic paintings of Delacroix, the Orientalist photograph did not counter the traveler's own experience of the "Oriental" real by making it seem banal, but rather enhanced it through the pleasure of identification (figure 1.4). The photographic image was not merely an indexical reference point for the Orientalist traveler but the mediator of his or her desire for "the Orient." The Orientalist photograph thus intensified the desire for "the Orient," helping it grow as a cultural phenomenon throughout the West.

As well, photography's potential for the evolution of Orientalism as an "objective" discourse was widely acknowledged early on. For example, in a review of du Camp's *Égypte, Nubie, Palestine et Syrie*, Louis de Cormenin wrote:

A daguerrian excursion is thus fortuitous from the dual points of view of eternal art and the written voyage (*voyage cursif*), above all when this excursion is undertaken in little known, unique, and strange countries of which science possesses only insufficient data. Nor is it rash to say that the publication of Maxime du Camp completes, in brief and comprehensible fashion, the works of Denon and des Champollion-Figeac, and opens a new way of investigation to Orientalists, just as it offers a horizon particular to artists' studies. Art, as much as science, can gain precious information from [such photographs]. The intellectual movement directed towards the Orient can, from now on, take it as the helping hand (*vade mecum*) of its research, and the most intelligent and the most definitive of guides.[21]

The new medium, which is viewed as a smart "helping hand," is valued for its potential contribution to both the arts and the sciences. In his review, Cormenin underscores the importance of photography to the project of Orientalism in that it completes the works of earlier scholars like Dominique Vivant Denon and Jacques-Joseph Champollion-Figeac. Photography, according to him, contributes to the production of "scientific" knowledge about non-European societies by providing new and objective "data." Indeed, photographic works such as du Camp's were valued not only for advancing the research and artistic projects of earlier Orientalists but also for paving the way for new approaches to the exploration and representation of "the Orient" and other non-Western societies visually, thus critically enabling the Orientalist will to knowledge.

Anchorage

The Orientalist image is characterized by excessive textual anchorage. In principle, the Orientalist photograph has the potential to be as polysemous as any other image, but the potential to allow a floating chain of meanings or interpretations in this case is commonly countered by the ubiquitous presence of the title in the Orientalist photograph's frame, as well as the repetition or translation of the title on the album page (figure 1.5). The handwritten labels below the images in albums might be understood as an attempt on the part of the traveler or collector to add a personal touch by way of asserting possession of the photograph as constitutive of its significance as an artifact. And yet that these labels simply repeat or are direct translations of the titles given by the photographer or the studio nonetheless draws attention to both the owner's lack of imagination and, more fundamentally, a desire to curb the photograph's potential polysemy. The title, in other words, serves the function of selective "elucidation" for the viewer, and, as Barthes put it, "it remote-controls him toward a meaning chosen in advance."[22] The title is therefore a linguistic supplement that

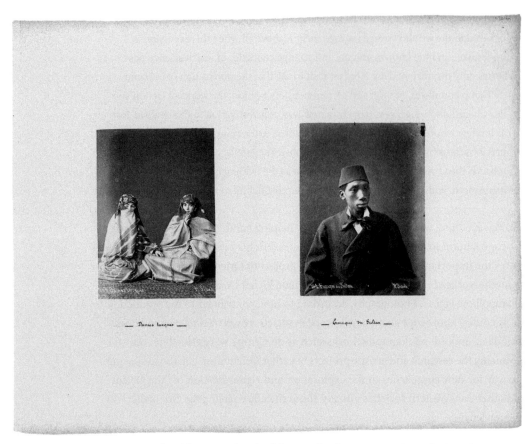

1.5 Pascal Sébah, "Dames Turques" and "Eunuque du Sultan" (ca. 1880s). Albumen prints. Pierre de Gigord Collection. The Getty Research Institute, Los Angeles.

constructs the meaning of the image through its accompaniment of the coded iconic message presented in the photograph itself. As with the album page referred to above (figure 1.5), on which a generic photograph of Turkish ladies is placed next to the dignified portrait of the sultan's eunuch, the placement and juxtaposition of images in albums add yet another layer of signification, in this case referencing the idea of the harem as an erotic and mysterious space where the sultan's women are overseen by his eunuchs. It is in this sense that I suggest the Orientalist photograph is *excessively* anchored, demonstrating a profound anxiety about the potentially ungoverned plurality of signifieds contained within. The title in the frame and its repetition in the handwritten descriptions aspire to impose fixity of meaning. Anchorage, as Barthes remarks, "is a control, bearing a responsibility—in the face of the projective power of pictures—for the use of the message."[23] The Orientalist photograph directs its viewer

to a particular meaning not only through indexicality but also by means of a title for the image; it attempts to constrain its meaning or content through the acts of labeling and relabeling. Here the title of the image is not simply a description of what is portrayed, but rather serves to contain the play of meaning, and in doing so acts as a countervailing force against the symbolic functions of the photograph or alternative meaning-making possibilities. The denotative title reins in the connotative potential. The naming of the image can be understood as a precautionary move by the photographer, anxious about photography's inability to discriminate or exclude, to channel the excess of signification. In this sense, the Orientalist photograph is not presented as being endowed with textured complexity; nor is the viewer offered multiple perspectival positions. Instead, the image's excessive anchorage renders it as univocal and flat, discouraging the viewer from assuming different standpoints with respect to what is in the picture. Here the possibility of looking past the continuity between the image and its referent is obscured. The title in the Orientalist photograph is therefore not simply a means of elucidation but also a technique of selective interpellation to limit the totality and plurality of the iconic message.

The title of an Orientalist photograph might even be said to serve an ideological function insofar as it seeks to cue a certain kind of conventional interpretive practice, one that privileges, for example, the recognition of the human agency behind the photograph, as well as its emergence in a certain time and place. By presenting the circumstances of the photograph's production as a fact or the truth, the title of the Orientalist photograph might be understood broadly as a means to counter the anxiety of uncertainty lurking behind any encounter with an ambiguous text or an exotic other. In this case, that discomfort may be fueled by the suggestion of an intrusion by the "Oriental" into the life of the European viewer absent the demonstration of control enacted through the presence of the title. The Orientalist photograph thus freezes the "Oriental" other twice: once through an exotic staging of his or her reality, and a second time through an ideological labeling of his or her appearance in the image.

Preservation

In the introduction to his collection of Holy Land photographs published in 1898, Adrien Bonfils, one of the most prolific and distinguished photographers in Lebanon, wrote:

> In this century of steam and electricity everything is being transformed ... even
> places: already in the ancient Plain of Sharon is heard the whistle of the locomotive.
> ... The moment is probably not far off, when the holy Mount of Olives and Tabor

will each possess its funicular like Mt Righi [outside Lucerne]! Before that happens, before Progress has completed its destructive work, before this present—which is still the past—has disappeared forever, we have tried, so to speak, to fix and immobilize it in a series of photographic views.[24]

Bonfils's alarmist claims about the disappearance of "the Orient" were hardly novel, for late nineteenth-century Orientalism, as I have shown elsewhere, is marked by a profound sense of belatedness.[25] For example, as early as 1850, Flaubert made a similar plea to Gautier: "It is time to hurry. Before very long the Orient will no longer exist. We are perhaps the last of its contemplators."[26] Nor is Bonfils's idea of photography as a means of cultural preservation and rescue original. Over forty years earlier, in his introduction to *Egypt and Palestine*, Frith wrote:

> I may be allowed to state, as giving additional value to good Photographs of eastern antiquities, that a change is rapidly passing over many of the most interesting: in addition to the corroding tooth of Time, and the ceaseless drifting of the remorseless sand, Temples and Tombs are exposed to continued plundering—Governors of districts take the huge blocks of stone, and the villagers walk off with the available bricks, while travellers of all nations break up and carry off, without scruple, the most interesting of the sculptured friezes and the most beautiful of the architectural ornaments. (not paginated)

From the very beginning of its invention, the camera provided Orientalists with a tool to visually "rescue" the remnants of the Middle East's antiquities just as they were pillaging the remnants of historical monuments in the region (figure 1.6). But what is more remarkable about Bonfils's comment is the mobilization of nostalgia to obscure the contradictory functions of Orientalist photography as both a means of cultural rescue and an agent of change. While Bonfils, like belated travelers, invokes a melancholic discourse of nostalgia in response to the expansion of tourist infrastructure and European colonialism, he resolves his contradiction as the agent and beneficiary of European tourism by engaging in a practice of photographic preservation. The Orientalist image is, therefore, both an expression of the belatedness so common among nineteenth-century Orientalists and an attempt to preserve the exotic by fixing it into a photographic icon. Bonfils's invocation of nostalgia masks the fact that his photographs, like those of other resident photographers in the region, were produced almost exclusively for European tourists; that is, the very agents of "progress" for whose comfort the tourist infrastructure was built, an infrastructure that threatened the demise of the "Oriental" reality. The Orientalist photograph is therefore a contradictory image, claiming to visually preserve "the Orient's" glorious past as a

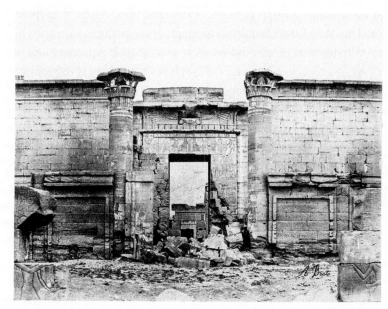

1.6 Antonio Beato, Egyptian ruin (ca. 1880s). Albumen print. Ken and Jenny Jacobson Collection of Orientalist Photography. The Getty Research Institute, Los Angeles.

means of historical documentation while contributing to its disappearance through tourism, colonialism, and Western modernity.

Depopulation

In a reading for a magic-lantern show of the Great Pyramid of Egypt in 1897, Professor Charles Piazzi Smyth expressed the following sentiment, commonplace in the nineteenth century, about the Orientalist photograph:

> The ghost-like figures of the Arabs might as well have been omitted, for with their black, unphotograhicable [*sic*] faces they make very bad ghosts; and besides the modern Arabs of Egypt are such ephemeral occupiers of the soil, that they have no right to any place amongst the more ancient monuments of Egypt.[27]

The Orientalist photograph often depopulates the Orient of its inhabitants, for their presences rob the image of its quest for a romantic monumentalism and circumvent

the possibility of visual appropriation.[28] Unlike Orientalist genre paintings where natural scenes and ancient monuments are always peopled with "colorful natives"—think of Roberts's paintings of the ruins of Baalbek in Lebanon or Prosper Marilhat's ruins of the al-Hakim mosque in Cairo—Orientalist photographs of Egyptian antiquity and the Holy Land often depict an empty space or site unobstructed by the presence of indigenous people. Indeed, early photographic representations of the Middle East are either close-up images of Egyptian antiquity and of religious sites in the Holy Land or panoramic and topographic views of the landscape, and in neither category is there any engagement with the people of the region or their everyday lives. This depopulation cannot be explained simply in terms of the medium's technical limitations in photographing moving figures at the time. The efforts on the part of early expeditionary photographers to eliminate local people from their images are deliberate and concerted, for what interests the Orientalist photographer, as du Camp makes abundantly clear in his narrative, is not the contemporary people and culture of the Middle East but its historical ruins and disintegrating relics of bygone civilizations. Viewed as "bad ghosts" without any photogenic quality, the indigenous people are either utterly erased from the scene or appear occasionally as anonymous physical blotches to provide a sense of scale. In contrast to the superabundance of de-contextualized, studio-based images of people produced by resident photographers in the Middle East, the absence of humanity in the Orientalist photography of Egyptian antiquity and the Holy Land at once participates in a form of static monumentalism that underpins Orientalist historiography and enables the possibility of colonial appropriation and intervention.

Béchard's photograph of the ruins at Thebes provides an example of photographic unpeopling (figure 1.7). Like many early other topographic images of the Middle East taken by expeditionary photographers, it presents a close-up of an archaeological site in decay. In this typical photograph of Egyptian antiquity, there are neither people nor traces of local culture, only the crumbling remains of a glorious past. In this photograph, the only references to human beings are the archaeologized figures on the standing walls, whose presence, juxtaposed with the fallen stones and crumbling remains, conveys dead magnificence, the remnants of a bygone civilization for nostalgic or romantic contemplation as much as for scientific observation and colonial appropriation. The absence of indigenous people in the Orientalist photograph foregrounds the presence of the viewer as both a yearning subject and a discerning savant. Such depopulating iconography is thus productive of an appropriating gaze that positions the European viewer as the potentially legitimate occupier through a visual erasure of the indigenous population.

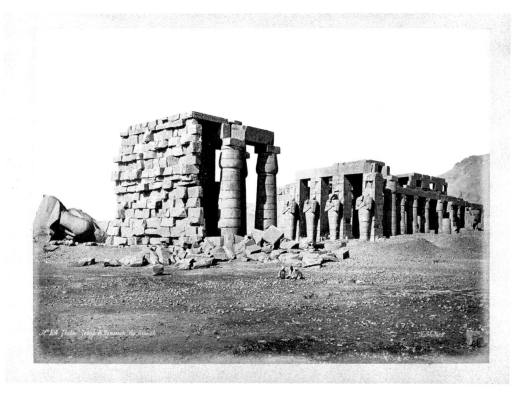

1.7 Henri Béchard, general view of the Temple of Ramesseum, Thèbes (ca. 1880s). Albumen print. Ken and Jenny Jacobson Collection of Orientalist Photography. The Getty Research Institute, Los Angeles.

Staging

Nothing belies the myth of photographic "naturalness" or "objectivity" in the Orientalist image more than the staging of what is being represented (figure 1.8). Orientalist photographers, from Fenton in the late 1850s to professionals in studios such as Sébah & Joaillier, Abdullah Frères, and Maison Bonfils in Istanbul and Beirut in the late nineteenth century, often used the same models to pose in stereotypical scenes in studio spaces filled with exotic props and fabrics to create "authentic" scenes of "Oriental" life. The photographer's intervention here goes well beyond mere framing, lighting, or focus, for everything in the image denotes a staged scene: the artificial backdrop, the ever-present props, and the unnatural gaze of the sitter. The staging, on the one hand, is used in the service of what one might call "typification," understood as a means of exemplifying some category such as "violin player," "Jewish," or *dame turque.*" Like the Orientalist photograph's excessive anchorage, the elaborate staging

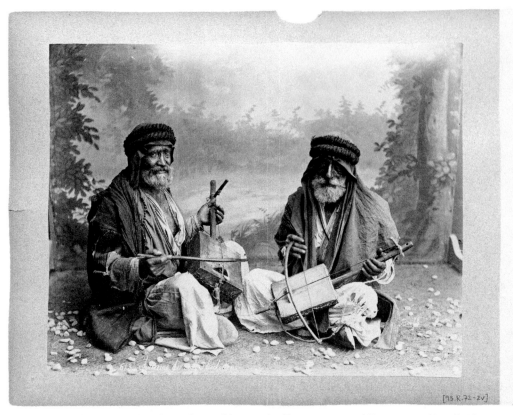

[93.K.72-2v]

1.8 Maison Bonfils, "Joueurs de violon Bédouines" (ca. 1880s). Albumen print. Middle Eastern and North African Views. The Getty Research Institute, Los Angeles.

is meant to offer the viewer an uncontested, albeit flat, representation of an "Oriental" type. The backdrops and props here do not add complexity to the photograph, nor endow it with perspectival complexity, but rather frame the person in the image as a representative of a professional or ethnic category.

On the other hand, the staging has a performative function. The Orientalist photograph is an exception to photographic representation, for it is never "related to a pure spectatorial consciousness," as Barthes claimed, but rather is related "to the more projective, more 'magical' consciousness on which film by and large depends."[29] Fenton, for example, titled all his staged images of Oriental scenes he exhibited in 1859 to help create a narrative line and to turn his "tableaux" into a vehicle for storytelling. Although the Orientalist photograph is born of an archaeological urge for documentary evidence and a classificatory desire for empirical knowledge,

its content ultimately reveals a projected fantasy of the Middle East and its people. The staged photographs of "Oriental" life are akin to the Victorian parlor amusement of tableaux vivants that consisted of individuals posing in various scenes in a motionless and silent fashion. The Orientalist photograph mobilizes a fictional lexicon that undermines its documentary aims, while its reproducibility diminishes its significance as an authentic souvenir of a voyage.

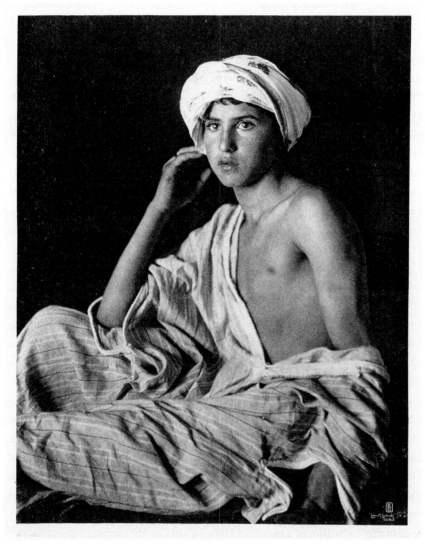

1.9 Lehnert & Landrock, boy (ca. 1910s). Gelatin print. Ken and Jenny Jacobson Collection of Orientalist Photography. The Getty Research Institute, Los Angeles.

Studium

A historian of photography ends his essay on the erotic photographs of Lehnert & Landrock (figure 1.9), one of the most prolific studios in North Africa during the first two decades of the twentieth century, with the following question: "Is the correct paradigm for interpreting this kind of work one of politics and power, or one of imagination and inspiration?"[30] The question is disingenuously suggestive, at once gesturing toward an acknowledgment of how the large archive of erotic images of the Orient can be potentially viewed as a record of exploitation while calling for an appreciative reading of such representations by applying the terms of aesthetic discourse to them. Like many other European viewers of Lehnert & Landrock's ubiquitous Orientalist photographs—photographs that range from highly idealized views of the North African landscape to eroticized harem scenes and homoerotic portraits of young boys—this critic wishes to study them as artistic expressions whose masterful use of light and shade and careful portrait compositions must be balanced against their exoticizing tendencies.[31] Such common expressions of ambivalence among historians of photography studying European images of the Orient reduce the politics of photographic iconography to mere exploitation while valorizing formal concerns as a pure and noble form of aestheticism. This view of the Orientalist photograph dichotomizes the iconic and the indexical, the form and content, and thus overlooks the complex ways in which aesthetics and politics coincide and coalesce in the image.

That Barthes's *Camera Lucida*, in which he privileges the *punctum* over the *studium*, "ironically has become the bible of those who wish to think about photographic art," as Rancière observes, speaks to the way art historians have viewed the politics of representation as anathema to the pleasures of aesthetics.[32] And yet the aesthetic of the Orientalist photograph is inseparable from an understanding of what Barthes called the *studium*, that is, what endows a photograph with such functions as the ability "to inform, to represent, to surprise, to cause to signify, to provoke desire."[33] What made Orientalist photographs such as those of Lehnert & Landrock so compelling and desirable as touristic souvenirs for Europeans who visited or resided in North Africa, especially French soldiers and colonial settlers, and what makes them valuable as art objects today, is precisely their emphasis on form, their deployment of classical composition techniques, their self-conscious dramatization of "Oriental" spaces, their attention to lighting, sartorial detail, and composed background. These aestheticized compositional elements elevated what was originally a documentary mode of representation or a means of ethnological classification into an art form.[34] Although the Orientalist photograph was implicated in colonial relations of power, at the peak of its popularity in the late nineteenth century, the sociohistorical truths it conveyed became inseparable from the aesthetic qualities that made it a desired

material object to be collected and assembled into albums. The politics of the Orientalist photograph, therefore, is located not simply in the message it conveys about the people of the Middle East, nor in its depiction of its sociocultural state, but even more fundamentally in the very distance it assumes with regard to these functions through aesthetic form itself. The Orientalist photograph reconfigures the relation between subjects and objects, spatiality and temporality, in such a way as to render impossible any real distinction between politics and aesthetics.

To point out the aesthetic dimensions of the *studium* is to underscore the complexities of the interrelated histories of Orientalism as a discourse of power and photography as a mode of representation. A reading of the Orientalist photograph that attends to the particular representational practices, institutional relations, and formal concerns that undergird its formation exposes the critical limitations of the common art-historical application of aesthetic discourse to the archive of Orientalist photography. By challenging the problematic binaries of *punctum* versus *studium*, form versus context, and aesthetics versus politics, my aim is to accentuate the value of an ascending mode of critical analysis that moves beyond the standard modalities of aesthetic theory that characterize conventional studies of photography, and thereby to address the pressing need for more sustained consideration of the affinities between discursive and visual formations of Orientalism, as I will seek to do in the following chapters.

<div style="text-align: right">

2

</div>

The Tourist, the Collector, and the Curator

On the Lives and Afterlives of Ottoman-Era Photography

"The creation of a photograph, the purchase of that photograph by a consumer, and the inclusion of the image in a larger collection within an album," Nancy Micklewright argues, are "far too complex, too variable to result in a straightforward body of images falling neatly under the title 'Orientalist.'" Micklewright, who rightly considers nineteenth-century photography albums of the Middle East as "complex cultural documents" that serve as "the tangible evidence of a whole series of interactions between people and cultures," admonishes postcolonial critics for overlooking their "role in constructing knowledge" and "the instability of Orientalism as a discursive category." Citing the large volume and extensive variety of nineteenth-century photographs of the Middle East from which a tourist in the nineteenth century could have constructed a personalized album, not to mention the different choices for the selection of images, Micklewright claims that the "experience of the Middle East [for nineteenth-century travelers] was personal, fragmented, and distinctive, despite the overarching hegemonic structures of British imperialism."[1]

This chapter challenges such art-historical claims about postcolonial critique being ill equipped to engage the complexities or nuances of

nineteenth-century tourist photography of the Middle East. Focusing on European tourist albums in the Pierre de Gigord Collection held at the Getty Research Institute, I discuss three moments in the lives and afterlives of images produced by commercial photographers in Istanbul to demonstrate that these images, both in the context of their original production and early collection by European tourists in the nineteenth century, and in their more recent circulation as collectable objects or archival materials, may productively be read in terms of the geopolitical distinctions, economic interests, and cultural assumptions about the Middle East and its people elucidated by postcolonial critics. Far from revealing the unique or idiosyncratic perspectives of individual tourists, the Gigord albums reveal a visual regularity and consistency born of an Orientalist vision of Ottoman society—a vision that was as much the product of the projection of Western fantasies about "the Orient" as it was the project of local photographers in the region. What interests me here is not only the organization of albums, the photographs' formal tropes, and the historical context of their production but also the broader implications of their consumption by European tourists in the nineteenth century, as well as the resuscitation of these albums and images as collectable objects and archival materials. Building on Rosalind Krauss's critique of the applicability of the genres of aesthetic discourse to the study of nineteenth-century photography,[2] I explore the overlapping relation of the discourse of tourism and topography, the sociocultural practices of collecting and documentation, and the consumption and uses of Orientalist photographs.

The Archive

The Pierre de Gigord collection of photographs of the Ottoman Empire and the Republic of Turkey consists of over six thousand photographs taken between 1852 and 1950 and includes a broad range of images, from albumen prints of monuments, Turkish women, and street types to cartes de visite of Ottoman sultans and officials to gelatin silver prints of royal visits and the empire's infrastructure. Of particular interest in the context of my argument here is a series of forty large-format photographic albums containing anywhere between ten and over one hundred images primarily of Istanbul and its environs by commercial photographers including the Abdullah brothers (figure 2.1), Guillaume Berggren (figure 2.2), Ernest de Caranza, Vassilaki Kargopoulo, Sébah, and the Sébah & Joaillier Studio (figure 2.3). Though some albums differ in order and construction—e.g., two commissioned albums document railroad construction in the region, another 1885 album is dedicated solely to images of tobacco-manufacturing operations, and still another consists of pictures of Turkish firefighters and their equipment—the vast majority are tourist albums purchased or assembled by European travelers in the nineteenth century. Selected from the in-

2.1 The cover of a tourist album produced by the firm of Abdullah Frères, untitled (1880). Pierre de Gigord Collection. The Getty Research Institute, Los Angeles.

ventory of one or more professional photographers in Istanbul, these albums were either assembled and bound by commercial studios as ready-made tourist souvenirs or put together by European tourists from individual photographs purchased while abroad and then bound in Europe.

What is particularly striking about these albums is the astonishing similarity among them in terms of their subject matter and the order in which the images appear. Whether assembled by French, English, or German travelers to the region, or locally in professional studios, the albums invariably begin with panoramic views of Istanbul (ranging from three to twenty photographs depending on the size of the album) (figures 2.4 and 2.5), followed by images of the sultan's palaces, mosques, fountains, and other monuments (between ten and sixty photographs in each case) (figures 2.6 and 2.7). Next come street types depicting the principal ethnic and professional groups dressed in the traditional garb of their occupation (between three and twenty photographs) (figures 2.8 and 2.9), and, finally, typical eroticized *dames turques* of both veiled and unveiled women (between three and fifteen photographs) (figures 2.10 and 2.11). No matter the photographer or assembler of the album, fully a third of the large-format albums in the Gigord Collection are organized in this way. Whence such visual regularity? And what are we to make of this iconographic consistency in late Orientalist photography?

In her discussion of the Lady Brassey albums, Micklewright argues that "if a single photographic image embodies shifting meanings, then an album of multiple photographic images is even less likely to present a fixed and stable view of its subject."[3] Yet what is demonstrated by the visual consistency of Gigord albums assembled by a variety of tourists to Istanbul and/or by commercial studios is precisely a fixed and stable view of their subject. Indeed, the visual regularity in the narratives of these albums not only indicates that the photographic styles of commercial studios

2.2 The cover of a tourist album produced by the firm of Guillaume Berggren, "Vues Constantinople, Bosphore" (1875). Pierre de Gigord Collection. The Getty Research Institute, Los Angeles.

2.3 The cover of a tourist album produced by the Sébah & Joaillier Studio, "Souvenir de Constantinople" (1890). Pierre de Gigord Collection. The Getty Research Institute, Los Angeles.

in Istanbul and in the broader Middle East adapted European pictorial conventions, likely to cater to the demands of the tourist market, but also demonstrates the ways in which the discourse of Orientalism, the practice of photography, and the business of tourism overlapped in the nineteenth century, producing a distinct style of representation that froze Ottoman society, its people and cultures, in an exotic and picturesque manner. Let us consider four dominant tropes[4] of photographic representation in Gigord's albums—i.e., the panoramic, the monumental, the exotic, and the erotic—by way of unpacking the historical circumstances and ideological underpinnings that provided the conditions of possibility for such visual consistency and uniformity of touristic taste.

The Panoramic

Almost every tourist album of Istanbul in the Gigord Collection begins with panoramic views of the city, which are referred to as *vues generales* or *vues panoramiques*. The labeling of these images as "views" points to the tradition of the picturesque

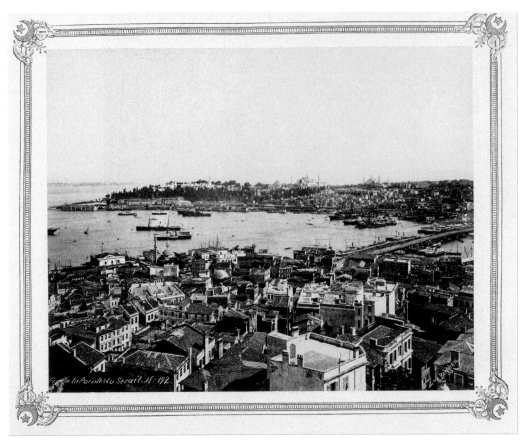

2.4 Guillaume Berggren, "Vue de la Pointe du Sérail" (1875). Albumen print. Pierre de Gigord Collection. The Getty Research Institute, Los Angeles.

as a formal aspiration for these photographic representations of the landscape.[5] As in the case of pictorial picturesque, these photographs, above all, aim to frame the overview of the landscape as a view that is compositionally balanced, spatially coherent, and visually legible, and yet it embodies an element of roughness and fragmentation. As Gary Sampson has discussed in the context of professional studios in nineteenth-century India, "The general notion of what constitutes the picturesque had become so thoroughly ingrained in the cultured Victorian imagination that it was imperative for a successful photographer of 'views' to be adept at searching out just the right sort of features, then strategically framing and articulating their physical subtleties through proper exposure of the negative."[6] Recognizing and catering to the aesthetic sensibilities of European tourists, the professional studios of Istanbul,

like their counterparts in India, produced images that endowed the landscape with the scenic and exotic charm that tourists expected to see in the Orient.

Though produced by a broad range of commercial photographers such as Apollon (figure 2.12), the Abdullah brothers, Berggren, Kargopoulo, and Sébah (figure 2.13), the overwhelming majority of panoramic views are taken from either the Galata Tower or the Beyazit Tower. The possibility of positioning the camera in such locations enabled the photographers to produce the effect of an illustrated and promontory map of the city in order to provide the viewer with a layout of the buildings and monuments that are depicted in the following pages of the album. Interestingly, these panoramic images of the city are so similar that only an expert with extensive knowledge of Ottoman-era studios would be able to identify images based on an individual photographer's style. Above all, the visual uniformity of these photo-

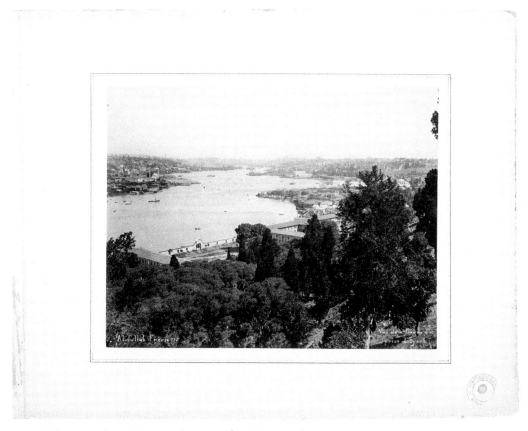

2.5 Abdullah Frères, "Vue de la Corne d'or prise d'Éyoub" (1880). Albumen print. Pierre de Gigord Collection. The Getty Research Institute, Los Angeles.

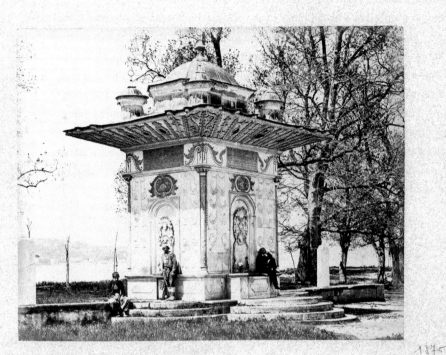

2.6 Abdullah Frères, "Fountaine des eaux douces d'Asie," Constantinople (1875). Albumen print. Pierre de Gigord Collection. The Getty Research Institute, Los Angeles.

graphic panoramas speaks to a romantic tradition in Orientalist representation that visually froze "the Orient" as a timeless space.[7] These aestheticized views are devoid of history, as they obscure, for example, the transformation of Istanbul into a modernized city that was taking place at the time due to the Ottoman reform movements of Tanzimat and Islahat.[8] Although, as Esra Akcan has argued, Ottoman officials also used the genre of panoramic photography to counter Orientalist representations of the empire, albeit by projecting a seemingly peaceful and beautiful image of the city that eclipsed the disciplinary uses of photography by the Ottoman state, the panoramic views of Istanbul were squarely inscribed within a European representational tradition that dated back to the panoramas of the city painted in the beginning of the nineteenth century, a tradition that was also adopted by local commercial photographers to serve Orientalist tourism.

Panoramic photographs of Istanbul, though produced by local artists, are aesthetically indebted to the genre of panorama as an artistic form in Europe. By the mid- to late nineteenth century, panoramas of Istanbul had long been a familiar and popular entertainment for European audiences. As early as 1801, Henry Aston Barker, the son of the English artist Robert Barker (who had himself produced 360-degree panoramas of cities at the end of the eighteenth century), introduced the panorama of Istanbul to the public, a panorama that was not coincidentally a view of the city from the Galata Tower.[9] The exhibit was so successful that the display of panoramic views of Istanbul became a common form of entertainment; for example, in 1822, Daguerre installed a panorama of Istanbul, while Robert Burford created another at the Panorama in the Strand in 1929. In addition to these publicly displayed large panoramas, smaller versions of panoramic images were published for private consumption in illustrated books such as Julia Pardoe's 1838 *Beauties of the Bosphorus*. Thus, by

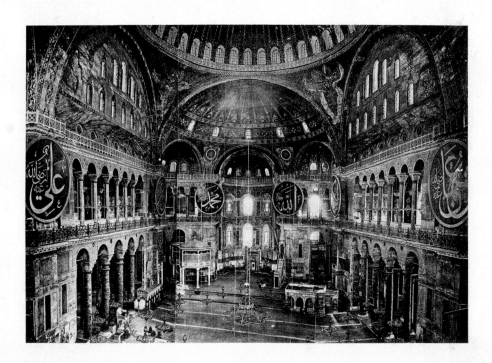

Vue intérieure de Sᵗᵉ Sophie.

2.7 Pascal Sébah, "Mosquée de Ste. Sophie" (ca. 1870s). Albumen print. Pierre de Gigord Collection. The Getty Research Institute, Los Angeles.

the time the democratization of travel brought large numbers of European tourists to Istanbul in the second half of the nineteenth century, the market for panoramic views of Istanbul had long been established, a market to which the commercial photographers of Istanbul addressed their efforts.

European travelers to Istanbul who included panoramic views of the city in their albums were no doubt inspired by the established tradition of panoramas in Europe, but also by travel books and guides. Travel narratives by established Orientalists, such as Albert Smith and Gautier, and tourist guides such as John Murray's enormously popular 1840 *A Handbook for Travellers in the Ionian Islands, Greece, Turkey, Asia Minor, and Constantinople*, typically began with a description of Istanbul's pano-

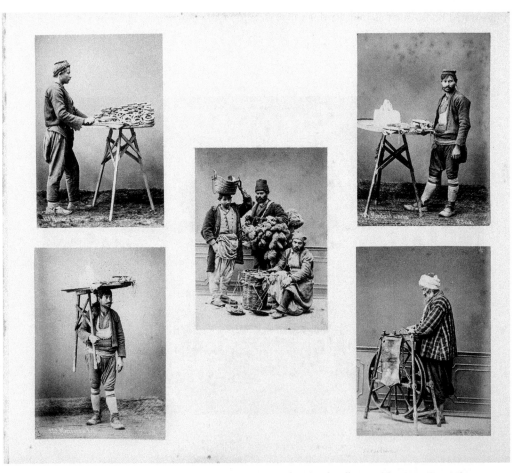

2.8 Pascal Sébah, street merchants (1885). Albumen prints. Pierre de Gigord Collection. The Getty Research Institute, Los Angeles.

2.9 Sébah & Joaillier Studio, whirling dervishes (1885). Albumen print. Pierre de Gigord Collection. The Getty Research Institute, Los Angeles.

ramic skyline from the Bosphorus, employing an Orientalist discourse marked by a blend of the picturesque and exoticism. The beginning passage in Murray's description of Istanbul provides one such example:

> At last Constantinople rose in all its grandeur before us. With eyes riveted on the
> expanding splendours, I watched, as they rose out of the bosom of surrounding

waters, the pointed minarets—the swelling cupolas—and the innumerable habitations, either stretching along the jagged shore, or reflecting their image in the mirror of the deep, or creeping up the crested mountain, and tracing their outline in the expanse of the sky.[10]

As in the tradition of the picturesque, Murray's description highlights the sensitized mind's eye of the individual traveler who views the landscape below him, and who, upon viewing it, seeks to create a visual scene for the reader seeking a firsthand account of one traveler's encounter with "Oriental" exoticism.

2.10 Anon., Turkish lady (ca. 1885). Albumen print. Pierre de Gigord Collection. The Getty Research Institute, Los Angeles.

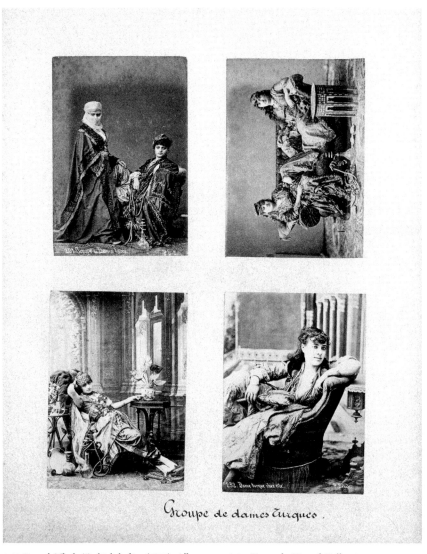

Groupe de dames turques.

2.11 Pascal Sébah, Turkish ladies (1875). Albumen prints. Pierre de Gigord Collection. The Getty Research Institute, Los Angeles.

Such romanticized descriptions of the city guaranteed that with the invention of photography, panoramic views would persist as an essential descriptive and imaginative device, not only to impress with sweeping images of the exoticized landscape but also to orient the viewer to the general layout of the city and its monuments depicted in the images that followed in the album. Tourist albums, in other words, maintained a mimetic relationship with Orientalist travelogues and tourist guides. While relying on the romantically inspired picturesque tradition of Orientalism in which the

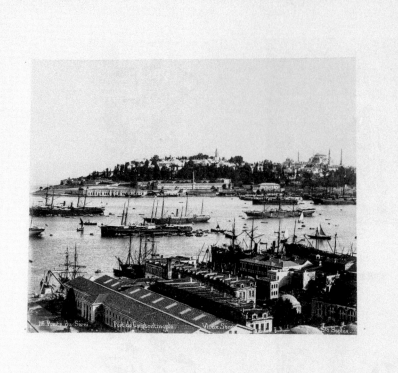

2.12 Apollon Studio, "Ponte du Séraï, Port de Constantinople, Vieux Séraï, Ste Sophie" (1890). Albumen print. Pierre de Gigord Collection. The Getty Research Institute, Los Angeles.

Middle East served as a place for symbolic, mythical, and religious contemplation for the individual traveler, panoramic views also engendered a sense of mastery over the landscape, positioning the viewer to have a total view of the cityscape below, representing the "right of (over)sight" that the European tourist assumed in Istanbul.[11] Like the promontory descriptions of the Middle Eastern landscapes produced by Victorian travelers, such as Richard Burton and Charles Doughty, panoramas of Istanbul created a hierarchical relation between the viewer and what was being viewed by positioning the European onlooker as one looking down on the aestheticized landscape below. In this sense, panoramas of Istanbul can be seen as a constituent feature of a scientific and expeditionary tradition that privileged visuality as a mode of knowledge production.

While earlier travel narratives informed European tourists' desire for panoramic views of Istanbul, late nineteenth-century guidebooks for travelers to the Ottoman

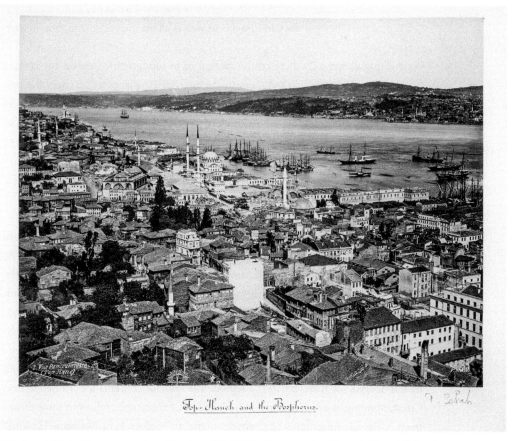

Top-Haneh and the Bosphorus.

2.13 Pascal Sébah, "Vue panoramique (Top-Haneh)" (1885). Albumen print. Pierre de Gigord Collection. The Getty Research Institute, Los Angeles.

Empire urged tourists to visit particular studios to collect images of the city as souvenirs; Murray's 1871 *Handbook for Travellers in Constantinople*, for example, advised European tourists that

> there are fine views of Constantinople, taken by Mr. Robertson, and coloured
> sketches by Mr. Freziosi, the artist. The best photographs, however, are made
> by Messrs. Abdullah Brothers, photographers to the Sultan and Court; they are
> native gentlemen whose remarkable talent has acquired them a European reputa-
> tion unsurpassed by any of the fraternity. Indeed, a photograph by these artists has
> become one of the most valuable curiosities that can be carried away from the capi-
> tal of Turkey. Their establishment is in the Grande Rue of Pera, opposite Missiri's
> Hotel, and their collection of photographs contain panoramas of Constantinople,
> views of its most interesting monuments, ancient and modern costumes, portraits

of the Imperial family and the whole Osmanli dynasty, from the miniature gallery kept at the Library of the Old Seraglio, as well as all the men of note in the empire.[12]

Tourist guides not only dictated the categories of topographic interest for visitors in the region but also directed them to the appropriate places to purchase the best photographs of what had been seen. In light of such direct guidance, it can hardly be considered coincidental that the order of photographs commonly found in European tourist albums should so closely follow the list of images included in Murray's handbook.

The Monumental

Photographs of historical monuments almost always follow panoramas in the Gigord large-format albums, taking up between 20 and 75 percent of the album pages. As Engin Özendes points out in the context of Sébah & Joaillier's photographs,[13] the order of images produced in the catalogue of professional studios in Istanbul, from which these images were purchased,[14] is "cinematic." That is, long shots and panoramas gradually narrow to middle-range shots of monuments and ruins, and then proceed to close-ups of tradesmen and portraits of harem women. This order of representation speaks above all to the way the tourist's vision of Istanbul was mediated by handbooks for travelers to the region. The table of contents for the section on Constantinople in John Murray's 1871 *Handbook*, for example, follows a progression from "General examination of Constantinople" to "Galata, Pera, Tophane, Haskuri" to "Walls-Gates-Seraglio-Mosques and Sultans' tombs-Antiquities, Hippodrome (Atmeidan), Greek Churches-Fountains-Harems, Khans, Bazaars, Slave Market, Baths, Cemeteries, Arsenal, Barracks, Hospitals, Dogs."[15] The order of photographs of monuments in Gigord albums is almost exactly that of the one listed in Murray's *Handbook*. The close correspondence between the progressive order of historical monuments in the handbooks for travelers and tourist albums, however, should not be attributed to a simple lack of imagination on the part of individual tourists, but rather speaks to the episteme of an age in which taxonomic representation determined the traveler's perception and experience of elsewhere. Nineteenth-century European travelers and tourists in the Middle East and elsewhere were informed by what Pratt calls a "planetary consciousness," that is, an epistemological vision "marked by an orientation toward interior exploration and the construction of a global-scale meaning through the descriptive apparatuses of natural history."[16] Dating back to Charles de la Condamine's scientific expedition of 1735 to South America and Carl Linnaeus's 1735 *Systema naturae*, planetary consciousness provided travelers and tourists with a classificatory system useful not only in observing and cataloguing what they saw but

also in creating a narrative of their experiences of other places. Although Pratt elaborates her notion of planetary consciousness in relation to the "authority of print" and in the context of the European colonial quest for locating commercially exploitable resources and markets,[17] this classificatory system was equally prevalent in photography, especially in photographic representations of the Middle East. The taxonomic order of photographic albums of Ottoman Turkey, in other words, points to a systematizing and categorizing consciousness through which European tourists made order out of what they perceived as "Oriental" chaos. Inscribed within the Cartesian perspective of European photography, and pandering to the classificatory consciousness of their European clientele, professional studios in Istanbul divided their images into specific categories to help tourists make their selection for an album. As Özendes points out, the studio of Sébah & Joaillier, for example, divided its photographs into categories, listed in its catalogue in the following order: "the golden horn, the islands, the Bosphorus, mosques, palaces, churches, tombs, cemeteries, museums, statues, city walls, bazaars and tradesmen...."[18] Photographic representations of monuments by Ottoman professional studios satisfied European tourists' desire for a sense of control over a seemingly complex, foreign, and chaotic city, making it comprehensible and serviceable for visual consumption. These images reflected both spatial certainty and temporal rationality as they fixed places and bodies in a distant temporality and in an exotic space.

More significantly, the monuments photographed are often pictured not as buildings in daily use but as picturesque sites and/or as ruins devoid of any contemporary relevance. That most European tourists associated "the Orient" with the ancient and biblical world compelled professional studios throughout the region to excise modern buildings and to empty the sites of people, especially if they do not appear in traditional costumes.[19] Photographic representations of Istanbul, like those of other regions in the Middle East, are meant to be picturesque, and therefore to exclude any sign of modernity and progress. The sites are also often in a state of evident decay. As Nochlin observes, the idea of the picturesque, especially in the context of "the Orient," is "premised on the fact of destruction" or "on the brink of destruction," and by being remnants of a disappearing or declining civilization, sites are "transformed into subjects of aesthetic delectation" for European tourists.[20] The images of monuments and historical places, like other images in the albums, also lack any allusion to the particularity of the image or the temporality of its execution. Although, as I discussed in the first chapter, the Orientalist photograph is marked by excessive anchorage, especially as it pertains to labeling the photographic image itself, there is a stark decontextualization of the subject of the photographs itself, presenting subjects and landscapes severed from any visual marker or reference to specific context, location, or even temporality. As examples of the photographic picturesque, images

of monuments demand a perception of the real that erases any trace of the everyday life of its inhabitants. As traces of a glorious past, they are empty and abandoned, and their melancholic state is meant to evoke a sense of historical nostalgia.

James Robertson's photograph of the Mosque of St. Sophia (figure 2.14) provides an early example of the ahistorical mode of representation. This beautifully executed photograph is on the surface a verisimilar image of an iconic monument to be purchased both by tourists as a souvenir and by painters and Orientalists as an aide-mémoire. Such photographs of historical monuments retain enough "representativeness" to be considered objective images of the region. In fact, the relatively clear, focused, medium-range shot proved valuable to Orientalist painters who reproduced such architectural details in their paintings, as well as to tourists to the region who wished to document their journey for themselves and others. Compositionally speaking, however, the image exudes a melancholic sense that evokes ancient times and a bygone era. Robertson, as Robert Nelson has observed, relied heavily on prior traditions of engraving, sightseeing, and painting to produce images of monuments that resembled the romanticized and exaggerated scenes that engravers and

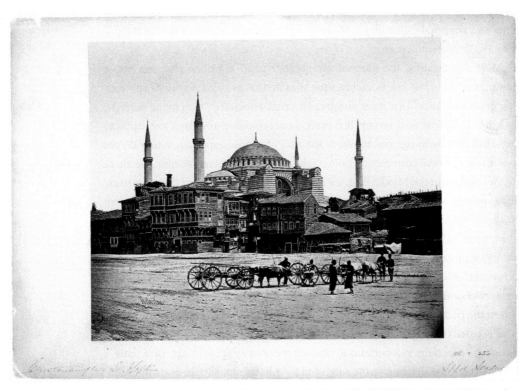

2.14 James Robertson, Mosque of St. Sophia (1860). Albumen print. Pierre de Gigord Collection. The Getty Research Institute, Los Angeles.

travelers had depicted before the advent of photography in order to make his photographs of Istanbul conform to the expectations of his European clientele.[21] In spite of the carefully arranged figures in the foreground, perhaps included in the image to provide both a sense of scale and a more picturesque quality, the monument seems abandoned and in a state of disarray. The absence of activity and movement, in other words, renders the mosque a "mute tableau, an inert image of the past," to recall Francis Wey's appreciative remark about Egypt in his review of du Camp's photography in 1851.[22] As souvenirs of the journey, the photographs of monuments function both as mnemonic objects to remind the tourist of his or her experience in Istanbul and as nostalgic images whose presence speaks to the loss of the irretrievable past of "the Orient."

The Exotic

A third trope marking the visual regularities of the tourist albums in the Gigord Collection consists of photographs of street vendors taken by professionals such as Sébah, the Abdullah brothers, and Kargopoulo, a feature that also demonstrates that the photographic styles of commercial studios in Istanbul embraced a European representational conception of racial and ethnic difference and were impacted by the demands of the Orientalist tourist market. For example, to accommodate the taste of their European consumers, professional studios directly borrowed the formal conventions and visual tropes of early nineteenth-century European illustrators of "exotic types" such as Frederic Schoeberl and Amadeo Preziosi—e.g., the use of rustic props, traditional costumes, and rugged settings.[23] Every tourist album in the Gigord Collection has at least a couple of pages of street vendors and/or ethnic types. These images transform a typological perception of Ottoman society and its people into exotic mementos by aestheticizing the ethnological penchant for categorization and classification, while catering to the touristic taste for the picturesque.[24] The photographs of Jewish types by the Abdullah Frères Studio provide representative examples of the aesthetization of racial taxonomy (figures 2.15 and 2.16). These photographs may resemble photographic tableaux vivants, but their iconography functions differently from their European counterparts. These beautifully executed images, found in two different European albums, work out of an ideology of difference that classifies people into professional, racial, and ethnic types. The Jewish people in these photographs could be represented only insofar as they could be pictured for visual consumption as temporally distant types.

At the same time, these images invoke the picturesque tradition in which the ragged poor in the countryside are portrayed through an aesthetically pleasurable iconography. While the labels in both frames and the handwritten titles in the album

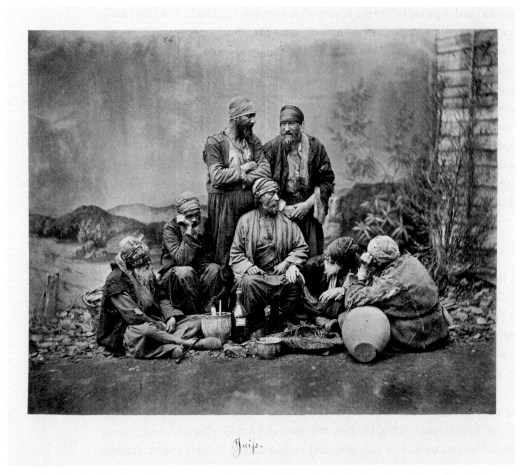

2.15 Abdullah Frères, Jews (ca. 1870s). Albumen print. Pierre de Gigord Collection. The Getty Research Institute, Los Angeles.

pages firmly inscribe them within the discourse of racial difference, the overall iconography aligns them with the picturesque by turning the sitters and their surroundings into an image or a "view." The sitters in these photographs are meant to represent ways of life on the margins of metropolitan modernity to invoke a sense of nostalgic pleasure for their European viewers. Despite their heavily staged quality, complete with dramatic painted backdrops of the countryside and exotic props, these images create a nostalgic aura that is as compositionally beautiful as it is ideologically violent. The nostalgia these images evoke establishes a temporal distance between the viewer and the Jews, who are meant to represent an earlier stage of human history associated perhaps with Biblical times. This relation between the viewer and the Jewish figures creates a unidirectional form of observation and pleasure, a kind of categoriz-

ing and aesthetic voyeurism; note that, as is often the case in such staged images, the Jewish figures are not looking into the camera's eye. In the Orientalist picturesque, a return gaze must be absent so that the other seems "natural" or realistic. Although these photographers claim realism as their strategy of representation, what is depicted in them is, of course, not the actuality of Jews' experience in Ottoman society but only a stylized depiction of their picturesque lifestyle and exotic costumes designed to enchant the European viewer. Details in these photographs do not inspire interest in the other; nor do they bring one closer to the viewer. Instead, the images create in the viewer a sense of difference from sitters who represent people on the periphery of Western civilization. The function of the photographic picturesque is therefore not merely aesthetic but ideological, in that it imposes a hierarchical distinction between the viewer as modern and civilized and the people in the photograph as distant and backward.

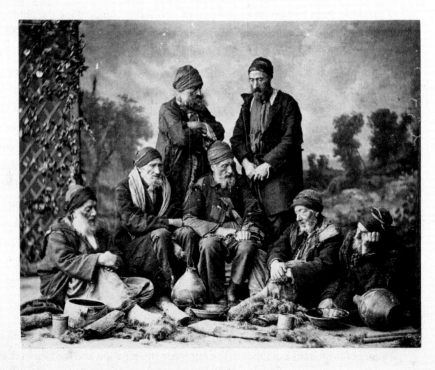

Juifs.

2.16 Abdullah Frères, Jews (ca. 1870s). Albumen print. Pierre de Gigord Collection. The Getty Research Institute, Los Angeles.

Finally, it is important to note that these photographs may also be contextualized within a local photographic tradition as expressions of an Ottoman form of Orientalism, that is, "a complex of Ottoman attitudes produced by a nineteenth-century age of Ottoman reform that implicitly and explicitly acknowledged the West to be the home of progress and the East, writ large, to be a *present* theater of backwardness."[25] A product of Tanzimat, Ottoman Orientalism assumed a hierarchical structure of power along class, ethnic, and religious lines through which Ottoman rule over Arab, Armenian, Jewish, Kurdish, and Bulgarian subjects was justified. As an ideological discourse of otherness, Ottoman Orientalism placed Arabs and religious minorities like Jews at a temporal distance from the cosmopolitan Istanbul. As exemplified in the photographic representations of the Ottoman population through their costumes in *Les costumes populaires de la Turquie en 1873*, which moves in a linear fashion from the Istanbul elite wearing Western attire to provincial, religious, and ethnic minorities dressed in their traditional costumes, the Ottoman elite classes were indeed implicated in the ideology of exoticism that assumed the evolutionary progression of mankind from barbarism to civilization. The text accompanying the photograph of "the Jews of Constantinople" in *Les costumes populaires*, for example, describes "lower class Jews" as being "encrusted in a systematic ignorance," who "push away with stubbornness all innovation, all progress, all improvement, whether intellectual or moral," and claims that "their morals and customs are almost the same as those of the Middle Ages."[26] Considered in the context of such anti-Semitic views of Jewish people among the Ottoman elite, the photographs of Jewish types point up a local form of exoticizing iconography that was not only informed by the thematic choices of Orientalist discourse but also was implicated in the ideology of racial difference that helped rationalize the Ottoman empire's colonizing relation with its others. By embracing the pseudoscientific theories of racial and cultural development, Ottoman elites were able to claim a superior status as modern subjects who had to take on the burden of civilizing the racial and ethnic minorities on the periphery of their empire.

The Erotic

The prevalence of *dame turque* photographs in the Gigord albums speaks to the persistence of the harem as a topos in the European imagination and the tourist demand for Orientalist eroticism.[27] Théophile Gautier's statement aptly captures the European tourists' scopophilic and epistemophilic desires for eroticism:[28]

> The first question invariably addressed to every traveller on his return from the East is: 'Well, and the women?' to which each responds by a smile, more or less mys-

terious and significant, according to his degree of fatuity, and the character of its inquirer; but always implying, with more or less distinctness, that he has encountered more of romantic adventures than he thinks fit to recount to everybody.[29]

The obscurity and inaccessibility of the harem, its lure of boundless pleasure and perennial lasciviousness so commonly represented in Orientalist literature, travelogues, and painting, made photographs of harem women and scenes fetishized souvenirs coveted by male and female European travelers alike. Given the high tourist demand for photographs of harem women, most professional photographers of Istanbul created large collections of such images from which European travelers could choose.

In contrast to the images of women produced by European photographers of the late nineteenth-century Maghreb, however, the photographs of Turkish women and harem scenes produced by professional studios of the Ottoman Empire are more innocuous and chaste. Indeed, there is little nudity or unvarnished display of desire, though in most photographs women appear without the prescribed Islamic dress (*hijab*), exposing their hair as well as part of their bodies. As well, these photographers, unlike their counterparts from the Maghreb, dignify these objectified women by using the respectful title of *dames turques*, or "Turkish ladies." Such photographic circumspection, and even reverence, was perhaps due to Ottoman regulations on photography designed to project a more positive self-image of the empire. Sultan Abdülhamid, for example, issued a directive to professional photographers stating, "Most of the photographs taken for sale in Europe vilify and mock our well-protected domains," and admonishing, "It is imperative that the photographs to be taken in this instance do not insult Islamic peoples by showing them in a vulgar and demeaning light."[30] The strict enforcement of his directive is attested to by the confiscation of a series of risqué photographs of Armenian women posing as harem women taken by Viçen Abdullah in 1892, and the consequent order that the journal *Servet-i-Fünun* publish one of the photographs with a note stating that the image was not of a Muslim but of an Armenian woman.[31] And yet, in spite of the sultan's order and its official enforcement, local photographers, including Sébah and the Abdullah brothers, produced a massive inventory of photographs of harem women and scenes to satisfy the high demand emanating from the tourist industry. Purchased as souvenirs, these metonymic objects of desire, which in the European's mind stood for the whole of the harem, allowed the average tourist to imagine entering the forbidden space and to possess a part of it.

The lack of complete nudity and the relatively mild quality of harem iconography in Ottoman photography rendered these images neither less erotic nor less Orientalist. In fact, the need for discretion and some veiling allowed professional photogra-

2.17 Pascal Sébah, Turkish ladies (ca. 1880s). Albumen prints. Pierre de Gigord Collection. The Getty Research Institute, Los Angeles.

phers to stage the phantasm of the harem in a more artistic and effective manner. The veil is crucial to Orientalist eroticism, arousing and perpetuating the viewer's desire to cross into a forbidden space, while restaging the harem as inaccessible, exotic, and mysterious. Many photographs of Turkish women by Sébah, for example, take advantage of discretion to engage in an artistic form of erotic indirection. Consider the images in a page of a tourist album (figure 2.17). Although none of the photographs on this page engages in an especially vulgar or violent form of eroticism, the images nonetheless invite the reader to consider both the actual inviolability and the imagined fantasy of the harem. The top three images, for example, which provide the viewer with a sense of Turkish women's public appearance, nonetheless acknowledge the viewer's scopophilic desire through subtle, indirect gestures. While

the image on the top is labeled "lady with companion" to reference both polygamy and despotic vigilance or overprotection of women, the images on the right- and left-hand sides display the richness of women's exotic dresses and focus on their seductive and indirect gazes that filter through their gauze veils. What is significant about the veiled subject, as Alloula points out, is the fact that she "becomes the purport of an unveiling." In other words, by challenging the voyeuristic desire of the viewer, the image of a veiled woman incites the viewer's desire to unveil her. In this way, the bottom image is rendered all the more erotic by the emphasis on the veiling of women in the top three images. The photograph at the bottom is therefore a response to the challenge the veiling poses for the viewer. This image, unlike the other three, features an unveiled woman and stages erotic availability and promise through the recumbent pose of the woman and the typical prop of a *narghili*. By unveiling the veiled woman, albeit in an artistic and discreet manner, this image performs what Alloula calls a "double violation"; that is, it unveils the veiled woman and gives "figural representation to the forbidden."[32]

The eroticized photographs of Turkish women had their genealogical beginnings in descriptions of the harem in European travelogues of "the Orient" dating back to the seventeenth century but relied mostly on the visual tropes of nineteenth-century Orientalist paintings of the odalisque. The image of three women posing together in front of the artificial interior backdrop with the ever-present and typical props—e.g., the tray of coffee cups, musical instruments, and *narghili*—offers one such example (figure 2.18). In this photograph, everything denotes a staged scene, making it a perfect projected image of the harem. The indexical quality of such staged photographs of harem life helped fuel the fantasy of "Oriental" eroticism, but at the same time the reproducibility of photographic representations excised the mystery and curiosity surrounding the phantasm of the harem by making it available to ordinary tourists. Unlike their textual and visual precursors, these photographs, in the inexpensive form of the carte de visite, "democratized" the possibility of possessing the eroticized other, while also making the iconography of the "Oriental" woman a cultural cliché. As a result, photographs of Turkish women inadvertently transformed the lure of the harem and its female occupants into kitsch, but in doing so, they also naturalized the notion of "Oriental" eroticism and made the phantasm of the harem seem factual.

What is remarkable about the prevalence of harem scenes in the albums is not only that these images were created by local artists and not European Orientalists but also that some local officials seem to have helped disseminate them, and even collected such images themselves. The photograph of a typical odalisque (figure 2.19) from an album in the Gigord Collection with Ottoman binding and pages bearing the sultan's *tughra* suggests that the inclusion of harem images in photographic albums was not merely a European touristic practice but was embraced by at least

some members of the Ottoman elite.[33] Although it is difficult to substantiate the claim that harem photography was widely consumed by local audiences, the appearance of such images of languorous odalisques in official and locally owned albums suggests that the Ottoman elite may have been complicit in the consumption, if not dissemination, of such images. It seems that while elite Ottoman men had their honorific portraits taken at the local studios of Sébah, the Abdullah brothers, and Kargopoulo, they also may have picked up eroticized images of women that were produced in the very same places.

That the models for photographic portraits of harem women were almost exclusively Armenian and Christian, and that there is a paucity of even honorific portraits of Turkish elite women, suggests that Ottoman Orientalism's system of subordination entailed also an elitist patriarchal ideology that could accommodate, and indeed enable, the contradiction of keeping respectable women away from the gaze of camera while allowing the production and consumption of eroticized photographs of

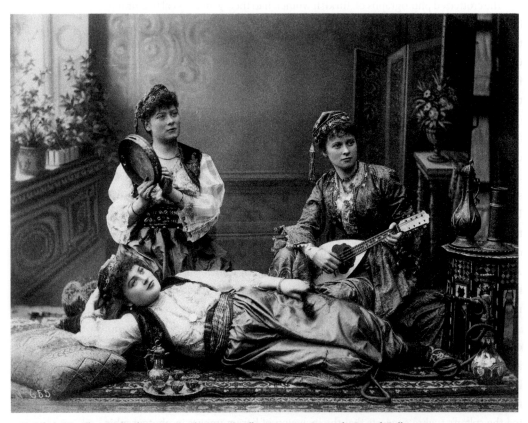

2.18 Sébah &Joaillier Studio, harem scene (ca. 1890s). Albumen print. Pierre de Gigord Collection. The Getty Research Institute, Los Angeles.

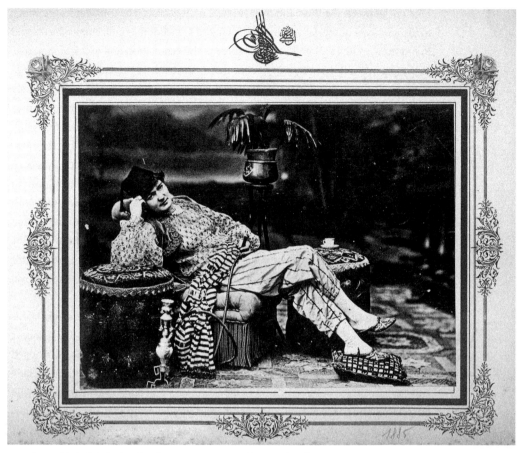

2.19 Anon., Turkish lady (1885). Albumen print. Pierre de Gigord Collection. The Getty Research Institute, Los Angeles.

non-Muslim women by the male Ottoman elite. I will elaborate this point further in the fourth chapter, but here it bears remarking that Ottoman elite men participated in a schizophrenic mode of self-representation through which they presented themselves as agents of modernity and progress while embracing a traditional form of Islamic identity that obscured the subjectivity of pious and respectable women, and participated in the production, and possibly consumption, of eroticized photographs of women from the margins of their empire.

The Afterlives of Ottoman Photography

To the extent that the notion of Orientalism throughout this book is presented as a transhistorical as well as a transnational network of aesthetic, economic, and political

relations between the West and the Middle East, it is crucial to consider its relevance to the afterlives of tourist albums of the Gigord Collection as collectable objects and in museum archives. Here I consider some of the acquisition and archival materials in the Gigord Collection by way of considering the broader implications of the practices of collecting, archiving, and displaying Orientalist photography. The fact that a collector such as Gigord was moved to amass a large body of photographs of Turkey because of an Orientalist "love affair" with the country, which was mediated through the canon of European representations of the Middle East, and the fact that the curatorial logic behind the Getty Research Institute's acquisition of this collection is born of the knowledge of, and interest generated by, critical debates about Orientalism in the academy and museum circles unleashed by the publication of Said's *Orientalism* in 1978 demand a transhistorical understanding of Orientalist photography that attends as much to the historical context of its production and reception as to its afterlives today. While Orientalist nostalgia may have inspired the French collector to aggressively purchase such photographs, aesthetic discourse informs the archival fever for attending to photography's Orientalism.

In an interview with a French journalist in 1993, Gigord traces the origin of his collection to his "Oriental adventure" (*aventure orientale*) in Turkey. He recounts how on his way to Afghanistan and other parts of the Middle East in 1964, he stopped in Istanbul to visit an aunt, Mme. H. de Saint Peine, a cultivated and charming lady and the wife of one of the founders of the Ottoman Bank and Turkish Tobacco, who introduced him to the old and cosmopolitan Istanbul bourgeoisie. In language reminiscent of Pierre Loti's and Flaubert's experiences in "the Orient," he describes his initial fascination (*le choc*) with Istanbul: "From the first moment, I was hooked. For three days, I visited the monuments, I walked the streets and the Bazaar, I plunged myself in the winding streets climbing the hills. In the evening, from the top of Galata or the Pierre Loti café, I contemplated the last rays of sun gild the minarets and domes."[34] It is this quintessentially Orientalist experience of the arrival that afflicts the young Pierre with what he describes as *"mal d'exotisme,"* a "malady" that leads him first to establish a small business of importing jewelry and textiles from Turkey in 1968 and then to open the store Anastasia in 1969, business ventures that financially allowed him to pursue his passion for collecting Orientalist paintings, stamps, coins, and eventually photographic images beginning in 1976.

In another interview, predictably titled "Comte Pierre de Gigord, sur les traces de Loti," Gigord speaks of his passion for images of the other, while acknowledging the mediating role of his Orientalist precursors: "In the seventies, I was passionately interested in the work of [European] writers, painters, and travelers [to the Middle East]. I sought primarily in Europe works with topographical, ethnographic, or his-

torical characteristics, especially painting, prints, and books."[35] As in the case of the belated Orientalists of the late nineteenth century, the works of such European travelers as Gautier and Loti seem to have engendered in Gigord an obsession that led him to meticulously collect photographs of Turkey in the bazaars of Istanbul and from European art dealers to preserve metonymically through his collection what he perceived to be a disappearing culture and civilization. That Gigord traces the origin of his interest in collecting Orientalist photography to his reading of European travelogues, exploring ethnographic and topographical works, and looking at paintings of the Middle East speaks to the productive function of Orientalism as a nostalgic discourse of exoticism that perpetuates the desire for "the Orient" to this day. It also brings into focus the complex interplay of his desire for the exotic, financial ventures in Turkey, cultural assumptions about the Middle East, aesthetic sensibilities, and ideological discourses, all of which undergird his practice of collecting. Though narrated as a the result of a deeply personal and passionate interest in the exotic, Gigord's collection is the material manifestation of a network of overlapping relationships between and among aesthetics and politics, culture and economics, the individual and the collective that informs Orientalist collecting practices.

While an un-self-reflexive, not to mention unapologetic, form of exoticism informs Gigord's own desire to collect images of and artifacts from Turkey, the Getty Research Institute's documentation of the acquisition of the collection demonstrate a more conscious engagement with Orientalism in both the historical and critical sense of the term. Consider the following statement from the acquisition justification letter:

> Beside its obvious value for scholars working in the history of photography, cultural and social historians would profit greatly from consulting this collection. Purchased primarily in western markets (Paris and London), the majority of the images were the kind that helped define the western perception of the east. While "Orientalism" has been viewed by some as a trend in research that may have reached its peak, the words of Carney Gavin, Curator at the Harvard Semitic Museum, seem to have particular relevance given the current unrest in the Mediterranean basin: "Orientalism—however defined artistically or in terms of intellectual colonialism—must continue to be analyzed as a phenomenon, even if primarily to permit Westerners to examine our consciences for webs of preconception and illusion woven throughout the period of Imperialism in ways which tragically continue today to shroud many perceptions of life and 'mentality' in former Ottoman territories" (*Journal of Turkish Studies*, 12, 1988, 280). Given its breadth and depth, Gigord's collection could function alone as a cohesive visual resource on the

perception of the Ottoman Empire in the west.... The 40 large-size albums, spanning a period from 1852–1920, alone chart a record of trends in the history of visual "Orientalism" and popular images.[36]

What is especially notable about this carefully crafted statement is the tension between a critical understanding of Orientalism as a discourse of colonial power, which is at once dismissed as a fashionable academic trend and made relevant as a historical and ethical issue, and an art-historical notion of the term, which, in spite of its ambiguity, is uncritically assumed. The symptomatic decoupling in this passage of the indexical and the iconic, the aesthetic and the political, the documentary and the imaginary, underscores the relevance of Orientalism as a viable term not only in justifying the acquisition of this collection but also in its scholarly usage to study this archive. The apolitical, anti-Saidian curatorial commentary obscures the productive function of Said's work in facilitating the current Orientalist revival. Read against the grain, this statement is a powerful reminder that Orientalism is not merely "a trend in research that may have reached its peak," as the curator claims, but a powerful discourse with which art historians and museum curators have to reckon in studying and displaying the large body of visual representations of the Middle East.

The Getty Research Institute's acquisition of Gigord's collection and its purchase of the Ken and Jenny Jacobson Orientalist Photography Collection in 2008 present a valuable occasion for critically engaging the contemporary interest in Orientalist art and photography. The very fact that a collector of Orientalist photography of the stature of Gigord could describe so unabashedly his project in terms of Loti's Orientalism—and that a major art institution would invoke Said's work to justify acquiring such a collection—draws attention to the fact that Orientalism as a discourse of exoticism continues to maintain its cultural currency into the present day, a currency ensured through practices of collecting and displaying photographic images. Ironically, far from dismantling the hegemony of Orientalism, Said's *Orientalism* and the subsequent postcolonial critiques of discourses of otherness have inadvertently contributed to the longevity of Orientalism in certain cultural and institutional contexts. In the years since the publication of Said's book, museum curators have often exhibited what I would call "Orientalist nostalgia," re-presenting the archive in aesthetic and exotic terms. Major exhibitions such as "L'Orientalisme: L'Orient des photographes aux XIX^e siècle" in 1989, "Étranges étrangers: Photographie et exotisme, 1850–1910" in 1994, both of which appeared at the Centre National de la Photographie in Paris, "Roger Fenton: The Orientalist Suite" at the J. Paul Getty Museum in 1996, and "Sight-seeing: Photography of the Middle East and Its Audiences, 1840–1940" at Harvard's Fogg Art Museum in 2001 display a recuperative urge to resituate European Orientalist photographs as aesthetic objects that, at best, "*permettent enfin*

de voir autrement," to use the words of one curator.[37] The usage of the notion of Orientalism by collectors and museum curators today as a means of intellectual justification to aestheticize nineteenth-century photographs of the Middle East discloses the way postcolonial critiques have been appropriated to perpetuate an Orientalist vision of the region and its people.

The current interest in Ottoman photography and other historical images of the Middle East among collectors and curators is also a powerful reminder that Orientalism should not be viewed as merely a historical discourse of power, but as a *trans*historical and transnational phenomenon that continues to inform the politics of knowledge and culture today. Insightful and important as their readings of European colonial history, culture, and subjectivity have been, many postcolonial commentators continue to overlook the ways in which dominant discourses of power such as Orientalism have maintained cultural currency through recuperative strategies that disavow the politics of aesthetics. That more than thirty years after the publication of Said's seminal text, curators and collectors alike unabashedly invoke and deploy Orientalism as an aestheticized discourse of exoticism and difference suggests that any engaged postcolonial critique of Orientalism must view itself as an open-ended, critical discourse that perpetually reconsiders its theoretical assumptions and remains attentive to the processes of transformation and rearticulation that ensure the cultural hegemony of Orientalism, while continuing to work against the kinds of cultural disavowal that perpetuate such discourses of power.

3

The Politics of Resident Photography in the Middle East

Reflections on Antoin Sevruguin's Photographs of Qajar-Era Iran

Art historians who have studied the works of resident professional photographers in the Middle East have attempted to move beyond monolithic views of their images as ideologically invested in the discourse of Orientalism by attending to nuances and inconsistencies in them. In her study of the Istanbul-based Sébah family, for example, Woodward has argued that photographic representations of Ottoman society by Sébah were "not monolithic or hegemonic, but rather reflect a complex range of perspectives." The Sébah family, she claims, "developed a mode of representation that combined a detailed view of local Ottoman society with visual signs of a new modern order."[1] Similarly, Frederick Bohrer draws on Homi Bhabha's postcolonial theory of hybridity to study the photographic representations of Qajar-era Iran by Antoin Sevruguin, an Armenian-Russian resident professional photographer in Tehran. Considering Sevruguin's images as expressions of cultural "between-ness," "hybridity," and "ambivalence," Bohrer contrasts Sevruguin's photographs of dervishes with those of Sébah & Joaillier, claiming that while the latter are firmly inscribed within conventions of Orientalist photography, Sevruguin's images are the "the opposite of the enforced passivity of the Sébah and Joaillier image(s)." "In Bhabha's terms," he further

elaborates, "we might say that Sevruguin's image [of a dervish] serves as 'mimic' to the dominant Western format represented by Sébah and Joaillier" in that "it adheres to the norms for such photography while refusing the explicit relation of power (of photographer over subject) often evident in purely Western Imagery."[2] Setting aside Woodward's and Bohrer's disagreement about the politics of Sébah's photography, their readings of resident photography in the Middle East speak to a common desire on the part of photography historians on the left to cleanse the archive of what is perceived to be its Orientalist sins through the application of new conceptual distinctions introduced by Bhabha and other postcolonial critics.

Focusing on the photographic archive of Sevruguin's photographs in the Arthur M. Sackler Gallery of the Smithsonian Institution, I wish to offer a counterpoint to recent critical attempts by postcolonial art historians who ascribe an oppositional agency for resident professional photographers in the Middle East by attending to aesthetic and stylistic differences among them. While these critics are correct in suggesting that resident photographers, perhaps because of their exposure to and contact with local cultures of the region, developed modes of representation that are neither monolithic nor purely hegemonic, they overlook the ways in which the circulation of these photographers' images in European markets and their inscription within Orientalism's photographic archive nonetheless implicate them in discourses of exoticism. These images therefore cannot be simply reassembled within the theoretical categories offered by either aesthetic discourse or postcolonial theory; rather, they must be studied in the context of particular practices, institutions, and relations of power to which nineteenth-century Orientalist photography belongs.

A Subjective Encounter with the Archive

When I first encountered Antoin Sevruguin's photographs of Iran at the Freer Gallery of Art and the Arthur M. Sackler Gallery Archives in Washington, DC, in the early 1990s, I knew almost nothing about the photographer and his work. Before my visit, I had consulted the meager scholarship on the photography of the Middle East available at the University of California–Los Angeles research library, but Sevruguin's name and work were not mentioned.[3] Without the usual background provided by a review of the scholarly literature, I initially approached Sevruguin's work in a personal and highly subjective manner, viewing the photographs not merely as a source of information, artistic expression, or historical evidence, but rather as a kind of tableau vivant that allowed the projection of my own identity and history as an Iranian into them. As an Iranian viewer, I could not help but read the photographs as representing a period and place similar to the setting of my own youth in a provincial town, inhabited by figures so seemingly similar to the people I was seeing in Sevru-

guin's images. For example, what drew me to Sevruguin's photograph of a *shahreh farang* (figure 3.1), literally meaning "European city"—a form of stereoscopic peep show, popular until the late 1960s in Iran, that provided kids in the street with magnified 3-D images of tourist sites in European cities—was not the particularity of its imagery, but rather the way it conjured in me nostalgic memories of a bygone era. The photograph took me back to a time when I was myself a spectator of a *shahreh farang* presentation in my neighborhood in our small town, imagining the day I would visit the fabulous Eiffel Tower or the Big Ben I glimpsed through the peephole. Viewing Sevruguin's photographs gave me in a sense the experience of direct, visual contact with my own past, a projection that transformed the viewing of a public image into an intensely personal experience.

The pleasure of identification soon yielded, however, to a critical interest in Sevruguin's work, as I became more familiar with his oeuvre by consulting other photographic archives—in particular, those at the Golestan Palace in Tehran, and at the Freer and Sackler galleries in Washington, DC, as well as several private photography collections in Tehran. Ironically, what led me to these archives was not my research at academic libraries, but instead a visit to Sherkat-e Ketab, a well-stocked Iranian bookstore in the ethnic enclave of "Tehrangeles" in Los Angeles. There I found a copy of Yahya Zoka's *Tarikh-e Akasi va Akasan Peeshgam dar Iran* (History of Photography and Pioneer Photographers in Iran), published in Iran in 1997, an unexpected discovery that speaks both to my position as a late, Iranian viewer of Sevruguin's work in the United States and to the marginality of early Iranian photography in the West. As I continued to seek out more of his images, I became more interested in Sevruguin's own politics of representation, as well as the historical contexts in which his photographs were produced and consumed. Through my research on his life and work, I became aware of Sevruguin's love for Iran and his sympathetic attitude toward its people, but I also was confronted with the exoticist tendencies apparent in many of his images. As a scholar who has extensively studied European literary representations of "the Orient," I could not ignore the ways his photographs were inscribed in, and informed by, an Orientalist sensibility and style that made his subjects appear exotic and primitive. Here, too, then, my situated subjectivity as a postcolonial scholar informed my reading of Sevruguin's photographs and the meanings they conveyed.

I begin my reflections on Sevruguin's photography with my first impressions upon viewing his work in order to acknowledge the particularities of my position as a viewer. Art historians and archivists have commonly treated the reading of a historical photograph as a direct encounter between the photograph's content and its context, a relationship that changes, as the image is reconsidered at different historical moments. And yet what is often left out of the interpretive equation is the criti-

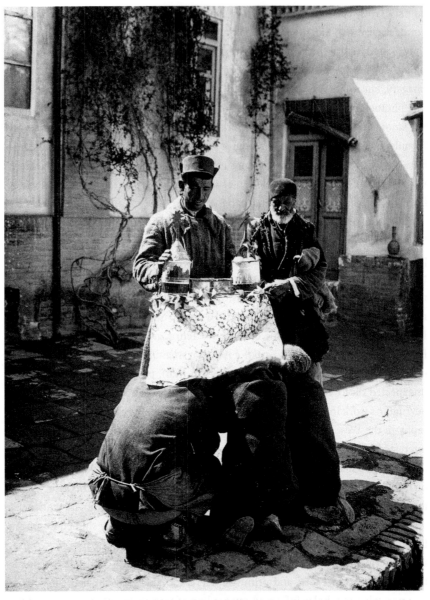

3.1 Antoin Sevruguin, *shahreh farang* (ca. 1890s). Gelatin silver print. Freer Gallery of Art and Arthur M. Sackler Gallery Archives, Smithsonian Institution, Washington, DC.

cal role of the viewer's subjectivity, which always mediates the relation between the content and the context of an image. My point in drawing attention to the subjective dimension of my historical and critical reading of Sevruguin's photographs, which is both personal and scholarly, is to underscore the impossibility of interpretive objectivity in viewing photography. This is not to claim that "the reading of the public photograph is always, at the bottom, a private reading," as Barthes insisted, but to suggest that the viewer's personal and professional subjectivity is a crucial component of interpreting a photograph.[4] The singularity of the viewing subject need not lead to an esoteric or purely subjective interpretation of an image, but instead can be the grounds for the kind of situated and reflexive reading and rereading of an image over time. Undoubtedly, the question "What does this photograph mean?" follows from the question "Who is reading it?" My attention to various audiences and collectors of Sevruguin's photographs in the pages that follow is an attempt to demonstrate the ways in which viewers' subjectivities have influenced the meanings attributed to these images, and have thus transformed their functions as historical traces and archive materials.

My personal reflections are offered here as well to acknowledge Sevruguin's own position as a resident professional photographer, which allows different, and even contradictory, readings of his work. As the product of a contact zone, Sevruguin straddled different subjective positions: he was an Orientalist who often represented Iranian society in an exoticist fashion and an *orienteur* who, as Said suggests with regard to Raymond Schwab, is "a man more interested in a generous awareness than in detached classification."[5] Sevruguin's photographs are simultaneously examples of an Orientalist tradition of photography of the Middle East *and* the expressions of a resident photographer genuinely interested in Iran and the everyday practices of its people. Attention to these opposing poles of representation is crucial to understanding the complexities and nuances of his photographs and their neocolonial uses as an example of what I have called "contact vision," that is, a mode of visual representation that embodies the asymmetrical effects of cultural, economic, and political contacts between the Middle East and European powers.[6] An understanding of Sevruguin's photography as the embodiment of a contact vision complicates both a postcolonial viewing of his work as indigenous photography that "writes back" to European Orientalism and the flat reading of his images as mere Orientalist representations. Let us consider these seemingly countervailing tendencies in Sevruguin's photography by way of elaborating more broadly the cultural and political implications of the works of professional resident photographers in the region.

Sevruguin, the Orienteur

Although Sevruguin's photography and the history of its reception can, and indeed should, be broadly interpreted under the sign of Orientalism as a discursive and artistic style, one must not overlook the plurality of his subject matter, a plurality that resists a reductive reading of his work as mere photographic exoticism. The word *orienteur*, too, proves inadequate here if this term is used to imply the possibility of an objective, purely empathetic, or oppositional approach to representing Iran. I nonetheless have deployed the term *orienteur* to describe Sevruguin in order to draw attention to a more nuanced dimension in his work, one less ideologically coded and more culturally interesting. As a professional studio photographer who spent most of his life in Iran, Sevruguin was far from being a detached observer, merely stereotyping people and exoticizing their everyday practices. That he worked for many years at the court of the late Qajar monarchs and was awarded the Persian Imperial Order—the Lion and the Sun—by Nasir al-Din Shah, who also conferred on him the title of khan (lord), all point to the enthusiastic and broad reception of his work by Iranian royalty and the upper-middle-class audiences who frequented his studio.[7] Despite his East European background and connections, Sevruguin was above all a participating photographer who maintained an intimate and informed relation with the country he chose to live in and visually represent. His "love and ardent affection [for] Iran and Iranian culture," according to his grandson,[8] made him use the expression "Parvarde-ye-Iran" (i.e., nourished or nursed by Iran) as a last name on his Persian passport, underscoring his commitment to the country and its people. Sevruguin, as an *orienteur*, represented Iran through the eyes of a man informed by local knowledge and interested in its cultures.

The broad range of subjects of Sevruguin's photography alone precludes a monolithic reading of his work. As a commercial resident photographer, Sevruguin seems to have photographed almost everyone and everything in Iran over his fifty-year career.[9] The collections of his photographs at the Freer and Sackler galleries contain portraits of royalty and courtiers, military officers and prisoners, religious and ethnic people, foreign royalty and diplomats, dervishes and harem women, images of rites and ceremonies, market scenes and other daily activities, traditional sports and hunting scenes, royal camping and executions, landscape and parks, cityscapes and villages, governmental and religious buildings, pre-Islamic and Islamic architecture, train tracks and roads, and aerial views of cities and villages. The exceptional diversity of his subjects highlights the imperative for a viewing of his photography that is attuned to the plurality of both his images and their reception in Europe and Iran—a reading that also engages the complexity and limits of his images' value as historical traces.

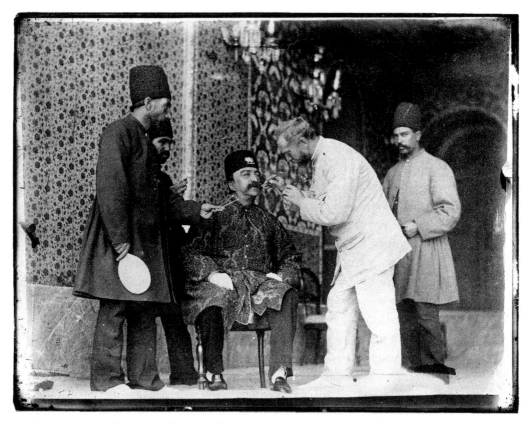

3.2 Antoin Sevruguin, Nasir al-Din Shah treated by his Austrian dentist (ca. 1880s). Glass negative. Freer Gallery of Art and Arthur M. Sackler Gallery Archives, Smithsonian Institution, Washington, DC.

Sevruguin's photographs of the *shahreh farang* (figure 3.1) and of Nasir al-Din Shah's doctor/dentist (figure 3.2) provide two examples of a dimension of his work that is less marked by Orientalism as a mode of representation. What distinguishes these photographs from the Orientalist images I discuss below is not so much their frame of reference as the relation of the photographer to his subjects. The photographer of these images is not detached but a participant observer who seems fully conscious of the medium that invests him with the power of representation, and who appears knowledgeable about the historical changes taking place in Iran during late Qajar dynastic rule. These two images neither rely on the picturesque tradition—in which the indigenous people are depicted in a pastoral setting as a form of reminiscence about a preindustrial age—nor participate in an ethnological quest to "typicalize" the curious and the exotic primitive. As a result, these images avoid a categorizing gaze that reduces people to types and labels their lives according to Ori-

entalist categories. Both photographs depict scenes that present the Iran of the late Qajar period as a "contact zone" where Europe encounters and clashes with the East, a complicated social space in which cultures (as practices of everyday life) and identities meet in an asymmetrical fashion.[10] These photographs, in spite of their strategy of realism, offer only an interpretation, one that is attentive to the asymmetrical, and in a certain sense surreal, encounter taking place within the frame as well as in the very act of photography itself.

The photograph of Nasir al-Din Shah and his European doctor focuses on the contact between the two disparate cultures of the traditional court and modern medicine. Perhaps commissioned by the shah himself as part of his effort to document the everyday life of his court, the photograph can be read as a symbol of the shah's power, evidenced by his ability to document his being treated by a European doctor. The elaborately dressed shah sitting in the traditionally decorated balcony of the court contrasts with the doctor wearing uniformlike attire, drawing our attention to the unequal relation between Iran and Europe—"unequal" in part because Iran in the nineteenth century was indirectly colonized by the British in the south and by the Russians in the north. Viewed in the context of the late Qajar period—one characterized by a weak monarchy and European domination—the photograph encourages reflection upon the linkage between indirect colonialism and the advent of modernity in Iran, and it can be interpreted as a symbolic expression of European intrusion. But this photograph is not a celebration of European colonial rule in Iran, given the tense, and somewhat melancholic, mood of the people in the frame and the photograph. Rather, its vision of the contact provides a representation of the encounter as uneasy. As such, the image stands as an inadvertent critique of the indirect colonial relationship between European powers and the Iran of Nasir al-Din Shah.

Sevruguin's photograph of the *shahreh farang* also suggests a more reflexive mode of representation, rendering the image a more engaged and less exoticist depiction of an otherwise ordinary street scene. The homemade stereoscope, which provided youth with glimpses of foreign places and monuments, can be considered an early form of television that delivered a popular cultural experience of contact with the Western world through magnified views of tourist sites in European cities. The photograph draws attention to the role played by such an apparatus of representation in making cultural contacts between the disparate spaces of industrialized Europe and feudal Iran. It can therefore be considered not so much exoticist in its approach as reflective of the very act of representation that facilitates cultural contact in the first place. The camera in this instance is in dialogue with the subject of the photograph: what the operator of the *shahreh farang* does for his street audience parallels what the photographer does for his (tourist) clientele.

1 Sébah & Joaillier Studio, "Souvenir de Constantinople" (1890)

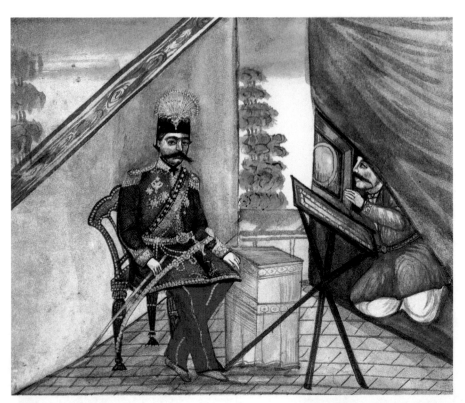

2 Anon., Nasir al-Din Shah (ca. 1863)

3 Lalla Essaydi, *Reclining Odalisque* (2008)

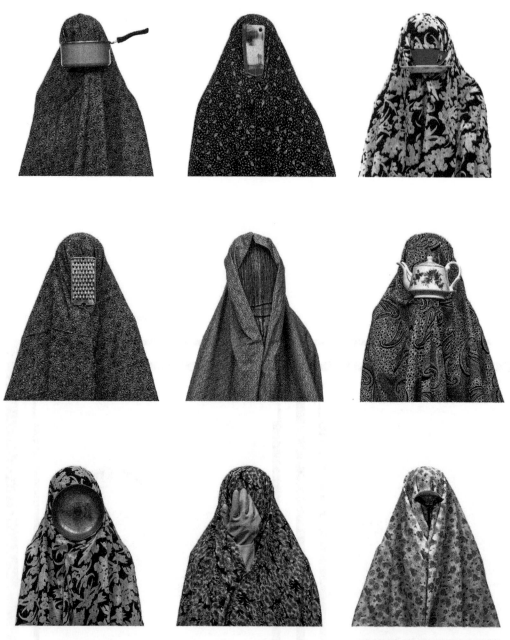

4 Shadi Ghadirian, *Untitled* (2000)

As contemporary viewers of Sevruguin's work, we are able to read the plurality of his photographs because these images are not merely stereotypical representations of Iranian society but also material traces of its history. Susan Sontag has compared the photographic image with a footprint or "something directly stenciled off the real."[11] In the context of late nineteenth- and early twentieth-century Iran, photography was specifically viewed as a historical trace and valued for its indexical and evidentiary qualities. For example, a large number of Sevruguin's glass-plate negatives were destroyed during the Iranian Constitutional Revolution of 1905–7 when his studio was plundered by the soldiers of the Qajar king, Mohammad Ali Shah, destroying over five thousand of the glass plates, and later by the order of Reza Shah Pahlavi, who confiscated the remaining two thousand plates to destroy all traces or evidences of the Qajar monarchy and what he considered "old-fashioned" or "backward" Iran. That the late Qajar is repressed in Iranian historical consciousness as a shameful chapter of loss and colonization makes Sevruguin's images more significant as traces of historical knowledge. This is not to claim that they constitute an objective chronicle of the country during the late nineteenth century. Undated, and often unidentified, these photographs are merely fragmentary traces of a repressed past. Still, they inspire historical interest when viewed in the context of Iran's conflicted contact with Europe during the late nineteenth century.

Sevruguin's photographs are material remnants of a repressed history, impelling us to take a more critical look at this period—not just to consider his photographs in the context of their colonial history but to reevaluate received notions of nineteenth-century Iran. As material traces of that history, they provide compelling grounds for rereading what we know of Iran during the reign of Nasir al-Din Shah and other late Qajar monarchs. Sevruguin's images of the Qajar court, in other words, invite us to interpret his photography along with and against written histories of the period. Take, for example, the photograph of a hunting scene featuring Malijak (figure 3.3), or Gholam Ali Khan (aka Aziz al-Sultan), the nephew of Amin Aghdas, one of Nasir al-Din Shah's wives. Often represented and ridiculed in historical studies of the period as a passive object of the shah's pedophilic desire, he has been consistently identified by historians as a representative figure of corruption and backwardness in the court of Nasir al-Din Shah. But Sevruguin's photographs of him make us view him differently, not as a submissive object of desire but as a sympathetic and powerful figure. His victorious and playful pose in the hunting scene conveys the image of a precocious child, manipulative of the shah's affection and cognizant of his own social role in the court. As a silent documentary, such images offer a visual counternarrative that complicates, if not contradicts, Pahlavi perceptions of the Qajar monarchy as backward (i.e., premodern) and corrupt.

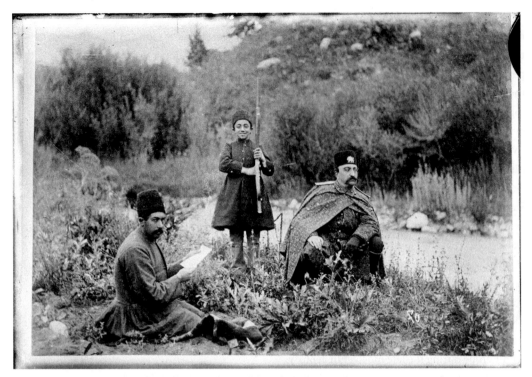

3.3 Antoin Sevruguin, Nasir al-Din Shah hunting with Malijak (ca. 1880s). Glass negative. Freer Gallery of Art and Arthur M. Sackler Gallery Archives, Smithsonian Institution, Washington, DC.

Sevruguin and Orientalism

While the particular location of Sevruguin as a resident photographer made him represent Iranian society in ways that sometimes diverged from the dominant forms of Orientalist photography, his work nonetheless maintained an intervisual relation with them and as such came to be deployed in the service of (neo)colonial enterprise. In this regard, it is crucial to consider the (af)filiated nature of Sevruguin's photographic practice in the context of its reception in Europe and the United States. By "(af)filiated" I mean to highlight the way his images uphold a "filial" relation with other forms of Orientalist representations and are "affiliated" with various neocolonial institutions and expositions.[12] Victor Burgin has cogently argued that photography, like any other mode of representation, "is the site of a complex intertextuality, an overlapping series of previous texts 'taken for granted' at a particular cultural and historical conjuncture."[13] Sevruguin's photography is no exception to the rule of intertextuality, for the large body of Orientalist discourses and visual representations provided Sevruguin with an intertextual and intervisual context, informing both his photographic practice and the relationship between his images and their viewers.

The Orientalist tradition in painting and in early photography of the Middle East played a central role in his style of representation, making his work legible, desirable, and even useful to his various audiences, ranging from tourists and armchair travelers to Orientalists and neocolonial officials.

The son of Vassil de Sevruguin, an Armenian Orientalist working in the Russian diplomatic mission in Iran, Antoin started out as a painter but switched to the more lucrative profession of photography after the premature death of his father, mostly in order to support his family. His work borrowed from the larger body of Orientalist representations available perhaps in his father's large library and later in European exhibitions and museums he visited during his frequent trips to purchase photographic materials and equipment. In addition, having moved to Tbilisi, the capital of Georgia, after the death of his father, he met the Russian photographer Dmitri Ivanovich Ermakov, whose early topographical photographs of Iran and Central Asia greatly inspired Sevruguin, prompting him to collaborate with the Russian master and embark on a photographic survey of Iran himself.

Sevruguin's photography of Iran, which dates back to 1870, when he first traveled back to the country of his birth, uses formal and contextual tropes from both travel narratives and paintings of the Middle East. The most dominant trope, of course, is that of "the Orient" as a place of eroticism, examples of which can be found in photographs of Iranian women in their interior spaces. Like images of *dames turques* by professional studios in Istanbul, Sevruguin's photographs are highly posed and constructed. And as in Ottoman harem photography, these images were mostly taken for European audiences and travelers, and perhaps certain elite classes in Iran and the Middle East, who visited his studio in Tehran. To cater to their Orientalist taste, the images encompassed an exotic and erotic gaze. Though less revealing than many of the picture postcards of North Africa,[14] these images are clearly indebted to the Orientalist pictorial tradition of the mid-nineteenth century and to accounts of harem life in European travel narratives produced in the seventeenth century. The photograph of a reclining Kurdish woman (figure 3.4), for example, recalls numerous paintings of idle Middle Eastern women in odalisque poses by artists such as Gérôme, John Frederick Lewis, Jean Lecomte du Nouÿ, and Ingres. Aesthetically reminiscent of its painterly precursors, this photograph offers, however, an individualized and subtle image of Orientalist eroticism by focusing on the details of her dress and jewelry. Such a focus combines the exotic with the erotic, creating a greater sense of novelty that transforms the cliché image of idle Oriental women posing seductively in their interior spaces into an aesthetic representation. As he indicated in his photographic imprint, Sevruguin considered his images *photographie artistique*, and thus attempted to infuse his photographs with an artist's sensibility.[15] The aesthetic quality of this photograph, however, is precisely what allows the renewal of an other-

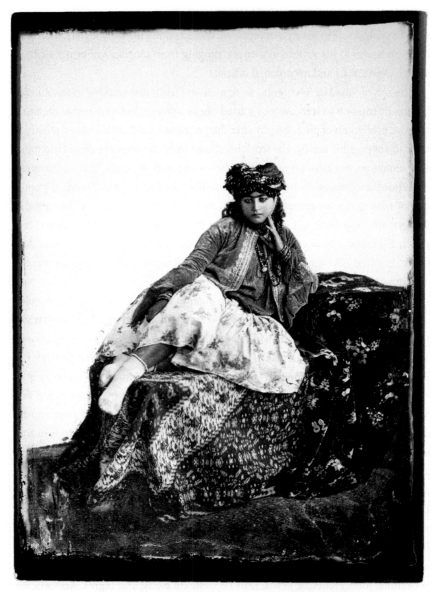

3.4 Antoin Sevruguin, portrait of a reclining Kurdish woman (ca. 1880s). Silver gelatin print. Freer Gallery of Art and Arthur M. Sackler Gallery Archives, Smithsonian Institution, Washington, DC.

wise clichéd image. The abundance of jewelry and exotic dress here speaks at once to an ethnological interest in the subject and to an erotic fantasy associated with the harem. That the image is titled "Kurdish" woman speaks to its classificatory impulse and highlights her ethnicity. However, the visual extravagance of her dress and exotic jewelry is meant to render the woman also beautiful and desirable, encouraging the viewer to indulge in an erotic fantasy.[16]

Similarly, the photograph of the harem fantasy (figure 3.5) provides another example of the way Sevruguin's photography is squarely inscribed within the Orientalist tradition, and therefore should not be interpreted anachronistically through postcolonial categories of hybridity and ambivalence. Though less revealing than other similar photographs of the harem from the period, this image still deploys typical tropes of Western fantasies of harem life, such as the color contrast between the black eunuch and the Circassian model, the ever-present hookah symbolizing boredom and self-abandonment, and the revealing posture of the woman inviting the male gaze. These Orientalist evocations are meant to authenticate an otherwise fanciful simulacrum, while providing signifiers of exotic lasciviousness to stimulate the viewer's erotic fantasies. This photograph, like the previous one, assumes a male gaze; idle and adorned, the woman appears ready to satisfy the onlooker's (hetero) sexual desires.

Finally, the photograph of the woman seductively removing her veil to show her eyes to the photographer-voyeur (figure 3.6) speaks to the Western obsession with the veil as a form of prohibition in "the Orient." The veil intensifies the male viewer's scopic desire by initially creating a visual interdiction. As such, it is crucial to the fantasy of the harem because it arouses and perpetuates the viewer's desire to cross into forbidden territory, while restaging the harem as an inaccessible, exotic, and mysterious space. In this perfectly rendered image, the contrast between the seductive pose of the veiled woman and the dark interior space behind her activates the viewer's scopic desire by depicting a scene that represents simultaneously the inaccessibility of the harem as a forbidden space and the possibility of transgressing it. The photograph can therefore be interpreted as an invitation to imagine what lies behind and to penetrate the closed space and the veiled body of the woman.

Sevruguin's Orientalist relation with his subject matter is not limited to his image of women in their interior spaces. It is also manifested in the numerous nostalgic and picturesque images that depict Iranian society as a premodern and primitive world, as can be seen, for example, in his photograph of a farm scene (figure 3.7). The image of a peasant's home in the province of Mazandaran claims realism as its strategy of representation: the peasants performing various tasks at the farm are depicted in their natural setting, and looking away from the camera and at one another, to create a "truthful" or non-staged picture of a peaceful and romantic lifestyle no longer

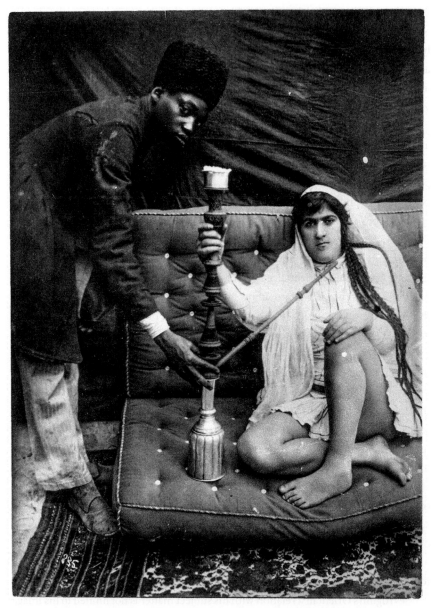

3.5 Antoin Sevruguin, harem scene (ca. 1880s). Silver gelatin print. Freer Gallery of Art and Arthur M. Sackler Gallery Archives, Smithsonian Institution, Washington, DC.

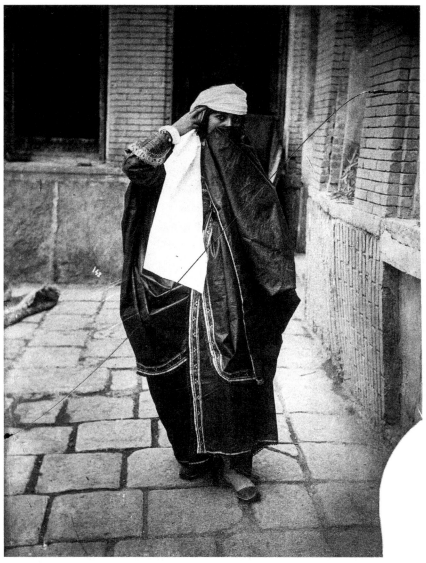

3.6 Antoin Sevruguin, portrait of a veiled Persian woman standing in a courtyard (ca. 1890s). Glass negative. Freer Gallery of Art and Arthur M. Sackler Gallery Archives, Smithsonian Institution, Washington, DC.

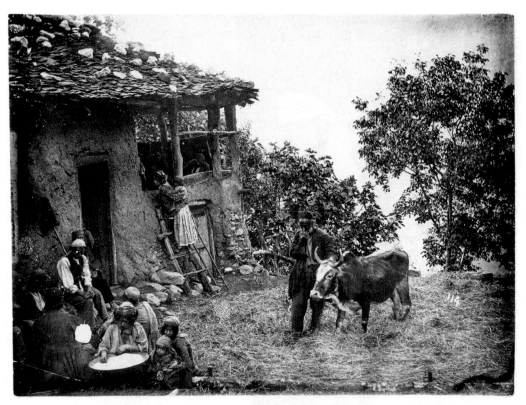

3.7 Antoin Sevruguin, peasants at their farm (ca. 1890s). Silver gelatin print. Freer Gallery of Art and Arthur M. Sackler Gallery Archives, Smithsonian Institution, Washington, DC.

possible in the industrialized West. In creating an image of rural life, the photographer offers the armchair viewer a peek into a world he or she no longer inhabits. As in Samuel Bourne's images of nineteenth-century India, or John Thomson's photographs of Chinese peasantry, with both of which Sevruguin would have been familiar, the picturesque quality of this photograph is a kind of longing for a disappearing, if not obsolete, way of life, a form that "is part and parcel of the changing perceptual arrangements of modernity, including colonial modernity," as Zahid Chaudhary has suggested. To the extent to which the colonial picturesque is "the symptomatic nineteenth-century fruit of a certain modernizing habitus," as Chaudhary observes, it also is implicated in the ethnological discourse that categorized and arranged human ethnicities into a linear narrative of progress.[17] Sevruguin's photograph is therefore both an ideological representation that produces a sense of difference between the "primitive" world of Iranian society and its modern European viewers and a nostalgic picture that establishes a temporal distance between the spectator and the indige-

nous people. The nostalgia this photograph evokes is the consequence of the temporal distance the viewer is made to assume in relation to the peasants who represent an earlier stage of human history. As a result, the photograph, in spite of having been produced through a shared temporality between the photographer and the portrayed peasants, embodies what Johannes Fabian has termed "a denial of coevalness or temporalization."[18] The photograph, like the anthropological discourse about "primitive" societies, places the "Oriental" in a time other than the present of the European photographer, a tendency that denies the native coevalness. Picturesque images such as this encourage the viewer to visualize the other in a specific way, one in which "the Orient" is represented as on the brink of vanishing, as the photographer attempts to preserve a trace of it. Here, the relation established by the photographer between the viewer of the image and the subjects photographed involves a unilateral form of vision, a kind of ideological voyeurism, in which the possibility of a return gaze is denied not merely for aesthetic but for political reasons.

Akin to pictorial nostalgia is the positivist urge to categorize people, classify their religious and ethnic differences, and document their everyday lives. Many of Sevruguin's images belong to the genre of *scènes et types* popular among both professional and lay audiences in the late nineteenth and early twentieth centuries. Motivated by a modernist desire to record the vanishing "primitive" people and societies, and enabled by the emerging discourses of ethnology and evolution, this photographic genre constituted an important part of the colonial project.[19] Throughout the second half of the nineteenth century, European photographers and local professional studios produced a large inventory of "primitive" types, documenting their physical and cultural characteristics in ways that not only objectified them but also subjected them to a hierarchical order of human development. In spite of the fact that Sevruguin was not directly implicated in colonial relations of power, nor did he embrace its ideology of racial superiority, his photographs of street types and scenes bear close affinity with those of his exoticist contemporaries such as Thomson and Felice Beato, as well as the images of Ottoman street types produced by professional studios in Istanbul for European tourist consumption.[20] As examples of the genre of *scènes et types*, Sevruguin's images of ethnic and religious groups and their daily activities embody similar processes of racial othering and classification. Consider, for example, his photographs of an ice-cream vendor (figure 3.8) and a dervish (figure 3.9). Unlike the photographs discussed in the first part of this chapter, these images lack any photographic reflexivity as they attempt to portray various types in nineteenth-century Iran. Like Thomson's images of racial and topographic types, or those of professional studios in Istanbul, these photographs are exemplary cases of what Barthes called a "motionless image," that is, an image in which the figures who are repre-

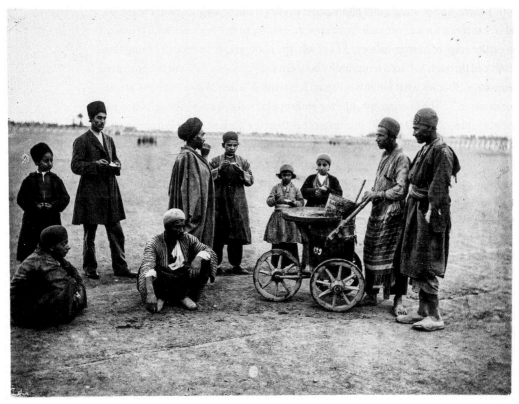

3.8 Antoin Sevruguin, ice-cream vendor (ca. 1880s). Silver gelatin print. Freer Gallery of Art and Arthur M. Sackler Gallery Archives, Smithsonian Institution, Washington, DC.

sented "do not *emerge*, do not *leave*: they are anesthetized and fastened down, like butterflies."[21] To indicate the "naturalness" of the representation, the figures in both photographs do not look into the camera's eye, which also reduces them to representative types to be observed. In the photograph of the ice-cream vendor, the people, in spite of their performing an activity, are frozen as types in the frames. Both images lack any empathy toward the subjects they represent. The figures in these images neither participate in the framing nor exude a sense of uniqueness or individuality that would disrupt the banal representation of people as motionless types. As such, far from deconstructing the explicit relation of power between the photographer and the viewer on the one hand and the sitters on the other, as postcolonial readers of Sevruguin's photography have claimed,[22] they betray a monolithic vision that mobilized tropes of classification through which European audiences came to see and understand people of other worlds.

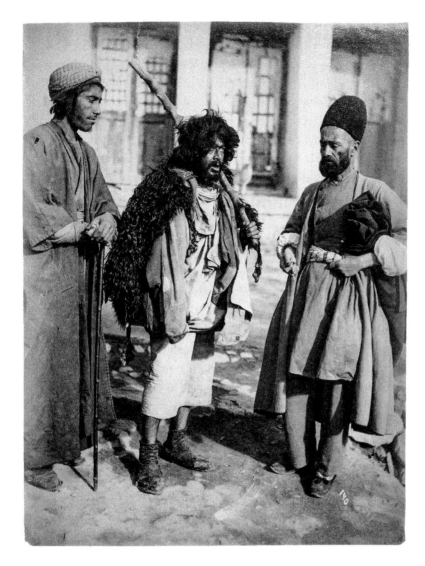

3.9 Antoin Sevruguin, a dervish and two men (ca. 1880s). Albumen print. Freer Gallery of Art and Arthur M. Sackler Gallery Archives, Smithsonian Institution, Washington, DC.

The (Neo)Colonial Uses of Sevruguin's Photography

These exoticist and categorizing tendencies in Sevruguin's work are perhaps what brought him the kind of recognition and reception he received in Europe during his lifetime, for exoticist photography's indexical claim to truth was useful to both sciences (ethnology, geography, archaeology) and pseudosciences (physiognomy, eugenics) of the late nineteenth and early twentieth centuries. His comprehensive photographic survey of Iranian antiquity and people, which won medals at European expositions in 1897 in Brussels and 1900 in Paris, was recognized as a particularly

valuable source of information for Orientalists, archaeologists, and art historians. That the British Museum even offered to purchase part of Sevruguin's photographic collection speaks to this consensus concerning the usefulness and the aesthetic quality of his photography.[23] Among the highlights of Sevruguin's professional career was the photographic exhibit of Achaemenid and Sassanid archaeological sites such as Persepolis he produced for the art historian Friedrich Sarre, who, with the archaeologist Ernst Herzfeld, published them in *Iranische Felsreliefs* (Berlin, 1911) without giving any credit to the photographer.[24] Accompanied by his brother Emanuel and escorted by a Russian colonel and soldiers from the Iranian Cossack brigade, Sevruguin created a large body of photographic images depicting the ruins of Iran's glorious past for the uses of Orientalists and archaeologists. His photographs of Iranian antiquity constituted a useful repertoire of archaeological and historical knowledge for scholars such as Sarre, providing them with information about Middle Eastern ancient architecture that continues to be helpful even to twentieth-century classical archaeologists and art historians, including Myron Bement Smith, the original holder of the collection now in the Freer and Sackler archives. In addition, as examples of the expeditionary tradition of photography, these images capture the remnants of Iran's vanished civilization for a more lay audience. The photograph of the gate and columns of the ancient capital Persepolis (figure 3.10), for instance, seeks to "preserve" the disappearing site while drawing attention to its deterioration and destruction. As the work of a preservationist, this image celebrates Iran's illustrious past and underscores the historical value of the site; as the product of a nostalgic Orientalist, it mourns the site's destruction, which perpetuates the stereotype of the Middle East's decadent civilization, while producing the idea that the site needs to be saved and protected from the ravages of time and presumably "indolent" natives.

The combination of ethnographic interest and photographic documentation is also what made Sevruguin's work useful for a popular variety of Orientalism, producing a visual archive of exotic cultures for European audiences in the form of picture books, postcards, and colonial exhibitions that proliferated in the late nineteenth century, displaying objects and peoples of the colonial world. An example is the popular 1920s *Peoples of All Nations*, an even more exoticist version of today's *National Geographic*, which aimed to create an encyclopedic account of all cultures. Several of Sevruguin's photographs appear with Sir Percy Sykes's entry on Persia in this multivolume project (figures 3.11 and 3.12). Symptomatically divided into a section on "Pastoral Life in the Land of the Shah" and another on "Its Past Grandeur and Present Predicament," Sykes's article uses these photographs to buttress his Orientalist account of the country by focusing on its past glory and its current backwardness. Describing Iran (erroneously) as a "sterile" land with "a dead heart," Sykes dwells on Iran's bygone imperial civilization while depicting its contemporary culture as deca-

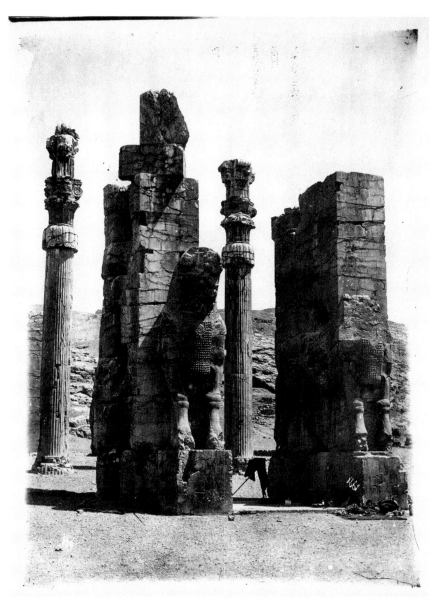

3.10 Antoin Sevruguin, Persepolis (1902–5). Gelatin silver print. Freer Gallery of Art and Arthur M. Sackler Gallery Archives, Smithsonian Institution, Washington, DC.

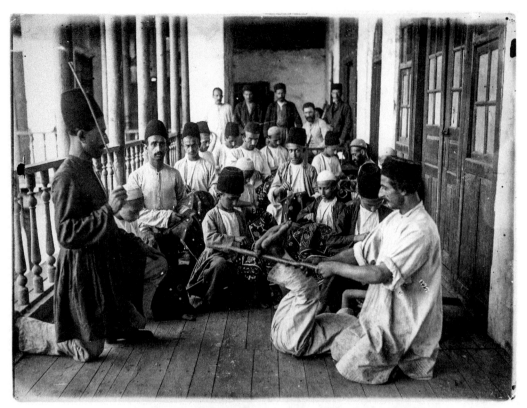

3.11 Antoin Sevruguin, boy receiving punishment in school (ca. 1880s). Silver gelatin print. Freer Gallery of Art and Arthur M. Sackler Gallery Archives, Smithsonian Institution, Washington, DC.

dent.[25] Quick to generalize and somewhat contradictory in his use of photography,[26] Sykes employs Orientalist stereotypes to paint a culture of women who "yawn their lives away like grown-up children" and men who "do nothing whatever, except that they occasionally repair a broken-down bridge and immediately charge a heavy toll" (3989, 4000). In this article, visual and discursive representations work in tandem to categorize people as types, while describing their costumes and everyday practices according to Orientalist taxonomies. The use of Sevruguin's photographs by Sykes in *Peoples of All Nations* illustrates the reproductive function of Orientalist photography. Sevruguin's images of street types and scenes rely on conceptions of racial otherness and ethnic difference that are readable in the images themselves, but his photographs become more impactful as representations through their reproductions in print media.[27] The visual images produced in the text, while perhaps contradicting some of Sykes's claims about the laziness of Iranian people—e.g., women in Sevruguin's photograph are actually working—nonetheless bring the exotic world

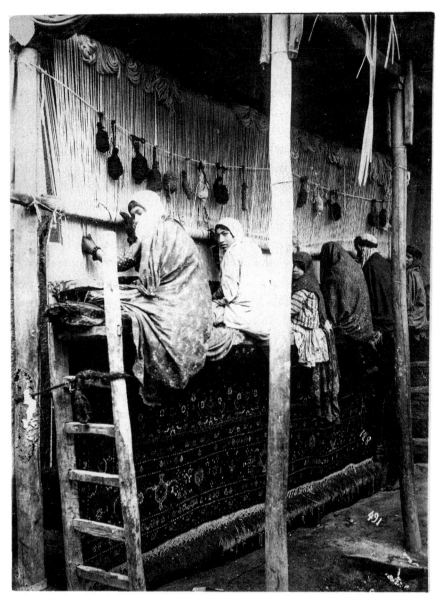

3.12 Antoin Sevruguin, girls weaving carpet (ca. 1880s). Silver gelatin print. Freer Gallery of Art and Arthur M. Sackler Gallery Archives, Smithsonian Institution, Washington, DC.

of "the Orient" closer to the reader, helping him or her visualize what is narrated in the text. As such, photographic images of the Middle East contributed to Orientalist discourse as visual aides to supplement textual accounts.

In addition to their function as iconographic purveyors of Orientalist knowledge and exoticism, Sevruguin's photographs proved useful to European and later American scholars whose research in and about the region was deployed in the service of (neo)colonial relations of power with Iran. Let us consider two exemplary cases of such usage of Sevruguin's photographs by way of elaborating how his photography was implicated in (neo)colonialism. One of the earliest collectors of Sevruguin's photographs was Willem Lodewijk Bosschart, the Dutch chargé d'affaires in Tehran, who played an important role in encouraging Dutch colonial companies to invest in Iran in the late nineteenth and early twentieth centuries. As a collector of exotic objects, Bosschart collected everything from children's toys and folk arts to zoological items during his several years of residence in Iran, most of which he eventually loaned or donated to various institutions such as the Royal Dutch Geographical Society and the National Museum of Ethnology in Leiden. Among the items he loaned and later sold to the National Museum of Ethnology were 179 photographs taken in Iran by Sevruguin.[28] These images, which include portraits of individuals and groups, dervishes, street scenes, daily activities, various ethnic and religious communities, cities, and monuments, proved useful to ethnographers and Orientalists such as J. D. E. Schmeltz in their studies of the region and to colonial officials for the information they provided as documentary photography. In one of his communications about Bosschart's collection (November 28, 1899), for example, Schmeltz wrote about the way some of Sevruguin's photographs were being used for such purposes.[29] Collections such as Bosschart's were not only helpful as a source of information for experts who advised various colonial agencies; they were also more broadly useful to the colonial enterprise in reenacting and thus perpetuating the quest for exoticism. Like ethnic displays in colonial expositions, photographic collections of "primitive" societies brought the exotic other to Europe, introducing the public to non-European cultures by way of bolstering popular support for European colonialism and boosting colonial trade.[30]

Another example of how Sevruguin's photography proved useful to Orientalist scholars with ties to neocolonial interests in Iran is Smith's collection, which is now held in the archives of the Freer Gallery of Art and the Arthur M. Sackler Gallery. Smith, a prominent scholar of Islamic architecture, traveled to Iran for the first time in 1934, where he purchased some of Sevruguin's photographs to build a research collection of photography, which later came to be known as the Islamic Archives. The Islamic Archives, which included photographs taken by Smith as well as images donated by other scholars, diplomats, and tourists, was meant "to be a depository of

photographs and slides for scholars and government agencies operating in Islamic countries," as Julia Ballerini has observed.[31] As part of this collection, Sevruguin's photographs—which increased in number after scholars of Islamic studies such as Joseph Upton and Jay Bisno contributed to the archives, and after Smith purchased 696 Sevruguin glass-plate negatives from the American Presbyterian Mission in Tehran—were collected for their potential as sources of historical, anthropological, geographical, and sociological information. While Sevruguin's images of Persepolis and other historical monuments helped Western scholars in their studies of Iran's pre-Islamic past, his photographs of people and street scenes provided anthropologists and ethnologists with representative examples of ethnic diversity in the country.

Such uses of Sevruguin's photography by various Orientalist scholars could be considered benign were it not for the fact that some of these scholars directly participated as experts and advisers in neocolonial relationships forged between the United States and Iran after World War II. From the very beginning of his career, Smith wished to take part in the US government's involvement in Iran, but in spite of his desire to be connected with the Foreign Service, it was not until World War II that he and other Orientalist scholars were recruited by the US intelligence service. In his personal communications and papers from this period, we learn that Smith had many conferences in the Pentagon, where he provided intelligence to the US government about Iran, presenting officials with maps and images of railways, bridges, and roads. Bohrer claims that Sevruguin's documenting of wireless towers, telegraph offices, railroads, and even airplanes provided a "visual field in which to refashion oneself as well as a sign in its own right of European-derived modernity,"[32] but the uses of such photographs by Orientalists serving as experts with ties to the Pentagon belie such anachronistic postcolonial readings of them. For example, about 768 items from the Islamic Archives were used by eleven governmental agencies between June 1942 and June 1943.[33] Indeed, Smith's close affiliation with various governmental agencies dealing with the Middle East continued well after the war as the United States became more involved politically and economically in Iran and throughout the Middle East. The Islamic Archives he established provided useful visual material for organizations such as the Foreign Service Institute and the Agency for International Development.

Another collector of Sevruguin's prints and a donor to the Islamic Archives, Joseph Upton spent many years in Iran exploring archaeological digs after the mid-1930s. Upton also was recruited by the US intelligence service to provide information on the social and political scene in Iran during World War II, and his affiliation with the intelligence community continued well into the 1950s as the United States became more heavily involved in Iranian politics, culminating in the overthrow of the democratically elected Prime Minister Mohammad Mossadegh and his govern-

ment by the CIA with Operation Ajax in 1953.[34] Because of his long residence in Iran, Upton was a more important contributor to US involvement in Iran than Smith, collaborating closely with another archaeologist colleague, Donald Wilber, who, as Stephen Kinzer has documented, plotted the coup and produced the blueprint of Operation Ajax with British agents in 1952 when he spent six months as the head of the CIA's "political action" office in Tehran. Though one can only speculate about the ways Sevruguin's images were used by Orientalist scholars and experts such as Smith, Upton, and Wilber as they advised the CIA and other government agencies, there is no doubt that photographic images of royalty, religious and ethnic types, daily activities, and geographical and infrastructural sites proved to be especially useful tools for US intelligence agencies in gathering information about individuals and political parties. While Smith's photographic images of monuments and geographical sites may have helped him produce intelligence about landscape and architecture in Iran, Upton's focus on portraits of Iranian people and their daily lives could have served him as visual tools in gathering intelligence about Iranian culture and society. It is perhaps not accidental that Upton donated his collection of Sevruguin's photographs to the Islamic Archives two months after the overthrow of Mossadegh and the reinstatement of the shah, for such an act at least symbolically signaled the fact that intelligence-gathering efforts had been concluded.

That the work of a sympathetic resident or local photographer such as Sevruguin became useful to scholars like Sarre, Schmeltz, Smith, and Upton with ties to neocolonial politics in Iran raises several issues about the productive function of photography as an ideological tool. First, the exoticist tendencies in Sevruguin's photographs suggest that, in spite of being reflexive and culturally knowledgeable, he could not occupy a position outside Orientalism and colonial relations of power to produce a nonexoticist vision of Iran. Orientalist conventions and forms, the European audiences' stereotypical views of what "the Orient" represented, and colonial interests in the region determined the limits of his photographic vision and the contexts of their reception. Sevruguin's photographs maintained a complicated relation to Orientalism that is at once manifest and unconscious—manifest because he intentionally participated in the visual quest for exoticism, perhaps to attend to the expectations of his audiences, and unconscious because an Orientalist imaginary informed his representations of Iran in apparently unwitting ways. The polarities of manifest and unconscious Orientalism in Sevruguin's work compel us to consider the dynamic tension between a photographer's intentionality and colonial hegemony in interpreting his and other resident photographers' images. In the case of Sevruguin, the reception of his photography is tied to both his position as a commercial photographer attending to the taste of his European audiences and the locations where his images were consumed, displayed, and utilized.

Second, that a diverse and complex body of photographic representations such as Sevruguin's ultimately comes to serve neocolonial interests in various ways also suggests that plurality and hybridity cannot be assumed to be modes of resistance and opposition to cultural and political hegemony, as some postcolonial art historians have argued.[35] Rather, splitting and pulverizing forces are signs of the productivity of Orientalism as a discourse of power. Orientalism as a geopolitical discourse of domination need not rely on monolithic representations, but instead maintains a complex structure of differentiation. Indeed, ambivalence, heterogeneity, contradiction, and difference are common attributes of modern Orientalist representations, and photographic images of the Middle East are no exception. These attributes, however, neither undermine the cultural hegemony of Orientalism nor threaten the dominance of colonial power. For, as expressions of the dissymmetric relations of the neocolonial encounter, they are what give Orientalism its durable reproductive power, and what make it a productive force in the colonial enterprise.

Third, the ways photographic representation proved useful to neocolonial enterprises in Iran points to a circular relationship between photography and Orientalism, knowledge and power, aesthetics and politics. In their historical context, photographs of the Middle East like Sevruguin's were produced by and productive of an Orientalist imaginary, and as such they were supported by and served European institutions and colonial interests. At the same time, Sevruguin's images came into circulation in a new context in which their informational, evidentiary, and indexical qualities were useful both to American Orientalism and to the neocolonial relationship between the United States and Iran. Here, too, photographic representations simultaneously were embedded in and contributed to a whole series of epistemological, cultural, economic, and political interests in Iran. The entangled relationship between Sevruguin's photography and neocolonialism is a crucial reminder that what enables Orientalism as a discourse of power is not ideological uniformity nor intentionality but rather unequal relations of production and reception that generate the complex patterns of its political utility.

In My Grandfather's Darkroom

On Photographic (Self-)Exoticism in the Middle East

Postcolonial scholars have often described the relation between the colonizer and the colonized, as well as their respective modes of representation, in a binary fashion as one of power and resistance. In *Orientalism*, for example, Said argues, "The relationship between Occident and Orient is a relationship of power, of domination, of varying degrees of hegemony."[1] Orientalism, as a Western mode of representation, is defined as a discourse of power in which the imperial consciousness and imagination of the European subject exoticize the other. In *Culture and Imperialism*, in contrast, Said goes on to theorize the colonized's cultural and discursive modes of resistance to colonialism and imperialism. Acknowledging his neglect of the question of the other's response to imperial culture in *Orientalism*, he points out that "nearly everywhere in the non-European world . . . the coming of the white man brought forth some sort of resistance." The colonized's resistance and opposition, which, according to him, "persist well after successful nationalism has come to a stop," involves three elements: "the insistence on the right to see the community's history whole, coherently, integrally;" "an alternative way of conceiving human history;" and "a more integrative view of human community and human liberation." Therefore, "the interven-

tions of non-European artists and scholars," according to Said, "are not only an integral part of a political movement, but in many ways the movement's *successfully* guiding imagination, intellectual and figurative energy reseeding and rethinking the terrain common to whites and non-whites." For Said, representations and discourses of postcolonial artists and critics work out of a decentered consciousness and are always secular, political, and oppositional.[2]

Not surprisingly, such a Manichean logic of the colonial encounter has not been limited to the field of literary studies. In recent years, scholars of visual culture have also elaborated the difference between Western representations of otherness and non-Western self-representations of their societies in binary terms as manifestations of power and expressions of resistance, respectively. On the one hand, art historians and cultural critics have defined European representations of non-European and colonized people as examples of colonial appropriation and domination. For example, Nochlin, in her seminal essay "The Imaginary Orient," has argued that European Orientalist genre painting should "be considered as a visual document of nineteenth-century colonialist ideology."[3] In a similar vein, Alloula, in his important book *The Colonial Harem*, describes early twentieth-century French postcards of the Maghreb as "the fertilizer of the colonial vision."[4] On the other hand, art historians of non-Western cultures have theorized indigenous artistic representations in terms of resistance to the West and imperialism. Çelik, for example, has argued that Ottoman artistic representations of Turkey at the World's Columbian Exposition, held in Chicago in 1893, "included oppositional perspectives to challenge Orientalist constructions" of Ottoman society.[5] Similarly, Roberts, in *Intimate Outsiders*, has argued that "photography was harnessed by the Ottoman leaders as a medium for presenting a revised collective self-image to Europe," and that critics ought "to consider its subversive relationship to existing Orientalist photographic codes."[6]

In this chapter, I seek to complicate postcolonial scholars' theoretical claims about the dualistic nature of Western and non-Western subjectivities and their modes of artistic and discursive practices. Focusing on early local photography in the Middle East, I seek to present a more nuanced picture of indigenous representation in the region than is typically offered. Local practices of photography in the Middle East were not merely derivative of their Western counterparts, nor simply oppositional representations working against Orientalist aesthetics or as "authentic" articulations of the vernacular cultures in the region. Photography in the Middle East was simultaneously enmeshed in local culture and politics and in dialogue with European aesthetic conventions. On the one hand, photography in the region was mobilized by middle- and upper-class men to foreground their social status and patriarchal values, and as such relied on local aesthetic conventions and ideological assumptions; on the other hand, photographic practices in the Middle East engaged in a local form of

photo-exoticism produced by the depiction of people of the lower classes as primitive and culturally inferior. At a time when photographic materials were extremely expensive to acquire, and processes difficult to execute, Iranian and other Middle Eastern indigenous photographers produced an impressive archive of exoticist and eroticized images that was in dialogue with Orientalist perceptions of the region. Some of these representations were produced for the European tourist market, but others were created for local consumption. The tendency to self-orientalize in the region was so dominant, in fact, that the Ottoman sultan Abdülhamid, for example, issued a directive in 1892 to resident photographers in Istanbul and throughout the empire stating: "Most of the photographs taken for sale in Europe vilify and mock Our Well-Protected Domains. It is imperative that the photographs to be taken in this instance do not insult Islamic peoples by showing them in a vulgar and demeaning light."[7] A consideration of the complex entanglement of indigenous photography in both local cultural practices and European aesthetic conventions generates a more nuanced understanding of the politics of representation in the Middle East that renders the postcolonial notions of center/periphery and power/resistance problematic.

The Missing Archive

During one of my research trips to Iran, my mother, who had been following my research interest in "old" photographs of Iran with skeptical curiosity, gave me several boxes of dry gelatin glass plates and a few original prints dating back to the early twentieth century. The plates and the photographs, which she had kept in an old chest in our basement since her family's home in the city of Sabzevar had been demolished to build a new apartment building, belonged to my grandfather, who, she told me, was one of the first people in our provincial hometown to take amateur photographs of his family and friends. Although I knew my grandfather was a *mota-jaded*, a nontraditionalist and forward-looking man, no one in my family had ever mentioned to me that he had dabbled in photography when he was younger; nor had I learned of the early appearance of amateur photography in small Iranian provincial towns such as my own. My mother later shared with me that my grandfather, who had learned photography from a teacher from Azerbaijan, had taken many photographs of my grandmother, a highly religious woman, without the *hijab*, but somehow the family had no traces of these images, even though my mother was certain that they had at one time existed. One photograph my mother clearly remembered showed my grandmother posing in a cutout cardboard in the shape of a car, pretending to be driving. After an artist friend developed positive prints from the glass negatives when I returned to the United States, I was struck by the absence of images of my grandmother, and, indeed, of any female family member in my grandfather's

4.1 Mahmood Oskoui, family photograph (ca. 1920s). Glass negative. Author's private collection.

collection. All the photographs featured my grandfather himself or other men, likely family members and friends, though most could not be identified by the various relatives of mine I consulted for clues. It seemed, then, that a concerted effort had been made to remove all images of women from the family collection. In fact, not only were there no traces of photographs of my grandmother, but a plate in which she may have appeared next to her children had been scratched out to remove any traces of the subject originally depicted in the image (figure 4.1).

I will return to some of these images, but I begin my discussion of vernacular photography in Iran with this personal anecdote because it illustrates some of the common predicaments of studying local traditions of photography in the Middle East—even if one is fortunate enough to gain access to photographs in the first place. To begin, most indigenous archives in the region, especially those held by nonelites or otherwise unofficially, are generally inaccessible or have been destroyed altogether. Some materials, like my grandfather's, have been kept in basements or other storage areas under conditions that have seriously compromised the quality of prints and glass negatives. And, as the elimination of images of women in my

grandfather's collection demonstrates, in other cases the materials have been altered or destroyed for personal, political, religious, and even economic reasons. In Iran, during both the Constitutional Revolution of 1905–7 and in 1925 when Reza Shah assumed monarchical power, most of the glass plates in the Golestan Palace archive were destroyed because they were viewed as symbols of the Qajar dynasty's cultural decadence. There are even stories told of people washing off glass-plate negatives from late nineteenth-century collections during the civil war in Lebanon and using them to replace broken windows! That a collector could amass such a large archive of Ottoman photography by roaming around the bazaars of Istanbul in the 1960s and 1970s, as Gigord did, is a particularly striking testament to the general neglect of early photography in the region.

Even when photographic collections or archives have been recovered by researchers and collectors, undated and often unidentified as they are, the photographs generally remain difficult to situate, offering at best fragmentary traces of the history of the society or culture to which they belong. The catalogues of the Gigord Collection at the Getty Research Institute and the collection of Sevruguin's work at the Sackler Gallery Archives, for example, contain numerous inconsistencies and some misinformation.[8] Few materials have been archived at all, and those images that have been preserved offer only highly selective representations of Middle Eastern societies. Moreover, although people of middle- and lower-class backgrounds were often photographed by resident and foreign photographers as early as the 1860s, they had no access to photographic tools to represent themselves until well into the second half of the twentieth century.

Attentive to these absences and predicaments, in what follows I first offer a brief history of the introduction of photography in Iran, and then provide a few examples of local photographic practices by way of considering the cultural and political dimensions of the rise of indigenous photography in the country. The visual archive of early Iranian photography offers a rich case study through which to substantiate my larger argument. While offering a closer examination of a particular national context in this and the following chapter, I wish to suggest that the Iranian case reveals dynamics with broader implications. In many instances my observations resonate powerfully with those of other scholars working with materials drawn from different countries and contexts. However, the conspicuous absence of attention to the Iranian archive demands address not only by way of affirming existing analyses but also because these materials have the potential to productively complicate them. In particular, consideration of the history of photography in Iran throws into stark relief the falsity of the polarized assumptions running through postcolonial commentary on nineteenth-century photography in the Middle East.

A Brief History of Photography in Iran

The history of photography in Iran dates back to the very beginning of its invention and is deeply embedded in the broader history of Europe's unofficial or indirect colonial involvement in the country.[9] Soon after daguerreotype photography was introduced to Europe in 1839, Queen Victoria and Emperor Nicholas I of Russia each made a gift to Mohammad Shah of the apparatus so that he could produce his own pictures. Although written instructions were provided to the Iranian court, it was not until the French educator Jules Richard came to Iran in 1844 that the novel technology was first put to use.[10] Besides Richard, many other European photographers worked in Iran in the mid-nineteenth century, including Luigi Pesce, Luigi Montabone, and Henri de Couliboeuf de Blocqueville. These European photographers were in one way or another associated with Western colonial powers. The Italian Pesce, for example, was an officer brought by the British to create a military school across from Dar al-Funun (the first Iranian polytechnic) so as to establish and reinforce Britain's political and cultural power in Iran. Montabone photographed Iranian monuments and royalty in 1862 as one of the sixteen members of an Italian delegation sent to bolster Italy's economic and political power in Iran.[11] Similarly, Blocqueville came to Iran in the late 1850s and took photographs as part of the French military mission to the country, which like its Italian counterpart was competing with other European powers, such as England, Russia, and Austria, to gain economic and political advantages in the country. Even Sevruguin, who was an independent and resident professional photographer, maintained a direct connection with the Russian embassy where his father had worked.[12]

And while hesitant at first, the Qajar royalty soon took up the art with a passion. As a result, photography quickly gained popularity among wealthy Iranians, both as an enjoyable pastime and as an invaluable tool of social documentation and self-fashioning. Like their Ottoman counterparts, the Qajar royalty appreciated the camera both in its honorific function as a tool to produce images of themselves and their subjects and in its repressive function as a means to consolidate despotic power. Photography was deployed both to provide for the ceremonial presentation of royalty and to typologize and survey rural and lower classes. Contrary to the Orientalist claims made by some art historians and archivists that the Islamic prohibition against iconic images prevented Middle Easterners from taking photographs in the nineteenth century,[13] photography also quickly became quite popular among upper-class Iranians, who embraced the new medium to fashion a modern(ized) sense of identity. As a result, there is an indigenous tradition of photography in Iran—a tradition that, though enmeshed in local culture and politics, is profoundly indebted to European aesthetic forms and ideological assumptions.

The Qajar prince Ghasem Mirza and Nasir al-Din Shah began taking photographs soon after the British queen and the Russian czar gave Mohammad Shah the daguerreotype apparatuses. Ghasem Mirza, a Francophile who studied in France and later became an associate of the French Orientalist institution Société Asiatique, was the first Iranian to use both the daguerreotype and collodion methods of photography. Professional court photographers such as Agha Reza Khan and Manuchehr Khan were also sent abroad to Vienna to refine their techniques of photography and learn about new methods of photographic processes. The first major photographer of Iran, however, was Nasir al-Din Shah himself, who learned photography from Richard at the age of thirteen when he was the crown prince at the palace of his father, Mohammad Shah. This early introduction led him to passionately pursue the practice of photography when he became king in 1848. While becoming an amateur photographer himself, Nasir al-Din Shah employed both foreign and indigenous photographers to create a vast archive of his dynastic rule. Recognizing the function of photography as a tool of reportage and documentation, Nasir al-Din Shah sent court photographers across the country to photograph historical monuments and the rural communities' practices of everyday life, and to document all his journeys at home and abroad. When Amin al-Dowleh, his prime minister, was in Europe on a diplomatic mission, the shah asked him to hire a professional photographer to introduce Iranians to new techniques of photography. Amin al-Dowleh subsequently hired the little-known Francis Carlhian[14] and brought him to Iran in 1859. Carlhian established the photographic link by teaching and training Iranians and by selling photographic equipment to them. He taught the more advanced methods of photography such as collodion to Nasir al-Din Shah, enabling the young king to pursue his interest in taking photos and developing them. The shah himself trained a boy, Gholam Hossein Khan, as his personal photography assistant to help him take private pictures of himself and his harem. Nasir al-Din Shah's contribution to the development of photography culminated in his establishment of a photographic institute, Akas Khaneh-e Mobarak-e Homauni, in one of the Golestan Palace's buildings. He had Carlhian train two palace attendants, Mirza Hossein Ali and Agha Reza Khan, in new methods of photography in order to run the new institute.[15] In addition, by order of the shah, a new department of photography was created at Dar al-Funun after the arrival of Carlhian, catering mostly to government business. Nasir al-Din Shah's contribution to the development of photography also included the publication of several photography manuals to provide Iranians with technical knowledge about the new medium. The first such manual, *Ketab-e Aks* (Photography Book), written by Mirza Kazem by order of the shah, dates back to 1864.[16]

From this point on, a large archive of photography was built as the court's own and commissioned photographers documented every official event, royal trip (figure

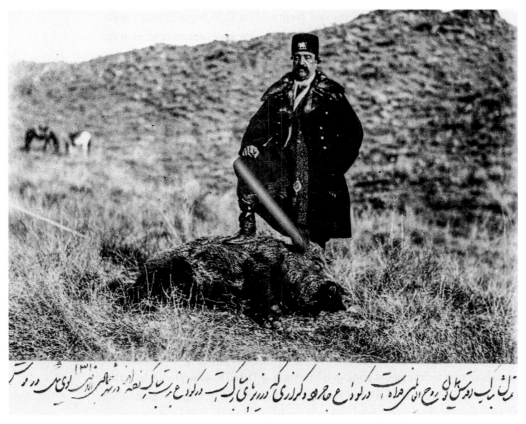

ریل بلب اوستل لی روح انی طبی دراء آست در کو دیع جاده و کزاری کی ازری بای کرست در کو دیع بر بناک ده در نظهم نظامی از انس لوی بی در و سم

4.2 Anon., Nasir al-Din Shah on a hunting trip (ca. 1880s). Albumen print. Golestan Palace Photographic Archive.

4.2), military campaign, significant royal and religious figure (figure 4.3), and histori-
cal monument (figure 4.4). The establishment of two centers of photography, one at
the court and the other at Dar al-Funun, allowed the shah to use photography as a
form of official reportage and a means of recording his rule. Nasir al-Din Shah em-
ployed court and commissioned photographers to visually document not only his
own royal trips and military campaigns but also ethnographic types, religious leaders
and court officials, political prisoners and common criminals, and historical events
and religious ceremonies. In addition, the shah was the recipient of many photo-
graphs and albums from foreign travelers as well as local amateur and professional
photographers. Inspired by the shah's interest in the new medium and fascinated
by the camera's ability to produce verisimilar images of people and places, the elite
classes took up photography not only as a pleasurable pastime but also as a means
to gain some influence at the court. The large number of photographs and albums
dedicated to the shah at the Golestan Palace's photographic archives suggests that

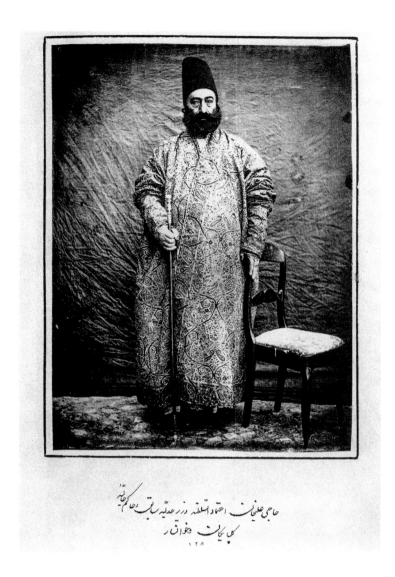

حاجی علی خان اعتماد السلطنه در زمره چهل تن سابق بالا کنم قطبیه
کلی یکان و خوان ر
١٢٨

4.3 Agha Reza Khan, Ali
Khan Etemad al-Saltaneh
(1865). Albumen print.
Golestan Palace
Photographic Archive.

photography became for both Europeans and Iranians a useful tool to become closer
to the shah and to acquire favors from the court. In addition, it is worth noting that
the first public photographic studio was established in 1868 by Abbas Ali Beyg under
the direction of Eghbal al-Saltaneh, Iran's first commercial photographer, a fact that
suggests the notable popularity of the photographic enterprise among Iranians since
it was first introduced. A review of images from this archive may serve as a case
study, then, in elaborating the broader cultural politics of local photography in the
Middle East.

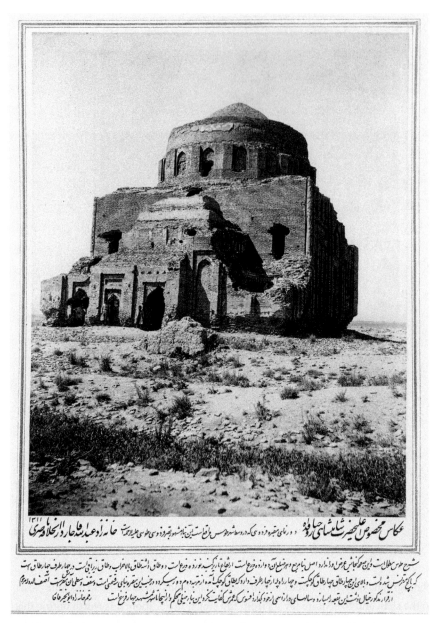

4.4 Abdullah Qajar, Haronieh tomb in Tous (1893). Albumen print. Golestan Palace Photographic Archive.

Orientalist Transculturation

From the very beginning, the art and technology of photography in Iran maintained an intimate relation with Orientalist knowledge and aesthetics. This is not a coincidence, for not only were most early photographers of Iran, such as Ghasem Mirza, Agha Reza Khan, and Abdullah Qajar, trained in Europe or by Europeans in Iran, but some of them also belonged to Orientalist institutions abroad. Fascinated by Western technological advances and enamored of European visual culture, Nasir al-Din Shah himself traveled three times to Europe, where he attended colonial expositions, was photographed by European commercial photographers such as William and Daniel Downey in London and Charles Jacotin in Paris, and purchased several cameras.[17] Through such exposures, early Iranian photography was greatly influenced by Orientalist representational and formal tropes, producing a visible rehashing of certain stereotypical views of the people and cultures of "the Orient."

In claiming that early Iranian photographers were in close dialogue with Orientalism as a style of representation, I do not mean to suggest that they were mere imitators of European artistic conventions. Rather, Iranian photography "grafted" certain visual and literary tropes from Orientalism, a process that often changed the meaning and connotation, not to mention the application and function, of these tropes.[18] In other words, the notion of mimesis, if understood as the imitation of an original European model, is inadequate to account for the influence of Orientalism on local photography because there is no evidence of a direct transposition of Orientalist iconography. The notion of "grafting," however, is more useful in understanding the intertextual and intervisual connections between Qajar and European representations, in that photographers' uses of Orientalist conventions often entailed a kind of transculturation to make their images desirable, legible, and useful for a local audience.[19] In this way, early Iranian erotic photography, for example, differs from its Ottoman counterpart in that professional photography studios of the Ottoman era followed more closely the European conventions of harem representation, in light of the fact that they mostly catered to European tourists.

Although there are thematic differences and aesthetic variations that distinguish early Iranian photography from Orientalist photography, there are nonetheless representational continuities between these two archives. Nowhere is the interpellation of indigenous photography by Orientalism more evident than in local Iranian photographers' representations of women. Consider the following images from a private collection I viewed several years ago in the home of a prominent collector and art historian in Tehran who wished to remain anonymous (figures 4.5 and 4.6). The photographs in this collection, dating to the last decade of the nineteenth century or the first decade of the twentieth, appear to have been produced locally for an Iranian

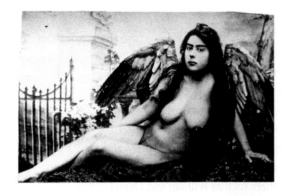

4.5 Anon., nude woman (ca. 1900s). Silver gelatin print. Private collection.

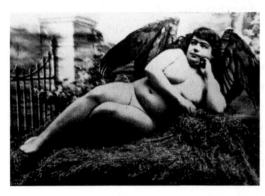

4.6 Anon., nude woman (ca. 1900s). Silver gelatin print. Private collection.

audience. As depictions of houris, the beautiful maidens that in Muslim belief live with the blessed in paradise, these photographs are on the surface somewhat different from European representations of "Oriental" women in which the phantasm of the harem, with its lure of unlimited pleasure and forbidden eroticism, is invoked to indulge the male viewer's fantasy. The European backdrops and furniture in the photographs and the wings of the female sitters clearly distinguish this from a typical harem scene presented by European and resident photographers of the late nineteenth century, including Sébah & Joaillier in Istanbul and Alary & Geiser in Algiers, in which women appear bejeweled and elaborately dressed in exotic costumes with the usual props of *narghili*, musical instruments, and coffee trays. As examples of local pornographic photography produced by and for Iranians, far from being purely mimetic of the European odalisque tradition, they represent a male Muslim Iranian fantasy of paradise populated with houris whose androgynous appearance and dark complexions speak to a distinctly indigenous standard of female beauty.

And yet these photographs cannot be fully differentiated from Orientalist representations of women either, as they are clearly in dialogue with European aesthetic conventions, both materially and formalistically. I say *materially* because what en-

abled their very production and existence is a European medium, as well as European techniques and means of representation, and *formalistically* because they engage in a tradition of male voyeuristic iconography that was imported to the country by Europeans and the semicolonial influences of England, France, and Russia. In these photographs, the women's reclining poses and their exposed bodies on divan-shaped chairs in front of European backdrops gesture toward a form of photographic grafting that borrows from European conventions to produce local pornographic images. The use of backdrops that depict natural settings associated with European landscape painting is significant in this regard in that they function as a kind of "supplement" in which, as Appadurai has it, "we can read the tensions and contradictions that accompany the dissemination of photographic practice in space and time." Put otherwise, the backdrops and other props in these photographs, which imply romance and conjugality in European iconography, are used here to signify the idyllic geography of paradise to help the depiction of the model posing in front of it as houris. As such, the props and backdrops in these photographs do not "allow for the documentary claims of photography to be resisted or suspended" as Appadurai claims,[20] but help to produce a male and pornographic fantasy of what lies ahead for pious men in paradise, all the while satisfying their voyeuristic desires in this world. In this regard, it is significant that, as was typical of nineteenth-century European erotic painting and photography, men are absent in these photographs, while women, prepared and adorned, and yet exposed and vulnerable, are made available for voyeuristic pleasure. As in nineteenth-century pornographic representations, the passive poses of women and their diffident and melancholic gaze in these locally produced images speak to the male expectation and fantasy of women as desirable objects to be looked at and possessed.

Understandably from an art-historical perspective, a counterargument could be made that these images are in dialogue not with European pornographic or Orientalist erotic representations but with the rich tradition of miniature nude painting in Iran, which dates back to the sixteenth century. Early photographers in Iran may indeed have been familiar with this tradition. However, given the fact that in miniature erotic painting there is an overwhelming tendency to represent androgynous-looking lovers, and not individual women in erotic poses, one is inclined to view these photographs in the context of their interpellation by European nude painting and photography.[21] Though meant as depictions of houris, these images recall, for example, the tradition of Victorian nude fairy painting by such artists as Richard Dadd, John Anster Fitzgerald, and John Simmons, not miniature paintings from the Safavid period or even Qajar female nude painting, in which there are no representations of fairies or angels, and in which nude women are generally accompanied by lovers. Thus, it would seem that just as the backdrops in these photographs were imported

from Europe, the subject matter and the modes of representation hailed from there as well. We do know that representations of fairies and angels were popular throughout the nineteenth century in England because nude female fairies were more acceptable to the Victorians than nude women, albeit the only material difference was the addition of wings.[22] Nonetheless, my argument here is not that these images are entirely mimetic of this European painterly tradition, for they splice this European tradition in a way that changes, and perhaps one might even say indigenizes, its meaning and connotation, in this case producing a fanciful representation of Islamic paradise for a local male audience.[23]

Parisa Damandan's private collection of vernacular photography from Isfahan contains many photographs of prostitutes in reclining nude poses, images that further confirm the mediated nature of the representations of women in Iran. In most of these photographs, women costumed in Western clothes pose seductively in front of European backdrops (figures 4.7 and 4.8). The unabashed gazes and direct eye contact of the women in these images confer upon them a sense of agency, even as they are positioned in the objectified role of prostitutes. Such representations of women speak both to a modern ethos of women's liberation associated with Western women and to an indigenous male form of voyeurism that, while taking pleasure in viewing erotic images of women, associates westernized Iranian women with moral corruption. In this way, these Occidentalist representations reaffirm an archetypal view of women in which westernized femininity is associated with erotic desire and moral decline, and the photographically unrepresented traditional women with dignity, piety, and respect.[24] The representation of women, or lack thereof, in Iranian vernacular photography evinces a divided consciousness in which desire and piety, modernity and tradition remain irreconcilable, evident on the one hand in the absence and erasure of virtuous wives and respectable daughters in local photographic representation, and on the other in the plethora of tirelessly repeated voyeuristic images of indecent, albeit desired, westernized women.

The practice of grafting in vernacular photography in Iran is not limited to erotic representations of women but also marks the way men represented themselves and their families. Though the Qajar royalty produced numerous albums chronicling their personal and political lives, it was not until the 1920s that the middle and upper-middle classes began to create family albums as a means of self-representation as modern subjects and as privileged status symbols to distinguish themselves from the lower and working classes.[25] Like their Arab and Ottoman counterparts during the late Ottoman and early Mandate periods, middle- and upper-middle-class men took advantage of photography to project an image of modernity and progress during the late Qajar and early Pahlavi periods, thus distinguishing themselves from the "backward" subaltern classes.[26] However, unlike their Arab and Ottoman counterparts,

4.7 Mirza Mehdi Khan Chehreh-Nama, prostitute (ca. 1920s–30s). Glass negative. Private collection.

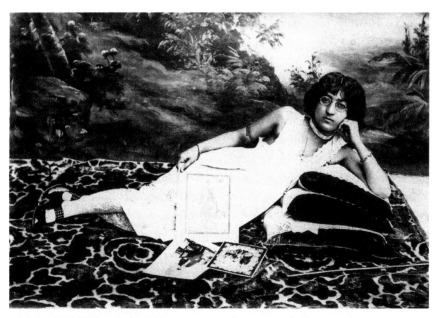

4.8 Mirza Mehdi Khan Chehreh-Nama, prostitute (ca. 1920s–30s). Glass negative. Private collection.

they generally excluded their wives and daughters from their visual iconography of modernity and progress. Symbolically absent though Iranian middle- and upper-middle-class men are in erotic photography, they are massively overrepresented in family albums, even as women are either marginalized or entirely absent. With the exception of Armenian, and perhaps Jewish, communities, most Iranians tended to keep their wives and daughters away from the gaze of the camera in the name of religious piety. Indeed, Iranian men zealously embraced the idea of *namus*, roughly translated as honor or dignified respectability, which entailed a complex ethical and patriarchal system of values that demanded that men "defend" their *namus* by shielding their wives and adult daughters from the gaze of other men.[27] Thus, while forbidding their wives and adult daughters to be photographed, upper-class men themselves often frequented professional studios to be photographed in honorific poses. It is telling in this regard that with the exception of just one image, which appears to be that of a foreigner, there is not a single photograph of a woman in my grandfather's entire collection.[28] Men, however, appear in individual and group portraits, often in serious poses to convey a sense of piety and grandeur, modernity, and social progress (figures 4.9 and 4.10). Instead of sitting on traditional Persian rugs as was the tradition at the time, the men almost always sit on chairs and pose with such symbols of modernity as clocks, guns, binoculars, bicycles, and cars. As in the European tradition of photographic portraiture, my grandfather's photographs speak to the dialectics of the inner and the outer, the individual and the community, the psychological and the social. In one example, my grandfather's serious expression, his rigid pose, calm demeanor, and somber expression convey his piety as much as they represent his social status as a respected merchant (figure 4.11). "The portrait," John Tagg has argued, is "a sign whose purpose is both the description of an individual and the inscription of social identity." At the same time, Tagg posits, "it is also a commodity, a luxury, an adornment, ownership of which itself confers status."[29] That my grandfather is sitting on a chair instead of a carpet, and that he is dressed in a European style of suit and hat posing in front of a white sheet that blocks out any trace of his domestic surroundings or external references, suggests a desire for self-fashioning as a modern figure. Photographic representation offered middle-class men in Iran the means to conjure an image of modern subjectivity. In the absence of any reference to his social and familial contexts, the figure appears as an iconic presence foregrounding individualism, enlightenment, and progress, values associated with the West. Whereas westernized women are considered morally lacking, the adoption of Western clothing for men is a sign of social status and privilege. Although my grandfather's adoption of Western practices of dressing and self-representation should not be viewed as a passive form of imitation, for he intentionally aimed to represent himself as *motajaded* (forward-looking and nontraditional), it nonetheless indicates how

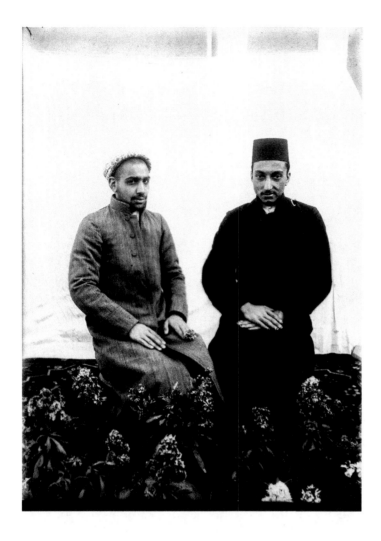

4.9 Mahmood Oskoui, family portrait (ca. 1920s). Glass negative. Author's private collection.

such indigenous representations of the self emulated European notions through signifiers of modernity and progress.

Emulations of Western modernity are most evident in the awkward inclusion of objects such as clocks, binoculars, and European furniture in portrait and family photography. Other images from my grandfather's collection provide examples of how such signifiers of progress were included in individual and group portraiture to highlight the social class and enlightened subjectivity of men in Iran (figures 4.12, 4.13, and 4.14).[30] These items in photographic representations of middle- and upper-middle-class Iranians are as much an ideological statement about the higher social class of the photographed subjects as they are signifiers of Western modernity to underscore their enlightened mentality (*tajadod*) of the sitters. The clock in the first

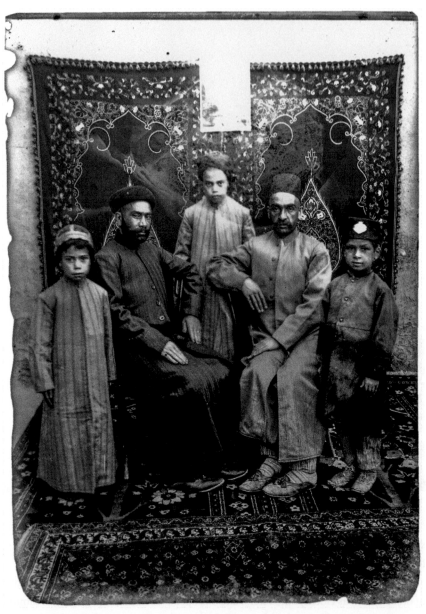

4.10 Mahmood Oskoui, family portrait (ca. 1920s). Glass negative. Author's private collection.

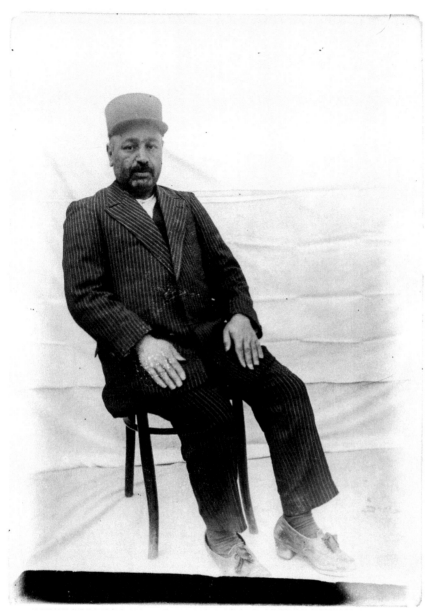

4.11 Mahmood Oskoui, self-portrait (ca. 1940s). Glass negative. Author's private collection.

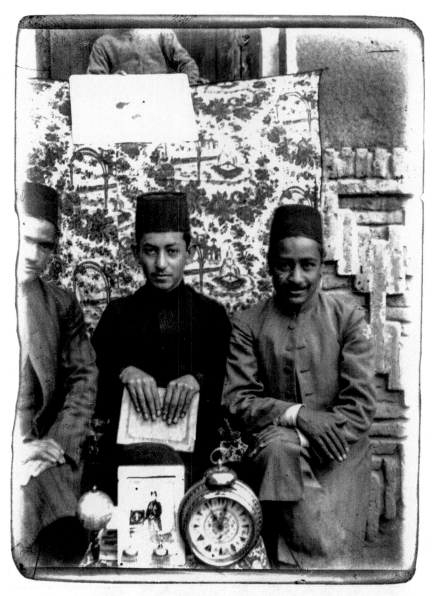

4.12 Mahmood Oskoui, photographer with family or friends (ca. 1920s). Glass negative. Author's private collection.

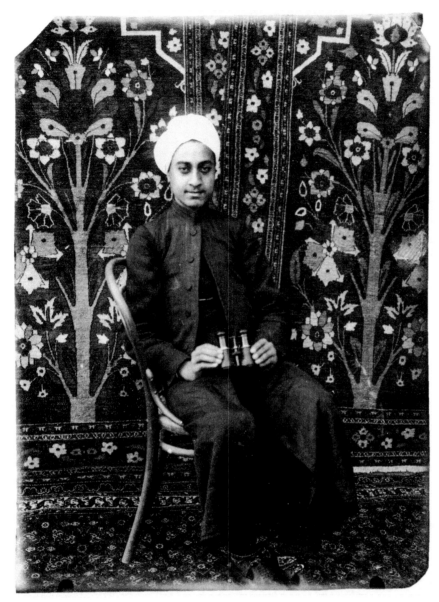

4.13 Mahmood Oskoui, photographer's cousin posing with binoculars (ca. 1920s). Glass negative. Author's private collection.

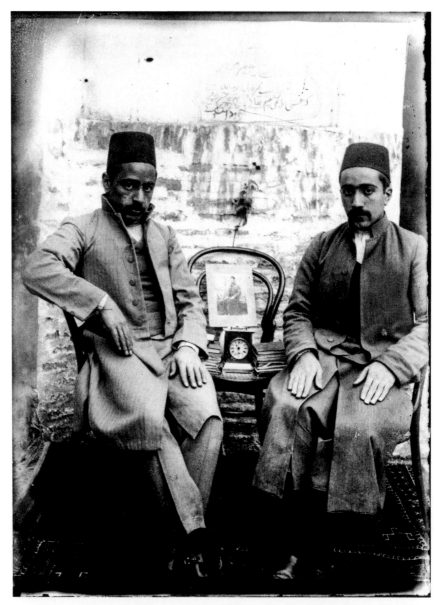

4.14 Mahmood Oskoui, photographer and a cousin (ca. 1920s). Glass negative.
Author's private collection.

and third photographs and the binoculars in the second demonstrate the sitters' access to these markers of progress, highlighting their high social status and modern subjectivity. In these images, the sitters presumably seek to distinguish themselves from subaltern classes by literally displaying their access not only to emblems of modernity but also to the very means of photographic self-representation, as is demonstrated by the inclusion of a previously taken photograph in this one. The photograph as a material object is itself significant as a signifier of privilege. Indeed, the presence of the photograph in the photograph underscores the sitter's understanding of the photographic image as a luxury object the possession of which confers social status.

As examples of photographic grafting, these images do not merely mimic Western iconography; the handwritten text and the Persian carpets in these photographs are contextual references that mark them as Iranian. Like their Arab counterparts, middle- and upper-middle-class Iranians hoped to fashion an indigenous form of modernity—one that was more pious and rooted in local traditions than its European version. However, the prominence of the clock in the middle of the first and third photographs and of the binoculars in the second foregrounds the centrality of the West in representations of bourgeois subjectivity and the hierarchy of taste in Iran. While the European clock links the sitters with Western temporality, the binoculars associate the sitter with Western technologies of visibility and surveillance. Furthermore, the awkward inclusion of these objects does not only appear to be an intentional effort to provide for the honorific presentation of the sitters' modern and forward-looking subjectivity. As idealized images of self, these photographs also marginalize the traditional and the communal, focusing instead on signifiers of capitalist modernity to represent their sitters.

While Iranian men projected a notion of enlightened subjectivity onto photographic portraiture, they nonetheless espoused traditional values as fathers and patriarchs. Early Iranian family portraits provide ample instances of how photography was used to reaffirm traditional gender roles that disempowered women. Unlike family portraits in Lebanon and Ottoman Turkey from the same period, which "animated the internalization of the vision of the earliest proponents for the emancipation and education of . . . women," as Sheehi has thoughtfully demonstrated,[31] women are generally excluded in Iranian family portraits. Consider three family portraits from my grandfather's and Damandan's collections (figures 4.15, 4.16, and 4.17). In all of these photographs, fathers and patriarchs are symbolically positioned in the center, often seated on a chair to highlight their privileged role as head of household. Next to them are the oldest sons, a placement that marks their secondary position in the family hierarchy. The general absence of mothers and older daughters in these photographs underscores women's and girls' marginalized roles within the

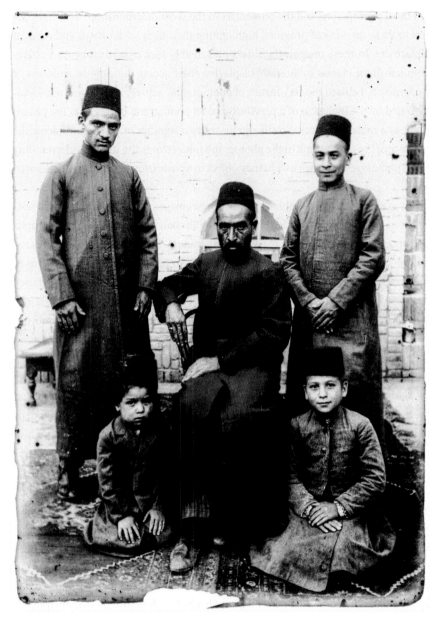

4.15 Mahmood Oskoui, portrait of photographer's uncle and family or friends (ca. 1920s). Glass negative. Author's private collection.

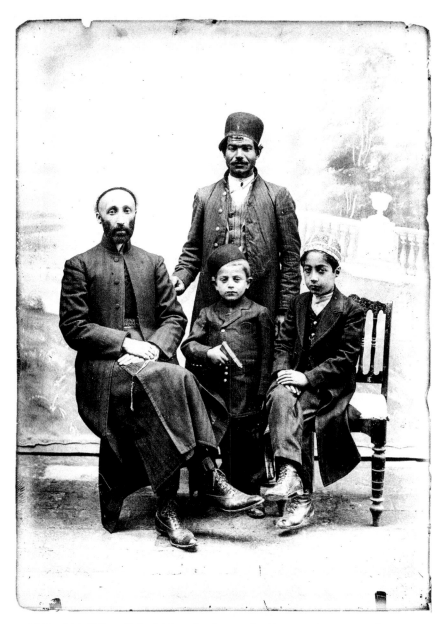

4.16 Mirza Mehdi Khan Chehreh-Nama, family portrait with servant (ca. 1920s–30s).
Glass negative. Private collection.

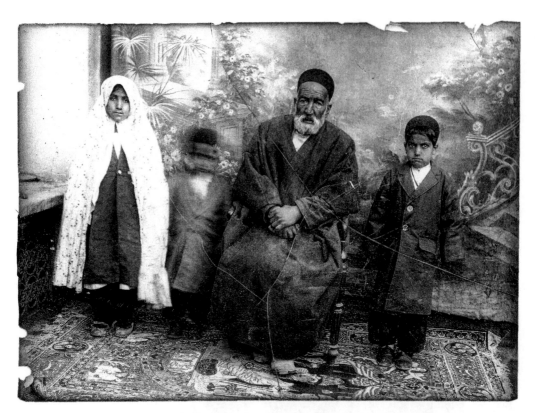

4.17 Minas Patkerhanian Mackertich, family portrait (ca. 1920s). Glass negative. Private collection.

family structure, an absence that also attests to a notion of male honor (*namus*) that guards against the public exposure of respectable and virtuous female family members. When young daughters do appear, as in the last photograph, they are carefully positioned farthest from the head of the household. These photographs illustrate, then, that the adoption of photography by Iranians was neither a passive act nor a sign of transition from tradition to modernity (from *sonnat* to *tajadod*). Rather, it can be characterized as a deliberate attempt to use the new medium to represent and reaffirm one's social status and consciously enduring embrace of traditional cultural values. Photography was not merely an inscription or representation of a social identity, but in fact was productive of it. Both as a material object and as a means of representation, the photograph helps construct the modern middle-class subject.

The adoption of photography by middle- and upper-middle-class Iranians as a tool to project an enlightened form of subjectivity also entailed what I call photoexoticism, a mode of representation that reduced people of the lower classes to less civilized types. The construction of a modern identity required a differential "other"

against whom the native elite could distinguish themselves. To fashion an enlightened self, the local bourgeoisie sought to present a contrast between themselves as civilized citizens and lower classes and rural communities as backward others. In this sense, the emergence of photography in late nineteenth-century Iran did not liberalize the economy of visual representation, as one might have expected, but rather enabled a representational system that preserved class and gender hierarchies. In an era in which photography was an exceedingly costly endeavor, it is remarkable how Iranian indigenous photographers, like their Ottoman counterparts, produced so many exotic images of people, their colorful costumes, and their timeless characteristics. As early as the 1860s, for example, Nasir al-Din Shah and his court photographers took pictures of opium addicts, gamblers, eunuchs, and snake charmers. That late Qajar-era Iran was not as significant a European tourist destination as were Istanbul, Cairo, and the Holy Land suggests that these images were produced primarily for local consumption. The appearance of these images in several albums in the Golestan Palace's photographic archives bolsters this contention.

The photograph of snake charmers by Mohammad Hassan Khan Qajar and that of a Mazanadrani porter with his cow (probably taken by Agha Reza Khan) offer two examples of a local form of photo-exoticism (figures 4.18 and 4.19). Compositionally speaking, these photographs are intervisually linked to the European genre of *scènes et types*, in which professional studio and traveling photographers produced innumerable stock images of "exotic natives" practicing their "strange" or "primitive" lifestyles. As a colonialist photographic practice, the European genre of *scènes et types* took advantage of the indexical quality of photography to generalize ethnic, professional, and religious types.[32] Like their European precursors, these locally produced photographs not only exude a fascination for the strange and an attraction to the picturesque but also speak to a desire to categorize people and professions. Although both pictures are accompanied by written descriptions of what they portray, their aim is not to contextualize the people or their activities but to "typicalize" their subjects and to provide the viewer with glimpses of primitive or backward types. In the first photograph, for example, the poorly placed, painted backdrop of what appears to be a palace setting, which was normally used in European studio photography to imply social status, not only makes the image uncannily awkward but also utterly decontextualizes the snake charmers, making them appear even stranger and more out of place than they would have been had they been photographed against the covered adobe wall. This photograph engages in a local form of exoticism as it reproduces and thus perpetuates the cliché image of snake charming prevalent among Orientalist genre painters and photographers in the nineteenth century. Neither reflexive nor ironic, it demonstrates all the shortcomings of the *scènes et types* genre, namely, the illusion of realism, the paucity of subjects, social typing, the othering of individuals,

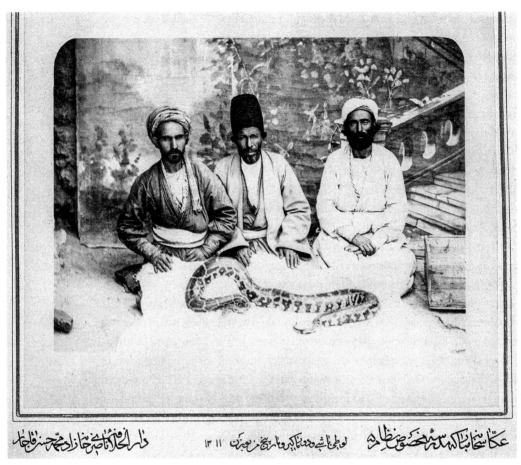

<div dir="rtl">عکاسخانه ی مبارکه ی مخصوص نظام یوطبانشی وندشنا کر وما پنجم میرزن ۱۳۱۱ دار الخلافه ی ناصری خانزاد محمد حسن قاجار</div>

4.18 Mohammad Hassan Khan Qajar, snake charmer with his assistants (1893). Albumen print. Golestan Palace Photographic Archive.

and romantic voyeurism. That a Qajar prince working for the photographic studio of a military school produced this image, as the handwritten text below the photograph indicates, points as well to its disciplinary function of surveying and documenting the lower classes. As such, the image aims "to establish and delimit the terrain of the *other*, to define both the *generalized look*—the typology—and the *contingent instance* of deviance and social pathology," to use Allan Sekula's words.[33]

The second photograph, of the Mazandarani porter with his cow, though less exoticist and more romantic than the first, reflects an indigenous form of the picturesque as well as a positivistic will to categorize. With the advent of modernity in the late nineteenth century in Iran, the local elite, like the bourgeois leisurely travelers in Europe, came to regard the rural life of the country nostalgically and endeavored to

capture its "primitive" beauty in their photographs. The second photograph is an exemplary case of the indigenous elite embracing the genre of the picturesque, while it also speaks to photographic surveillance by the government. Like European images of ethnic or provincial types, this image does not call attention to itself as a representation, positioning the viewer as the spectator of rural life. The obscure natural background foregrounds the porter as a quaintly "primitive" figure whose temporally distant way of life offers the possibility of nostalgic contemplation for the intended "modern" or "civilized" viewer. The explanatory caption below the picture further distances the viewer from the subject of the photograph by designating the person as a mere representative of an ethnic type (i.e., Mazandarani) and a professional category (i.e., porter).[34] In this way, the photograph serves to enable the classification of the population. Indeed, like their Ottoman counterparts, Qajar officials used the camera to enable them to survey and document their subjects. During their trips to various provinces of Iran, Nasir al-Din Shah and Mozaffar al-Din Shah were always accompanied by a court photographer who created a visual documentary of the places they visited.

Early local photographs of Iranian lower and rural classes were not only inter-

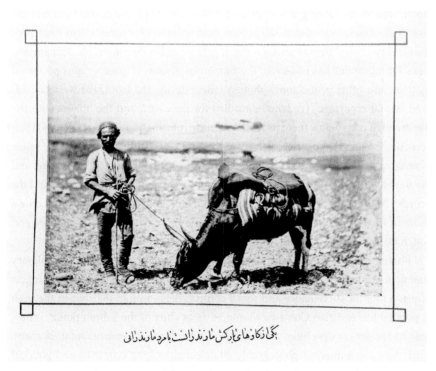

بگلۍ ذکاوِهاىُ اورکش مازندرانست بامره مازندرانی

4.19 Anon., Mazandarani porter with his cow (ca. 1890s). Silver gelatin print. Golestan Palace Photographic Archive.

visually linked to Orientalist representations of Middle Eastern cultures; they also were implicated in a hierarchical and repressive visual economy of power. The fact that local photographers in Iran could not resist the referential power of such exoticist iconography suggests that there is no outside to Western knowledge and vision of otherness in the nineteenth century. The intervisual indebtedness of local photography in Iran to European representations of the exotic suggests that Orientalism cannot be viewed as a unilateral artistic, intellectual, and political force, but instead must be recognized as a network system of representations that circulated between the West and the East and was adopted and embraced by Middle Easterners themselves, albeit in localized fashion. To project an enlightened self-image and to claim the discourse of progress, middle- and upper-class Iranian men thus assumed an exoticist view of lower classes and rural communities in need of the modern subject's civilizing mission.

At the same time, these images testify to the repressive function of photography in the Middle East. As in the context of Europe, photography provided a useful tool to royalty and state officials in the region for surveillance and documentation. Like his Ottoman counterpart, Abdülhamid, Nasir al-Din Shah sent professional photographers, such as Mohammad Hasan Khan Qajar, Abdullah Qajar, and Agha Reza Khan, who were working at the military school, the polytechnic institute, and the court's photography studio, to the provinces in order to photograph ethnic and professional types and thus to amass a visual archive of his dominion. As Mohammad Reza Tahmasbpour has observed, the numerous albums of photographs produced by these and other professional photographers during the late Qajar were considered "visual reportage" (*gozaresh-e tasviri*) for the court, and the images with the handwritten texts below them provided valuable information about people and their activities.[35] Viewed almost exclusively at the time in terms of its evidentiary value, photography was therefore bound up with practices of observation, recording, and documentation in late nineteenth-century and early twentieth-century Iran and the broader Middle East. Photography allowed the monarch and his court to become a modern *rooh al-alemin*, the all-knowing, divine representative who could see and watch his subjects throughout his dominion without actually being there.

Photography's use as a means of documentation also included a disciplinary function. For example, Nasir al-Din Shah and other Qajar officials used photography as a tool for surveillance and social control. Beginning in 1878, when the shah appointed the Austrian Conte de Monte Forte as chief of the Tehran police, criminals and prisoners were often photographed to be able to document and track them. That there are numerous photographs of dejected-looking criminals and political prisoners in the Golestan Palace's photographic archives indicates the common use of photography for disciplinary purposes by Qajar officials in the late nineteenth cen-

tury. In addition to their value as criminal records and means of identification, these photographs were often used to shame criminals and to intimidate the average citizen by exposing him or her to images of punishment. Photographs of criminals being punished or hanged in public were popularly used throughout the late Qajar era. For example, images of Nasir al-Din Shah's assassin, Mirza Reza Kermani, in shackles and hanging from the gallows were widely circulated in 1896 to remind the average citizen about the consequences of such criminal acts.

Beyond Manichaeism

"Where there is power," Foucault reminds us, "there is resistance, and yet, or rather consequently, this resistance is never in a position of exteriority in relation to power." The relational character of power, Foucault asserts, means that "there is no single locus of great Refusal, no soul of revolt, source of all rebellions, or pure law of the revolutionary," but instead "a multiplicity of points of resistance," some of which function as "support, or handle in power relations."[36] Foucault's observation about the relational character of power offers critical insight to complicate postcolonial critics' presumption of the Manichean structure of colonial modes of representation in terms of power and resistance. My case study of vernacular or indigenous photography in Iran has aimed to challenge the tendency among postcolonial scholars to view Orientalism as a unidirectional form of representation in which the European is the active subject and the "Oriental" is the passive object of representation. The early history of photography in Iran, and more broadly in the Middle East, demonstrates that it is possible to be both the subject and the agent of Orientalist representation. Put otherwise, indigenous forms of representation do not necessarily constitute a locus of opposition against colonial powers or resistance to European representations of the Middle East. Concerned with Saidian orthodoxy, which has privileged a dualistic relation between the "Occidental" as the agent of representation and the "Oriental" as the object of representation, art historians have drawn critical attention to indigenous forms of representation in order to argue for the need to decenter Orientalism not only as a discourse of power but also as a means of elaborating indigenous oppositional responses to European hegemony. Mary Roberts and Jill Beaulieu, for example, maintain that by focusing on indigenous representations "the univocality of the West is fractured into a plurality of voices with divergent and conflicting allegiances, and 'Orientals' are recognized as participants in the production of counternarratives or resistant images, rather than solely as mute objects of representations."[37] While the shift from a monolithic to a heterogeneous notion of Orientalism and a transition in focus from Western to non-Western representations are salutary, celebratory claims about the oppositional nature of indigenous repre-

sentation are problematic not only because such claims still rely on a dualistic model, albeit in a postcolonial fashion in which the other is endowed with oppositional agency, but also because they fail to account for the inequalities of power and access to representation that characterize non-Western cultures as in any other context. Indigenous representations, therefore, do not necessarily offer a resistant mode of representation. On the contrary, viewed more accurately in the historical context of their production and circulation in the nineteenth century, the elite classes in the Middle East with access to new technologies of representation and enamored of Western modernity fashioned local forms of Orientalism through which they exoticized rural communities and lower classes, while perpetuating traditional structures of power by deploying new technologies of representation. Although the late nineteenth- and early twentieth-century indigenous photographers in Iran and the broader Middle East were actively engaged in the politics of representation, what they represented and the manner in which they represented themselves and their society did not entail liberation from Western hegemony but constituted a local form of domination.

<div align="right">

5

</div>

Local Representations of Power

On Royal Portrait Photography in Iran

Is there an "other" history of photography in the Middle East? Was there
an autonomous tradition of photography in the region free of any Euro-
pean influence? Can photography of the Middle East be restored to its
own history? These important questions may arise in response to my
discussion of the intertwined history of nineteenth-century photogra-
phy of the Middle East and Orientalism's network of power relations
thus far. To the extent to which there is a sizable body of photographic
representations in the Middle East that were not directly impacted by
Orientalist discourse, including portraiture and family photographs,
it is crucial to attend to how photography was locally appropriated in
the region.[1] My discussion of how early practices of photography in the
Middle East were implicated in the visual and discursive culture of Ori-
entalism has not been intended to reduce photography in the region to
an ideological medium that simply perpetuated the Orientalist phan-
tasm.[2] Indeed, photography's history in the Middle East, like any other
history of photography in the non-Western world, should not be read re-
ductively through the logic of instrumentality nor be reduced to a mere
reflection of Orientalist ideology. And yet the acknowledgment that cer-
tain local photographic productions in the Middle East had their own

133

histories and that some of them stemmed from indigenous visual traditions in the region is hardly sufficient to establish the ideological autonomy of photography at the time. This chapter considers how a local photographic practice that was generally free of the ontological and epistemological distinctions on which Orientalism rests was equally implicated in relations of power. My discussion of royal portrait photography in Iran as a case study problematizes recent claims about the autonomous nature of local photographic practices in non-European contexts by demonstrating how Qajar-era photographs, though firmly rooted in local traditions of royal portraiture, also reflect European influences that are themselves rooted in ideologies of domination.[3] More particularly, I explore the ways in which the monarchical use of photographic portraiture in Qajar-era Iran was not merely a *tool* of statecraft but productive of power itself.[4]

The Tradition of Royal Portraiture in Iran

Royal portraits and other representations of the ruler have always played a crucial role in monarchical power in Iran.[5] Whether in the form of bas-reliefs during the Achaemenid and Sassanid dynasties, the royal representations of Safavid kings in the illustrated manuscripts of the period, or the more westernized portrait paintings of Qajar monarchs, Iranian rulers traditionally have relied on portraiture to represent and consolidate their power. The relationship between visual representations of the ruler and dynastic power, however, found its most distinctive articulation during the reign of Fath-Ali Shah of Qajar (1798–1834). During his reign, portrait paintings of the ruler became an integral part of statecraft as they were prominently displayed in the government buildings and other public spaces as manifestations of his supreme power.[6] In light of the long-standing relationship between royal portraiture and political power in Iran and its most prominent manifestation during the Qajar monarchy, it is not surprising that with the introduction of photography during the reign of his grandson Nasir al-Din Shah (1848–96), the photographic portrait should become the quintessential representation of monarchical power in Iran. A little-known painting (figure 5.1) offers a representative example of this shift in royal portraiture.

In this anonymous Qajar work, the court photographer, perhaps Agha Reza Khan, is photographing Nasir al-Din Shah, the first Iranian photographer and the patron of photography in Iran. The image, as an example of the tradition of royal portraiture in Iran, is meant to capture the dynastic power of the shah, a figure so grand he is simultaneously painted and photographed by court artists. As a "dynastic image,"[7] the painting focuses on the grandeur of the shah's power symbolically represented by his opulent regalia, his royal pose, and the attendant modern technology—he is at once the subject of the old and new forms of portraiture. This image

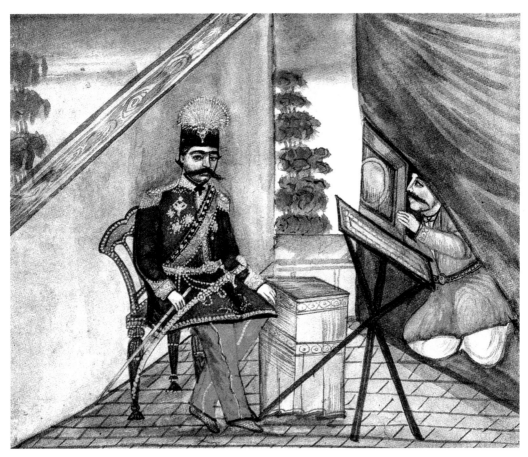

5.1 Anon., Nasir al-Din Shah posing for a photograph (ca. 1863). Watercolor. Private collection.

foregrounds the shift from painting to photography in portraiture during the mid-nineteenth century in Iran. While the court photographer himself occupies a marginal position in relation to the shah in the painting (he is symbolically kneeling and positioned behind the curtain), the proximity of the photographic apparatus to Nasir al-Din Shah suggests how the photographer has displaced the painter as the portrait artist. In this image, the camera is centrally located between the artist and his subject, suggesting the privileging of photography as the most powerful means of representation in Iran. The presence of the camera here is a reminder that during the reign of Nasir al-Din Shah the photographic image became the emblem of dynastic power.

Indeed, at the origin of photography in Iran is the royal portrait photograph, for photography provided late Qajar rulers with an efficient and easily reproducible means of representing their autocratic power to their subjects. Following in the footsteps of his grandfather Fath-Ali Shah, who had cultivated the tradition of por-

trait painting by encouraging and supporting new artists at his court, Nasir al-Din Shah successfully displaced that artistic tradition with photographic portraiture as he procured the means and conditions for the development of this new technology to consolidate his diminishing power during an era of British and Russian indirect colonialism in Iran.[8] As I discussed in the previous chapter, the Qajar royalty, and especially Nasir al-Din Shah and his sons Zell al-Sultan, the governor of Isfahan, and Mozaffar al-Din Shah, the governor of Tabriz and later his father's successor, appreciated the camera both in its honorific function, as a tool to produce images of themselves and their subjects, and in its repressive function, as a means to consolidate and display their dynastic power through photographic survey and documentation. While becoming an amateur photographer himself, Nasir al-Din Shah, for example, employed both foreign and resident photographers as early as the 1850s to create a large archive of his dynastic rule. Unlike his Ottoman counterpart, Sultan Abdülhamid, who assiduously avoided the camera's gaze, the Qajar king took advantage of every opportunity to be photographed.

In highlighting the shift from portrait painting to photography as a medium of representing power in the 1860s, the point is not that the emergence of photography in Iran coincided with the complete disappearance of portrait painting during the reign of Nasir al-Din Shah, for as the image discussed above reveals, even the "photographer king" had his image painted often. Nasir al-Din Shah was very interested in drawing and painting, and he supported a broad range of artists at his court, from painters and photographers to musicians and calligraphers. In addition, Iranian artists, who were trained in Western techniques of painting abroad or at Dar al-Funun (the polytechnic institute), were commissioned not only to produce academic portraits of the king, but also to provide illustrations for newspapers. Nor do I mean to suggest that the medium of photography ushered in an entirely new set of subjects, or of formal concerns, or an artistic grammar to represent monarchical power. Rather, my claim is that a general aesthetic and political transformation took place in the way the court represented itself—a representation that paralleled other photographic traditions in Europe since the mid-nineteenth century. Such a transformation in portraiture in Qajar-era Iran, though governed by new practices and techniques, nonetheless returned to and borrowed the themes and formal sensibilities of the previous modes of visual representation, especially portrait painting. And yet photographic portraiture was not a direct transposition of a local tradition of portrait painting either, for both photography's evidentiary quality and its reproducibility radically transformed the ways in which visual representations of power became an integral part of statecraft. Let us consider some examples of portrait photography to highlight some of its formal concerns and to elaborate the sociopolitical implications of the introduction of the new medium.

Early Photographic Representations of Monarchical Power

Although photographic portraiture was rooted in local pictorial traditions of representing the ruler in Iran, to the extent to which the earliest photographers of the Qajar court were either Europeans or local artists trained by Europeans, it nonetheless maintained a mimetic relationship to its European counterparts. In addition, diplomatic gifts in the form of photographs, albums, and cameras played an important role in linking representations of the monarch to their European counterparts.[9] Three early photographs of Nasir al-Din Shah, the first by an unknown photographer (possibly Pesce) (figure 5.2), the second by Montabone (figure 5.3), and the third by the shah himself (figure 5.4), provide representative examples of how local portraiture was not entirely autonomous but was also formalistically in dialogue with European portrait photography. In all three images, what is underscored compositionally is what one might call the cult of the individual. In the European tradition of early photography, as Inge Morath and Graham Clarke have suggested, the portrait photograph sought to present a verisimilar image of the individual, expressing his or her inner being by engaging in a form of character revelation.[10] As in European photographic portraits, these images of Nasir al-Din Shah involve a strong sense of interiority and play up his individuality without much, if any, reference to local history or the culture of the court. All three pictures depict the shah in European-style royal costumes and headdresses and with a serious and stern look.[11] In all the images, he is either leaning against or standing next to a chair, which, though a technical necessity in early photography due to slow shutter speeds and the long exposure time necessary to take a picture, nonetheless situates him within a European frame of reference. His erect posture, slight tilting of the head, and resting of an arm on his hip recall similar corporal expressions of nineteenth-century European photographic portraits of monarchs. In all these photographs, the shah stands alone, unaccompanied by court attendants or an entourage, in a setting that bears no resemblance to the opulent and bustling palace he inhabited. Even in the picture taken by himself, with the exception of a highly ornate chair, the nondescript backdrop covers his surroundings, literally decontextualizing him. As a result, these photographs occlude the communal, conflicted, and socially active culture of the Qajar court in which the shah was inscribed, instead engaging in an "ideology of the charismatic individual or celebrity," which, as Roger Cardinal has argued, defined the genre of early portrait photography in Europe.[12] What these portraits reveal, then, is the representation of a singular being whose physical appearance and facial expression are meant to convey a sense of his individuality. The seemingly confident posture of the king, the stern and somber gaze, and his elaborate costume and decorated sword align these early portrait photographs of the shah to a European model of portraiture in which the

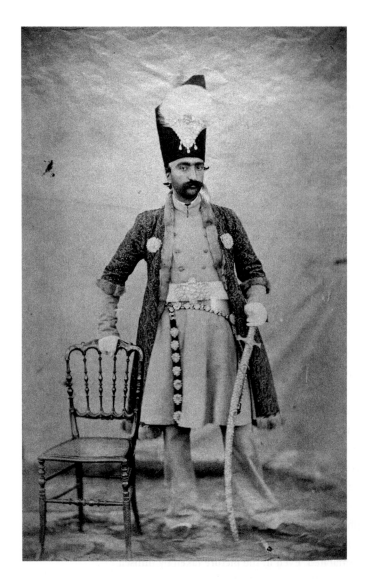

5.2 Anon. (likely Luigi Pesce), portrait of Nasir al-Din Shah (ca. 1850s). Salt print. The Metropolitan Museum of Art, New York, Gift of Charles Wilkinson, 1977.

cult of individual celebrity is valorized. The photographs, in sum, represent a generic image of an individual ruler.

These images also seem indebted to another European tradition, namely, amateur photography in mid-nineteenth-century France, which was advocated for and practiced by such photography proselytizers as Francis Wey, Henri de Lacretelle, and Victor Regnault.[13] Wary of the rapid proliferation of photographic portraits by professional studios, which Wey and others saw as detrimental to the artistic possibilities of photography, some mid-nineteenth-century artists such as Regnault en-

gaged in a form of photographic portraiture that avoided the elaborately detailed and explicit images produced by professional studios, instead privileging psychological depth and subtle aesthetic insights in their portraits. As Laurie Dahlberg points out, Regnault's photographs, for example, are marked by a private and intimate approach that is "unceremonious, off hand, and unaffected," images in which "accessories and props ... appear infrequently."[14] The portraits of the shah recall the amateur photo-

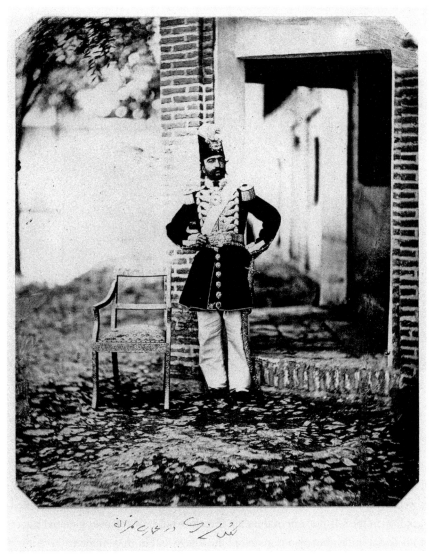

5.3 Luigi Montabone, portrait of Nasir al-Din Shah (1862). Albumen print. Golestan Palace Photographic Archive.

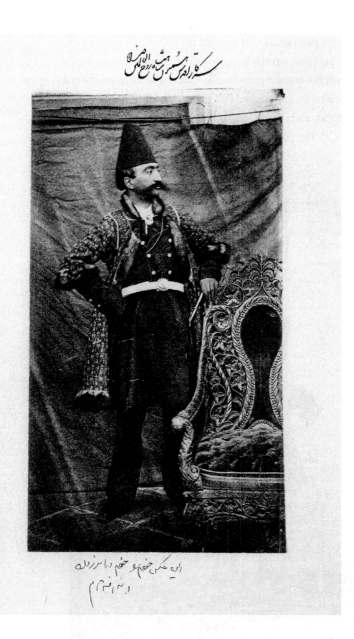

5.4 Nasir al-Din Shah, self-portrait (1865). Albumen print. Golestan Palace Photographic Archive.

graphic portraits taken by Regnault in their minimal uses of accessories and props, as well as their unaffected and improvised execution. The plain and unsophisticated backdrop in the self-portrait of the shah therefore not only removes material traces of his social milieu but also reinscribes the image within mid-nineteenth-century European amateur photography.

Still, to the extent to which every portrait is meant to be at once an expression

of the sitter's individuality and a representation of his or her social status, the portrait photographs of the shah also underscore the social status of the monarch.[15] Put otherwise, the images not only describe the character of an individual but also draw attention to the fact that the individual who is being represented is a member of the royalty. In all three photographs, for example, the shah dons costumes similar to those of European sovereigns, or he wears military-style uniforms to project a powerful image. In addition, Nasir al-Din Shah's grave look, not to mention the ornate sword and chair, serves as a signifier of his status as a potential potentate. In short, all three portraits also fashion an image of power.

As material objects representing his absolute power, these photographs proved inadequate as illustrations of his supreme being. The second and third photographs, which appear in personal albums of Nasir al-Din Shah, include his handwritten notes describing them. These notes are perhaps instances of his marking the private for public consumption on the assumption that, as a royal, even his most personal moments might be of public interest, either in the present or for future generations. A comparison of these captions further suggests his understanding of these images as inadequate representations of his royal persona. The shah, clearly unsatisfied with the merely indexical quality of his portraits, actively engaged with them as an interpretive agent by adding his own captions to augment the density of photographic meaning. In the image taken by himself, he uses the technical term for the photograph in the lower handwritten caption. The caption reads *"in aks-e khodam va khodam dar andaroon andakht-e am,"* which can be translated as "this is a photograph of me that I took inside the palace." Given the more elaborate calligraphic writing above the image, supplied perhaps by a court artist, which in an ornate and exaggerated language identifies the shah as the all-knowing spirit (*rooh al-alemin*), the handwritten note below suggests the shah's desire to underscore his own skill as a photographer and hence his dual role as subject and agent of representation. The shah, in other words, assumes not just agency but authority by referencing his knowledge of photography while also specifying the location of his photographic practice.

What is particularly noteworthy about the handwritten note below the photograph taken by Montabone, in contrast, is the king's word choice in reference to what the image depicts: instead of describing it as *"aks-e man ast dar emarat-e Tehran,"* which would translate as "this is my photograph at a palace building in Tehran," he states *"shakl-e man ast dar emarat-e Tehran,"* which can be translated as "this is an appearance or representation of me at the building in Tehran." Narsir al-Din Shah's choice of *shakl* instead of *aks* to describe the photograph speaks not only to the evolution of photographic vocabulary during his reign but also to the split between the perception of the image as a realist representation of his being and the recognition that the photograph is merely a rough semblance or a general rendering, one that

cannot fully capture the essence of his supreme being. That, as is the case with the other image, he chooses to state the location where the photograph was taken further suggests his skepticism about photography's indexicality and the need to contextualize the image in terms of his sociopolitical status as a powerful king by making reference to the fact that the photograph was taken in his palace. The captions, in short, suggest that the monarch considered the photographic portrait as a dangerously fragmentary emblem of his identity, an image requiring contextualization as well as interpretation, even in the case of a personal album, to guarantee the inseparability of his image and his authority.

Late Photographic Representations of Monarchical Power

In light of this recognition, it is not coincidental that as Nasir al-Din Shah and the court became more actively engaged in the production of his photographic portraits as projections of monarchical power, the portraits came to depict more elaborately his regal surrounding and social milieu. A portrait of Nasir al-Din Shah by Sevruguin (figure 5.5) provides a representative example. As in the other photographic portraits, here the monarch wears a regal, long coat while staring confidently into the camera with that familiar stern and somber look. Unlike the earlier amateur portraits, the image depicts the king wearing a more traditional coat made of *termeh*, the handwoven cloth associated with the powerful Safavid monarchy, sitting on the Takht-e Tavus (Peacock Throne)[16] in his opulent Golestan Palace. The palatial surroundings not only reference the social identity of the Shah as a powerful monarch but also historicizes his rule by affiliating it with that of Nader Shah Afshar and Safavid monarchs. The fact that the shah poses sitting on a replica of the Peacock Throne, the most prominent and nostalgic signifier of the Iranian imperial culture, which was brought to Iran by Nader Shah after his conquest of the Mogul Empire in 1738, is meant to affiliate the Qajar monarch, whose sovereignty was utterly undermined at this historical juncture by the indirect colonialism of Russian and England, with a powerful monarch from the Afsharid dynasty to convey a sense of grandeur and power. As such, the photographic portrait does not so much aim to characterize an individual personage as to provide an idealized inscription of his dynastic rule.

That this and similar portrait photographs can be found in several albums from the period suggests that such images of power were widely distributed by the court, demonstrating the Qajar royalty's attentiveness to the political function of portrait photography to project an image of strength and confidence in order to consolidate their waning power. As metonymies of monarchical rule, portraits of the shah and his sons, both in larger formats and cartes de visite, were not only collected by dignitaries and local officials as symbols of veneration for and obedience to the Qajar

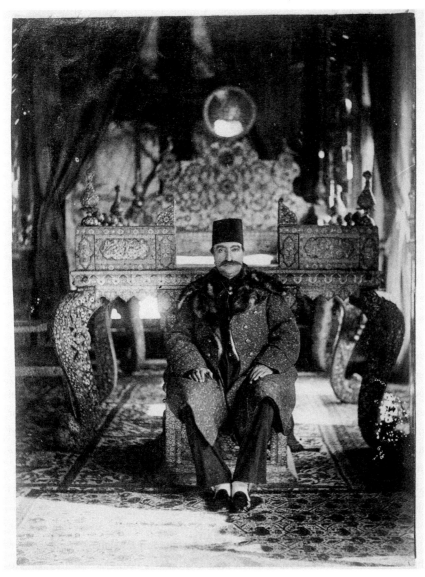

5.5 Antoin Sevruguin, Nasir al-Din Shah in front of the Peacock Throne in Golestan Palace
(ca. 1880s). Albumen print. Freer Gallery of Art and Arthur M. Sackler Gallery Archives,
Smithsonian Institution, Washington, DC.

ruler but also displayed in government and public buildings, as well as at official ceremonies to signify his royal presence when the shah himself could not attend.[17] In this way, royal portrait photographs, beyond their representational function, were viewed as valuable material objects, ownership or display of which conferred a certain social and political status. Consequently, the royal portrait photograph was not just a representation of monarchical authority but, as a material object, was a metonymy for power itself.

To the extent to which photography in Qajar Iran was encouraged by its productive function in the political ideology of monarchical sovereignty, a more communal or contextualized aesthetic sensibility marked the genre of portraiture in Iran during the late Qajar era. Although photographic portraits of individual royalty did not disappear as indigenous and local artists took a more active role in photographing the Qajar court, the overwhelming majority of royal portraits taken by the court's photographers were either group portraits or portraits of the shah in the company of court attendants and servants. In contrast to the early portraits of the ruler, the compositions of these images contextualize him within his sociopolitical milieu. Four portraits of Nasir al-Din Shah from the Golestan Palace's photographic archives are exemplary of this shift in Qajar court photography from representations of the individual ruler to a more socially situated portrayal of the monarch with his court attendants (figures 5.6, 5.7, 5.8, and 5.9). In all of these images, the shah is centrally located in the foreground and middle of the photograph to bring into focus his social and political prominence as the ruler. All the attendants are located behind him or in the background, often holding items that symbolize their subservient status and dutiful service to the shah. In the first two photographs, in spite of the fact that the shah is on a hunting trip, he does not demonstrate any cheerfulness or lightheartedness, but instead stiffly looks into the camera with a somber look that conveys his piety and power.

The last two images compositionally draw attention to the royal stature of the shah by completely marginalizing court attendants and officials in the frame. In these images, the shah, dressed in his royal costume, is sitting on what appears to be the only chair available—note that in the third image, everyone else around him is either standing up or sitting on the ground in a posture of deference—to project not simply a sense of confidence and fortitude but absolute command. Everything in these images, from the ornate dishes in front of the shah to the radical distance between the shah and his subjects, distinguishes him as the sole figure of power, indeed as a divine subject of adoration and adulation. Interestingly, even the photographer's use of lighting aims to underscore the shah's divine status. Whether photographed outside, as in the third image, or inside, as in the fourth photograph, Nasir al-Din Shah is seated in such a way as to have the natural lighting projected solely onto him,

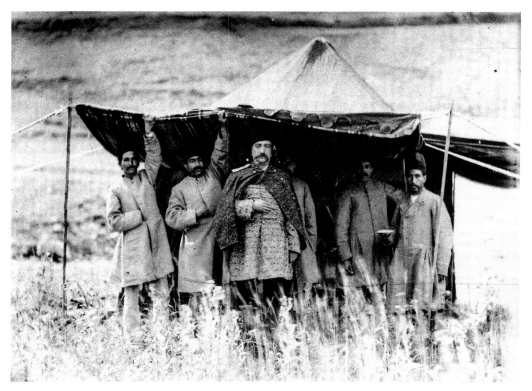

5.6 Anon., Nasir al-Din Shah on a hunting trip (ca. 1880s). Glass negative. Golestan Palace Photographic Archive.

while other people in the composition are kept in the shade. In both photographs, the bright sunlight on the shah and the empty space before him, combined with the blurring of the court attendants and officials in the shadier and marginal spaces in the background of the frames, direct attention to the monarch as a supreme being, perhaps even as the representative of the divine, while foregrounding the social character of his dynastic rule. The lighting in these photographs creates the effect of a halo, associating him with holiness. As such, Nasir al-Din Shah, like Allah, is situated and understood with reference to light and in relation to his superior power over his subjects. As a Muslim monarch, Nasir al-Din Shah was undoubtedly familiar with the Light Verse (Qur'an 24:35), in which Allah is called "the light of the heavens and the earth" and seems to have arrogated to himself the Qur'anic association between light and godliness. That the shah was often called *rooh al-alemin*, the all-knowing spirit— as demonstrated, for example, by the calligraphic title in the abovementioned photograph that identifies him as such (figure 5.4)—speaks to his appropriation of the idea of being the representative of divinity on earth. Indeed, everything in these compositionally elaborate photographs, from the use of sunlight and the ornate dishes

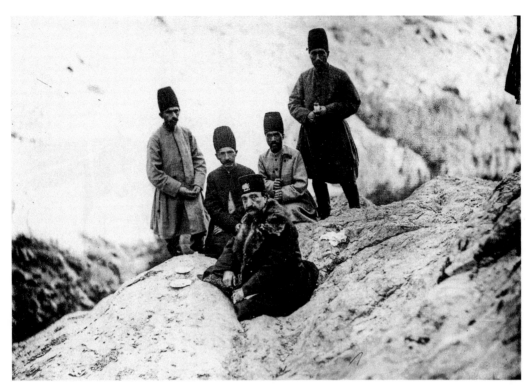

5.7 Anon., Nasir al-Din Shah on a hunting trip (ca. 1880s). Glass negative. Golestan Palace Photographic Archive.

in which the shah's meal is served to the distance between him and his subjects on the margins of these images, distinguishes him as a divine subject worthy of adoration and adulation. In this way, the photographs reveal a compositional and stylistic negotiation between a European notion of portrait photography as the trace of an individual and a local Qajar conception of the portrait as an emblem of the supreme ruler's divine status. As examples of iconographic grafting or photographic transculturation, the images deploy elements of composition and style from European portrait photography to fashion a localized form of portraiture that is attentive to the sociopolitical exigencies of the Qajar court as well as to the strategic value of the association of monarchy with godliness.

The compositionally contextualized character of Iranian portrait photography brings into focus not only the male-centered nature of Qajar society but also the role of photographic representation in the construction of patriarchy itself. As I discussed in the previous chapter, one of the most striking aspects of Qajar-era photography is the conspicuous absence of female family members and relatives in group portraits. With the exception of two early private albums of Nasir al-Din Shah, which include several images taken by himself of his wives and daughters, there is hardly any por-

trait or public photograph of female members of the court. Qajar royalty prohibited their wives, sisters, and daughters from entering photographic studios,[18] even while endeavoring to deploy the new technology to fashion a forward-looking image of their rule. This is a particularly glaring absence since court photographers took so many pictures, including numerous photographs of Nasir al-Din Shah's servants, his eunuchs, and even his cats. The absence of women in even family or group portraits, though partly due to standards of Islamic piety that defined family honor through the exclusion of female family members, can be viewed as an expression of a local form of homosociality that perpetuated a patriarchal structure of power undergirding the court's iconography. The massive archive of Qajar portraits of men in contrast with the almost total absence of portraits of female subjects attests to the way the court used photography to reaffirm traditional gender roles that buttressed monarchical power. The family portrait of the Qajar prince Etezad al-Saltaneh (figure 5.10) provides a representative example of the court's unequal representations of gender. In this typical portrait of the royal family, the prince is symbolically positioned in the center, seated on a chair and surrounded by his sons and brothers to highlight his

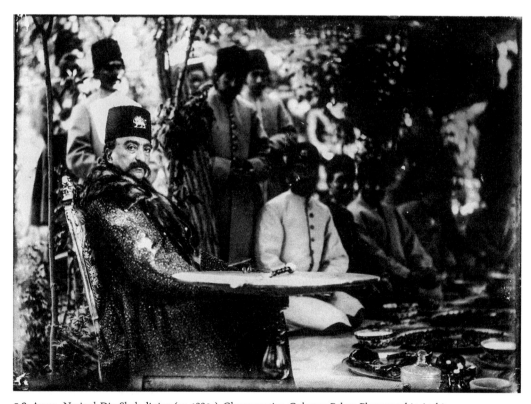

5.8 Anon., Nasir al-Din Shah dining (ca. 1880s). Glass negative. Golestan Palace Photographic Archive.

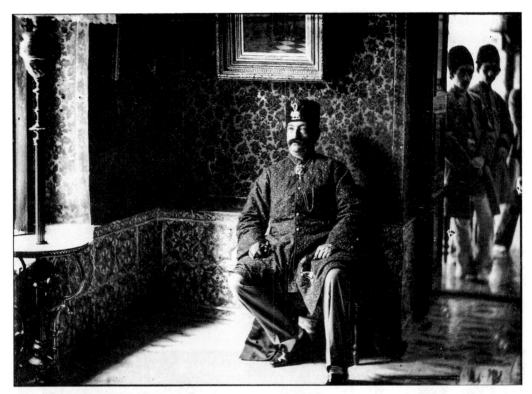

5.9 Anon., Nasir al-Din Shah in Dushan Tapeh Palace (ca. 1880s). Glass negative. Golestan Palace Photographic Archive.

privileged standing as the head of the household. His elder sons, perhaps from differ-ent wives, and younger brothers stand behind him, while his younger sons, perhaps the children of his youngest and favorite wife, sit next to him. In this representation of the royal family, there is no space for mothers, sisters, and daughters, whose ab-sence is a visible sign of their marginal role in a court that was marked by gendered segregation of space and strict control over the visibility of women.

The Divine Power of Photography

On the second day of his 1867 visit to Sabzevar—the city of my birth—Nasir al-Din Shah asks his court photographer Agha Reza Khan to take a photograph of the Islamic philosopher Haji Mulla Hadi Sabzevari (figure 5.11)—who happens to be my great-great-uncle—perhaps to impress the philosopher, who had apparently not encountered photography before. Upon seeing his own photographic portrait, Haji Mulla Hadi is awed—in one account, told by Hakim al-Mamalek, the philosopher is

described as being utterly astonished or stunned (*kamal-e tahayor*), while in a second account, told by Etemad al-Saltaneh, he is described as expressing extreme bewilderment (*nahayet-e mota'jeb*).[19] Tales of the philosopher's incredulous reaction suggest that photography, to those unfamiliar with it, registered not simply as a novel mode of representation but as a generative medium capable of conjuring that which was hitherto unknown, even by the most learned of men. Throughout this chapter, I have sought to shift the focus from viewing nineteenth-century royal photography as a representation of power or mere tool of statecraft to a consideration of its function as a material object in the production of power. What is significant about the photographic practice in this instance is not what the image actually represents but the fact that it is an exercise of power by the sovereign. Like European colonizers who used the camera as an instrument of aggression to shock and awe the natives, the shah deployed the new medium as an apparatus to demonstrate his absolute power. The photograph of Haji Mulla Hadi Sabzevari, in other words, is a demonstration of, and

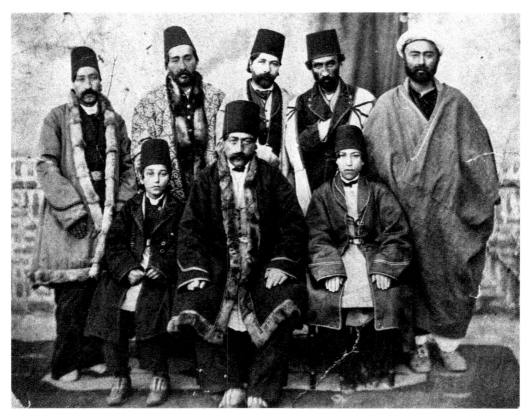

5.10 Anon., Prince Etezad al-Saltaneh and his children (ca. 1860s). Albumen print. Golestan Palace Photographic Archive.

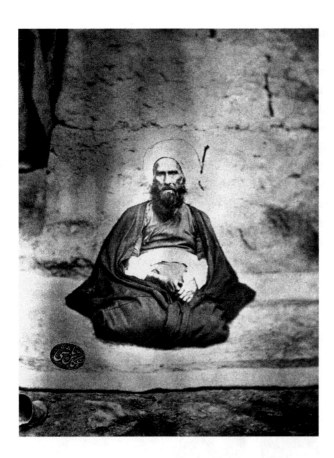

5.11 Agha Reza Khan, Haji Mulla Hadi Sabzevari (1867). Albumen print. Golestan Palace Photographic Archive.

a metonymy for, Nasir al-Din Shah's divine power: like God, he is able to produce verisimilar images of his subjects. What is most remarkable about the ghostly image is its instantiation of the power of representation itself.

Portrait photography has traditionally been considered a representation or validation of an individual identity. In more recent years, art historians have drawn attention to the socially encoded nature of such representations. Graham Clarke, for example, has argued that "the portrait's meaning exists within wider codes of meaning: of space, of posture, of dress, of marks, of social distinction. In short the portrait's meaning exists within a world of signification which has, in turn, already framed and fixed the individual."[20] This contextualized understanding of portrait photography, while a welcome departure from the traditional perception of the portrait as a trace of a unique personality, nonetheless maintains a semiotic view of the genre that regards it as the reflection of a socially inscribed identity. What semiotic accounts of portraiture overlook is both the material history of portraiture and its productive function in the construction of power. Portrait photography in Qajar-era

Iran was not merely a tool of self-expression or an inscription of monarchical rule but was a technical means to produce effects of power. As the anecdote of Haji Mulla Hadi Sabzevari's first encounter with photography demonstrates, the meaning or significance of the portrait resided not solely in the image itself but also in the uses to which it was put as a material object.

On Photography and Neo-Orientalism Today

Although the history of photography in the Middle East, especially the history of indigenous photographic practices in the region, generally has been marginalized, if not completely overlooked, by art historians in the West, there is at the same time a voracious desire for photographs and other works of art by contemporary Middle Eastern artists evident among curators, collectors, and countless audiences in the United States and Europe.[1] The photographic works of artists both from the region and in diaspora, including those of the lesser-known figures such as Shiva Ahmadi, Shirazeh Houshiary, and Shirana Shahbazi, as well as more prominent artists such as Shirin Neshat, Mona Hatoum, and Shadi Ghadirian, have been exhibited in world-renowned galleries including the Saatchi Gallery in London, the Gladstone Gallery in New York, and Galerie Jérôme de Noirmont in Paris, as well as in leading museums such as the Tate Gallery in London, the Stedelijk Museum in Amsterdam, the Whitney Museum of American Art in New York, and the Los Angeles County Museum of Art. In light of my discussion in the preceding pages of the entwined relationship between the history of photography in the Middle East and Orientalism, some reflection on the exceedingly warm embrace of contemporary photography and art by Middle

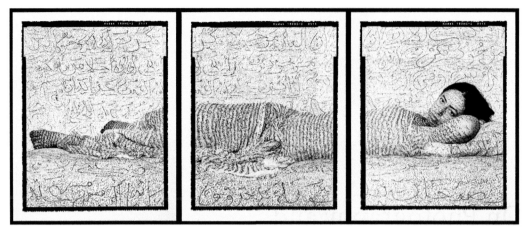

6.1 Lalla Essaydi, *Reclining Odalisque* (2008). From *Les femmes du Maroc* series. Three chromogenic prints mounted to aluminum and protected with Mactac luster laminate. Los Angeles County Museum of Art, purchased with funds provided by Art of the Middle East. Courtesy of the artist.

Eastern artists in the West and its politics is in order. What explains the prodigious demand for the works of these artists? And what are the cultural and political implications of the circulation of these works in the West?

To be sure, the works of artists from the Middle East and in the Middle Eastern diaspora in the West are too diverse to be addressed here. Nonetheless, the politics of their consumption and reception in the West bears notice, for it speaks, I would suggest, to the inscription of these aesthetic works within the geopolitics of neo-Orientalism.[2] In what follows, I consider the photographic works of some of these artists with the aim of unpacking the implications of not only their circulation, but also their enthusiastic reception, throughout the West.

In recent years, many contemporary photography artists in the Middle East and those living in diaspora have thoughtfully engaged in a double critique,[3] attempting to deconstruct Orientalist representations of the Middle East, and especially of women, while also critiquing subordinating structures of patriarchal power in Islamic societies. Some diaspora artists, like Lalla Essaydi and Tal Shochat,[4] have appropriated Orientalist tropes of the reclining odalisque and harem scene in an oppositional manner to return the voyeuristic gaze of the male European onlooker. For example, in her series *Les femmes du Maroc*, the Moroccan artist Lalla Essaydi depicts reclining women covered with words written in henna to challenge the viewer's stereotypes of harem women as objects of male voyeurism (figure 6.1). Essaydi's 2008 *Reclining Odalisque*, which references Ingres's iconic 1814 *Le Grande Odalisque*, offers an example of how contemporary Middle Eastern artists provocatively challenge the Orientalist perceptions of Muslim women. Not emulating the rich colors of Ingres's

painting, and resisting the sexual innuendos of his representation, Essaydi's feminine figure is dressed in ghostlike white embroidery and covered with henna lines of Arabic calligraphy on her body—both of which powerfully signify female crafts—to unsettle the fantasy of Orientalist eroticism by reaffirming the figure's agency[5] and spirituality. Other artists, like Hassan Hajjaj and Abbas Kowsari,[6] have attempted to dismantle the Western stereotype of the contemporary Muslim women as agentless and oppressed. For example, in his 2000 piece *Gang of Kesh, Part 2*, the Moroccan artist Hajjaj portrays a group of women, who are dressed in traditional *djellaba* and wear full veils with camouflage designs, posing in a confident and defiant manner while straddling or sitting in front of their motorbikes (figure 6.2). The image, like other pieces from his *Kesh Angels* series, which borrow from traditional North African studio photography, is a playful and subversive response to Western stereotypes of Islamic veiling as an oppressive tool that disenfranchises Muslim women.

In addition to challenging Orientalist stereotypes of "Oriental" women, Middle Eastern artists also have tackled the subject of unequal gender relations in Islamic societies themselves. In the context of Iran, for example, Bahman Jalali's 2003–5 photographic series *Image of Imagination* and Shadi Ghadirian's 1998–99 series *Qajar* provide two representative examples of artistic works from the Middle East that evidently are in dialogue with the early tradition of photography in the region in a critical fashion. Jalali's series *Image of Imagination* features powerful images in which several thematically incongruous photographs from the late nineteenth and early twentieth centuries are layered to create photographic montages that are as hauntingly beautiful as they are politically oppositional. The idea for what Jalali calls "mixing two eras, the present and the past, and the present's reaction to pictures of unveiled women" was inspired by a sign for one of the first photo studios in the city of Isfahan, the Chehreh-Nama Photo Studio.[7] Far from being the product of an accidental encounter with a historical institution of photography, these images offer a careful engagement with the gendered history of Iranian photography to expose the deep historical roots of unequal relations of power in Iran.

Jalali's aim in using early photographs of Iran in his work is twofold. On the one hand, he brings into view the patriarchal nature of local representations of women by making the male gaze itself visible as he layers locally produced images of odalisques and harem women with photographs of men who adopt, without their wives and daughters, more serious and dignified poses. In one photomontage (figure 6.3), for example, Jalali combines the image of a prostitute (produced by the studio of Mirza Mehdi Khan Chehreh-Nama in Isfahan) posing in an odalisque fashion in the foreground with a group photograph of men dressed in modern fashion in the background. In juxtaposing the images of men and the woman, Jalali not only underscores the patriarchal structure that engenders a differential photographic gaze in the

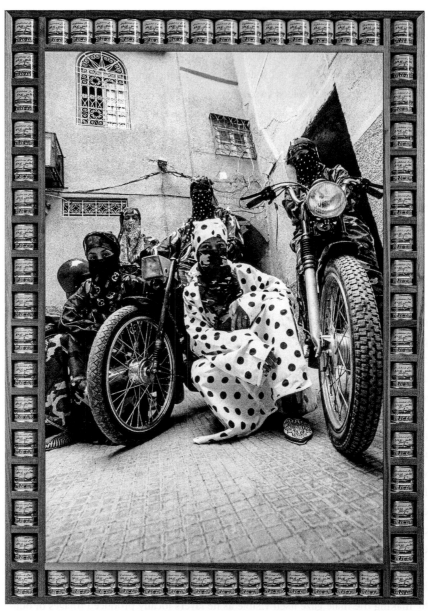

6.2 Hassan Hajjaj, *Gang of Kesh, Part 2* (2000). From *Kesh Angels* series. Chromogenic print with wood frame and car-paint tins. Los Angeles County Museum of Art, gift of the artist. Courtesy of the artist and Taymour Grahne Gallery, New York.

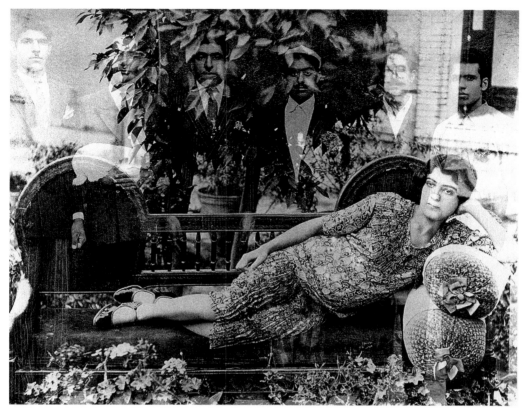

6.3 Bahman Jalali, *Untitled* (2003–5). From *Image of Imagination* series. Silver-bromide print. Courtesy of Rana Javadi.

case of male and female subjects but also draws attention to the problematic arche-
types of women as either modern and indecent or traditional and pious. The absence
of "decent" or "respectable" women in the group photograph of "modern" men in the
background, and the prominent figure of the odalisque woman dressed in a Euro-
pean fashion in the foreground without any men (signaling that its intended audi-
ence is male), bring into focus the historical complicity of the photographic tradition
in Iran in the objectification of women and the empowerment of men.

On the other hand, Jalali confers upon the women who are re-presented in his
photographs a sense of agency by self-consciously drawing attention to how women
traditionally have been objectified by photographers. A print that combines a photo-
graph of a Qajar woman who melancholically gazes into the camera with colorful
brush strokes and calligraphy offers an example of Jalali's attempt to challenge the
depiction of women as either sexual objects or victimized subjects (figure 6.4). The
juxtaposition of the woman's direct gaze into the camera with the calligraphy is

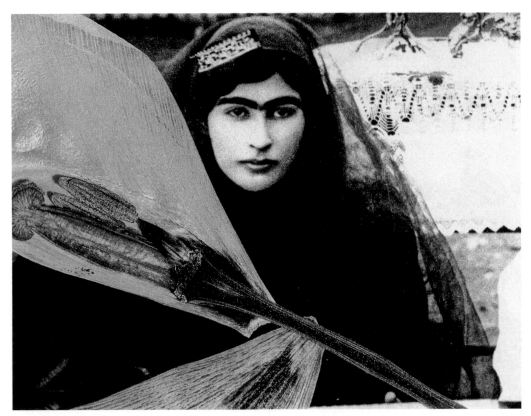

6.4 Bahman Jalali, *Untitled* (2003–5). From *Image of Imagination* series. Silver-bromide print. Courtesy of Rana Javadi.

meant to simultaneously eliminate for the viewer any possibility of assuming a voyeuristic perspective and endow the women with a richly complex subjectivity conveyed by the written word and the melancholic affect.

Jalali's uses of Qajar photographs and early twentieth-century photographs from Isfahan point to his critical attitude toward traditionally gendered images in indigenous photography in Iran and the broader Middle East. His reworking, or perhaps manipulation, of these images pointedly highlights the ways in which the royalty and the elite in Iran internalized Orientalism and thus not only participated in the production of the phantasm of an exotic and erotic East but used the novel medium of photography to reaffirm unequal gender roles and to perpetuate traditional forms of patriarchal power (*mard-salari*) in their society. His uses of the Qajar and Chehreh-Nama archives, in other words, is a self-conscious reflection on how new technologies of representation have been implicated in maintaining the subjugation of women and the valorization of masculinity, in spite of their potential use for artistic

and oppositional practices or as tools of modernization. Jalali's photomontages oper-
ate in the register of the allegorical, exposing the ways photography was used by the
ruling and elite classes in Iran to consolidate their cultural and political hegemony
by way of addressing the treatment of women as second-class citizens in contempo-
rary Iran. Like other contemporary Middle Eastern artists, Jalali also engages in the
contemporary debate about Islamic *hijab* as either a marker of women's oppression
or a culturally specific practice of piety. As examples of double critique, Jalali's photo-
graphic montages at once problematize the stereotype of Islamic *hijab* in the West as
purely oppressive while underscoring the complicity of Muslim men in the objectifi-
cation of women in the Middle East.

While Jalali uses photographs from the late Qajar period to construct photo-
montages that are critical of how women historically have been represented in Ira-
nian photography, Jalali's student Shadi Ghadirian, in her masterfully executed series
Qajar, also puts to use the iconography of Qajar photography to critique traditional
views of women and the tradition of *mard-salari* that undergirds them by re-creating
the atmosphere of the era in her images. Ghadirian traces the origins of her interna-
tionally successful series to her teacher, who regularly showed his students at Azad
University nineteenth-century Qajar portraits.[8] Ghadirian's photographs present
women dressed in traditional costumes posing before painted backdrops resem-
bling those used in late nineteenth-century photography. The sepia color of Gha-
dirian's photographs, associated with albumen prints from the nineteenth century,
gives them an antique or vintage aura, allegorically displacing her critique of women's
second-class status in contemporary Iran into the past. The models often hold anach-
ronistically modern props such as a Pepsi can, a vacuum cleaner, a boom box, or a
bicycle, while gazing directly into the camera in a confident fashion that refuses the
presumptive passivity of the object of the gaze.

Like Jalali's *Image of Imagination*, Ghadirian's *Qajar* and her second series, *Like
Everyday*, oppose the persistent tradition of *mard-salari* in Iran that objectifies
women and confines them to the domestic realm, while provocatively challenging
the assumption that the social subordination of women in the present can be under-
stood in terms of a simple or seamless continuity with subordinating practices in the
past. The photograph of the woman vacuuming in Qajar garb, for example (figure
6.5), links tradition with modernity in Iran, while also jarring the viewer by high-
lighting the temporal disjunction—thereby inviting consideration of the paradoxi-
cal role that modern technology plays in maintaining connection to the past. The
seemingly anachronistic prop of the vacuum cleaner draws attention to how modern
technology in contemporary Iran, far from liberating women, provides the possi-
bility of renewal for a social order in which women are confined to a domestic space
and carry out tedious and monotonous tasks—a topic she further explores in her

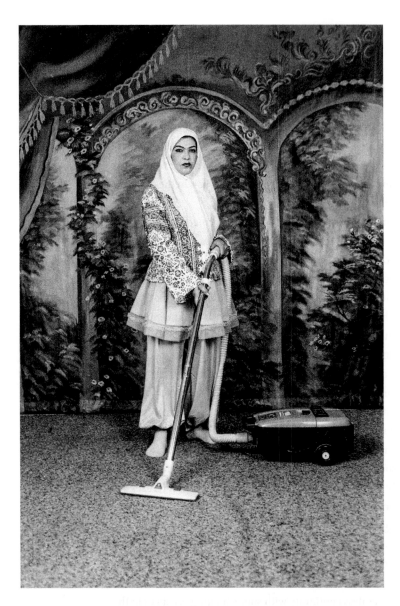

6.5 Shadi Ghadirian, *Untitled* (1998–99). From *Qajar* series. Gelatin-silver bromide print. Los Angeles County Museum of Art, purchased with funds provided by the Art of the Middle East Acquisition Fund, Art of the Middle East Deaccession Fund, the Ralph M. Parsons Fund, the Joan Patevsky Bequest by exchange, and Catherine Benkaim, with additional funds provided by Angella and David Nazarian. Courtesy of the artist.

2000 *Like Everyday* series. The photographs in her second series all depict women fully covered in traditional Persian *chador* whose faces have been covered by brooms, irons, pots, pans, and other everyday household objects (figure 6.6). The juxtaposition of old backdrops and traditional costumes with the modern technology of the electric vacuum cleaner in the photograph from the *Qajar* series highlights the historical continuity of women's subordinate status in Iran while further suggesting that progress itself—emblematized by the "modern conveniences" of domestic life—

provides the critical relay that maintains connection with a *mard-salari* tradition that dates at least as far back as the Qajar era.

In contrast, the photograph of a woman dressed in Qajar-era costume and reading the newspaper underscores the agency of women and draws attention to their participation in contemporary Iranian politics (figure 6.7). While critical of the unequal gender relations in contemporary Iran, Ghadirian guards against the impression that women are entirely disenfranchised. In this image, the female model reading *Hamshahri*, a liberal Tehran newspaper, looks directly into the camera. The

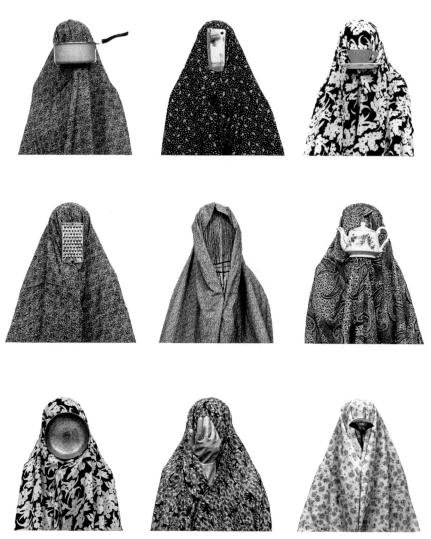

6.6 Shadi Ghadirian, *Untitled* (2000). From *Like Everyday* series. Chromogenic print. Courtesy of the artist.

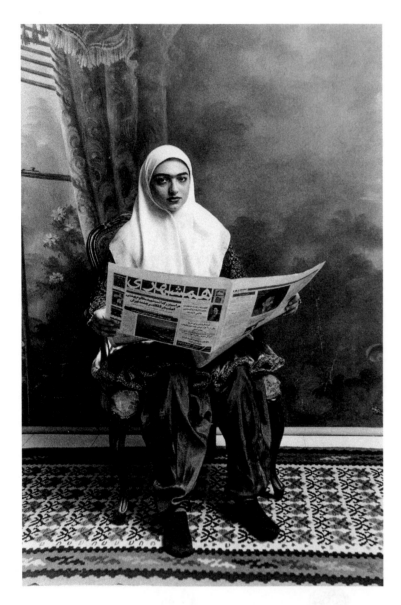

6.7 Shadi Ghadirian, *Untitled* (1998–99). From *Qajar* series. Gelatin-silver bromide print. Los Angeles County Museum of Art, purchased with funds provided by the Art of the Middle East Acquisition Fund, Art of the Middle East Deaccession Fund, the Ralph M. Parsons Fund, the Joan Patevsky Bequest by exchange, and Catherine Benkaim, with additional funds provided by Angella and David Nazarian. Courtesy of the artist.

photograph presents her as a confident and informed citizen, a role typically made available only to men. The inclusion of the newspaper in the photograph is at once ironic, in referencing the familiar scene of a man at home comfortably reading the newspaper while women perform tedious domestic chores, and oppositional, in positioning the woman as literate, liberal, and politically informed.

Similarly, the photograph of a traditionally dressed model holding a boom box on her shoulder offers an acidly comical image whose humor arises from challeng-

ing the common association of femininity with not only objectification in the realm of the visual but silence in the domain of the aural (figure 6.8). That the woman carries a sound system on her shoulder as an urban male teenager would, on the one hand, seems to suggest a comparison, if not an equivalence, between the plight of the women in contemporary Iran and that of disempowered racialized groups in the United States. On the other hand, the model's look of confidence tinged with anger, viewed in combination with the culturally rebellious activity of not just listening to but publicly blaring what the viewer presumes would be rap music emanating from the boom box, undercuts the reflexive assumption that the female subject necessarily must function as a symbol of disempowerment. As such, the image takes a critical view of the social constraints imposed by traditional values, and the repressive laws that perpetuate them, while simultaneously compelling the viewer to encounter one's own implication in reproducing the unequal social relations one might more comfortably assume belong to a less enlightened past.

Interestingly, representations of Muslim women and engagement with the issue of Islamic *hijab* have found their most prominent expression in the works of the diaspora artist Shirin Neshat, whose photographic images and their warm reception in the West have been a great source of inspiration for young artists in the Middle East. Her photographic series *Women of Allah* (1993–97), for example, which brought her to international fame throughout Europe and the United States, has inspired a younger generation of Middle Eastern artists, such as Essaydi, Ghadirian, Manal Al Dowayan,[9] Afshin Pirhashemi,[10] and Parastou Forouhar,[11] all of whom have emulated her style and subject matter, thereby capitalizing on the genre status of Islamic *hijab* in Western art markets to create what one Middle Eastern artist and curator disparagingly calls "chador art."[12] Neshat's *Women of Allah* is comprised of unsettling photographic self-portraits of the *chador*-clad artist, her exposed body parts covered with written texts in Persian, posing with guns and bullets and staring directly, albeit disconsolately, into the camera's eye (figures 6.9 and 6.10). Neshat has described her photographs as a reflection of "the new Iran" after the 1979 Islamic revolution, to "show how [women] can find liberation and strength in a situation that is so limited by authority." Her use of guns and bullets as props in the photograph aims "to shatter our stereotype of the typical Muslim woman as a passive and submissive victim."[13] Neshat's defiant women of Allah challenge Western perceptions of Muslim women as powerless victims of their own faith, emblematized by the practice of veiling.

Art critics have extensively reviewed Neshat's photographs in terms of postcolonial notions of ambivalence and hybridity. Igor Zabel, for example, has argued that "her photographs not only deconstruct stereotypical Western representations of the Middle East, but simultaneously explore the complex position, role, and ideological context of women in Iranian society."[14] On the one hand, Neshat's photographs ap-

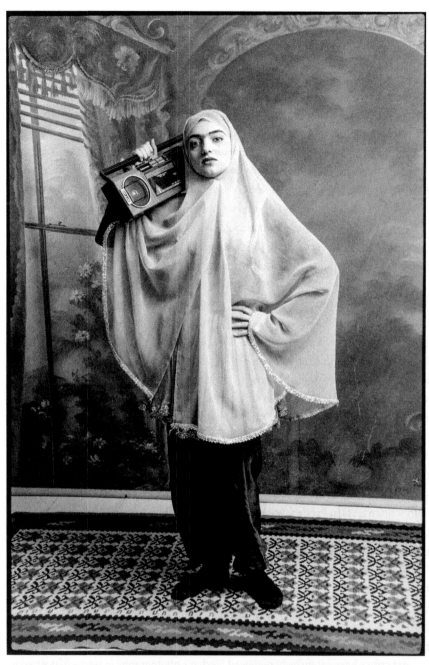

6.8 Shadi Ghadirian, *Untitled* (1998–99). From *Qajar* series. Gelatin-silver bromide print. Los Angeles County Museum of Art, purchased with funds provided by the Art of the Middle East Acquisition Fund, Art of the Middle East Deaccession Fund, the Ralph M. Parsons Fund, the Joan Patevsky Bequest by exchange, and Catherine Benkaim, with additional funds provided by Angella and David Nazarian. Courtesy of the artist.

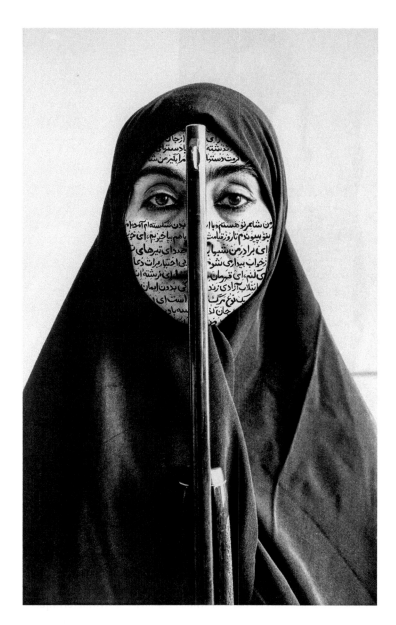

6.9 Shirin Neshat, *Rebellious Silence* (1994). © Shirin Neshat. From *Women of Allah* series. RC print and ink (photography by Cynthia Preston). Courtesy of the artist and Gladstone Gallery, New York and Brussels.

propriate the media cliché of Islamic societies as violent and oppressive to women in their depictions of veiled women covered in Persian calligraphy and posing with weaponry associated with terrorism. Iftikhar Dadi has described Neshat's photographs as "postcolonial allegories" that critically intervene in "the ongoing Orientalist obsessions with the trope of veiled women and its reformulation in political debates about the role of the veil in contemporary society as well as in contemporary

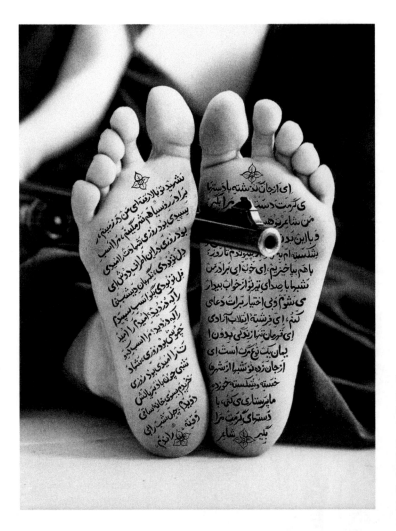

6.10 Shirin Neshat, *Allegiance with Wakefulness* (1994). © Shirin Neshat. From *Women of Allah* series. RC print and ink (photography by Cynthia Preston). Courtesy of the artist and Gladstone Gallery, New York and Brussels.

visualizations of the U.S.-led global war on terror."[15] On the other hand, to the extent to which the Persian calligraphy written over the images is meant to conjure the work of such feminist poets as Forough Farrokhzad whose Pahlavi-era writing critiqued patriarchy, as well as the work of other contemporary female poets such as Tahereh Saffarzadeh, who has written on the topic of martyrdom, Neshat's images address an Iranian audience to offer a different sort of critical engagement with the politics of gender in Islamic societies. Aphrodite Désirée Navab, for example, has argued that Neshat and Gazel, "like Iran's pioneering women writers, are public storytellers who challenge the verbal, spatial, and physical limits placed on women in Iranian culture."[16]

What critics such as Navab and Dadi overlook, however, is the inscription of the

works of Middle Eastern artists in the geopolitics of neo-Orientalism. Oppositional as the works of contemporary Middle Eastern artists such as Neshat, Jalali, and Ghadirian may be, they also are deeply implicated, however inadvertently, in the project of neo-Orientalism. I say inadvertently because it is quite clear that none of these artists has any intention of furthering the project of Orientalism. Quite the contrary: they all would seem to pointedly reject commonplace misrepresentations of Iranians, Arabs, and Muslims in the Western media. Ghadirian, for example, has criticized European media for wanting her to corroborate the neo-Orientalist notion of the "oppressed Iranian woman" and the idea that the "veil is bad."[17] And yet, in spite of self-consciously refusing to be conscripted into certifying the oppression of women in Islamic societies (and by implication US political projects waged under the sign of a liberatory mission), we nonetheless find that Ghadirian's photographs, like those of her exiled counterpart Neshat, have been widely and enthusiastically received in the United States and Western Europe as works that speak to the plight of Muslim women. While Ghadirian's, Jalali's, and Neshat's images have been alternately overlooked and censored in Iran, where their oppositional stance against *mard-salari* and sexism is most politically and culturally relevant, they have been prominently displayed in art galleries and museums in the West, where the distance from the sociocultural contexts that they address, and in which they are inscribed, obscures and in some cases reverses their original political critique. More problematically, Western viewers who are illiterate in the language of these works' iconography and histories often interpret them in ways diametrically opposed to those intended by the artists. For example, in the case of Neshat's *Women of Allah*, as the artist herself acknowledges in an interview, her calligraphic inscriptions are often mistaken as verses from the Qur'an and associated with Islamic *sharia*.[18] Instead, these potentially critical representations of patriarchy and gender roles in Islamic societies and their challenge to Orientalist stereotypes are being incorporated in the West by media and art critics as testimony to the oppressive situation of women in Islamic societies. In spite of the conscious efforts of contemporary Middle Eastern artists to reject the stereotype of the veiled and disempowered Muslim woman in the West, reviews of their works in Western media are peppered with such stereotypes, underwritten by the assumption that these artists intend to speak *for* the oppressed women of the region rather than speak *to* them. The exhibition of some of these artists' works in group shows such as "Unveiled: New Art from the Middle East" at Saatchi Gallery in London in 2009, which featured an array of disparate works by artists in the region, provides a representative example of such recuperative moves on the part of neo-Orientalism in the West. In a review of Ghadirian's work in the *Guardian*, for example, one reviewer describes her *Qajar* series as "a defiant study of female emancipation in the face of political and social adversity,"[19] echoing the words of another art critic who

has described Neshat's art as "depicting Islamic women's collective strength and re-silience in the face of misogyny and despotism."[20] That a renowned art critic such as Jan Avgikos praises Neshat's work for portraying "the actual texture of day-to-day life of women in the Middle East," and as such making an important "contribution to the area's developing women's movement," testifies to the predominance of pater-nalistic and neo-Orientalist reception of Middle Eastern artists' works in the West.[21]

Even when the works of these artists are displayed as "international," as opposed to "Islamic," as was the case in the exhibition, "Without Boundary: Seventeen Ways of Looking," at New York's Museum of Modern Art in 2006, the exhibition itself "was organized around formal traditions that stereotypically say 'Middle East' in the West: calligraphy, miniature painting, and carpet making," as Amie Wallach has cogently observed. Wallach is correct in claiming that the overwhelming majority of viewers and art critics in the West lack "the discriminating knowledge of the details of other people's histories, assumptions, desires, and disappointments necessary to a close reading of work that is embedded in experiences not easily accessible to those born in the United States," making them "see nothing but that same old familiar face [of a cul-turally other] staring back."[22] The fact that the works of contemporary Middle East-erners are most commonly disseminated, displayed, and enthusiastically received in the United States and Western Europe suggests that these artists' investment in political critique must be considered not only in light of their manifest oppositional demand for women's liberation in Islamic societies and their critique of Orientalist stereotypes, but also in relation to neo-Orientalist interests and neo-imperial inter-ventions of the West in the region.

In his preface to the twenty-fifth anniversary edition of *Orientalism*, Said re-marks that nothing has changed in the way Western representations of "the Orient" depict "the contemporary societies of the Arab and Muslim for their backwardness, lack of democracy, and abrogation of women's rights."[23] My discussion of how con-temporary photographic works by Middle Eastern artists are circulated, consumed, and viewed in Euro-American art markets and museums is in accordance with Said's observation that Orientalist perceptions of the region continue to inform contem-porary cultural practices in the West, while attempting to broaden the implications of his theory of otherness by attending to the ways in which neo-Orientalism pro-duces distinctive discourses of alterity. As I have argued elsewhere, "Orientalism is not a single and unchanging entity whose totalizing impulse leaves little room for discursive and ideological transformation," but rather a complex network of power relations that "always entails re-articulations of otherness to ensure its cultural hege-mony in the face of complex political and social change."[24] The seemingly insatiable hunger for "chador art" speaks to new cultural forces that trade on the circulation of old tropes, such as the veil, even while apparently critical of traditional forms of

exoticism. As a result, in spite of the conscious attempt on the part of Middle Eastern artists to dismantle the stereotypical perceptions of the Middle East, their works are consumed in the West as "authentic" expressions of women's disenfranchisement and their desire for Western-style freedom and democracy, a function that implicitly sanctions a paternalistic attitude in the West toward Middle Eastern societies and justifies neo-imperial discourses of rescue. Though "chador art" is widely understood as a mode of representation that calls into question stereotypical views of Islamic societies, its enthused reception in the West throws into relief the neo-Orientalist investment in sustaining consensus about the sexist and undemocratic nature of Islam to justify ongoing missions waged in the name of liberating Muslim women, and more broadly Muslim societies, from tyrannical fathers, husbands, and regimes.

Today, then, a critique of neo-Orientalism cannot merely identify the ideological nuances and allegorical content of Middle Eastern artists' practices that have positioned them as privileged translators who mediate the image of the "Oriental" other in the West, as some postcolonial critics have argued.[25] Attending to the critical tendencies of aesthetic works by Middle Eastern artists or locating what Foucault would call their "politics of truth" as a form of ideological resistance does not necessarily constitute an effective response to neo-Orientalism.[26] What is needed instead is a way to challenge the geopolitics of their circulation and reception in the West through an exploration of what Rancière describes as the "paradoxical intertwining between the operations of art, the modes of circulation of imagery, and critical discourse that refers the operations of the one and forms of the other to their hidden truth."[27] What is needed, in other words, is a critical reckoning with the forces that enable the "discovery" and dissemination of seemingly oppositional aesthetic practices by Middle Eastern artists in Euro-American art markets, forces that simultaneously render them desirable to an audience with completely different aesthetic sensibilities and make them useful to the politics of neo-Orientalism.

Notes

Introduction

1. "Pour la première fois peut-être nous aurons la vérité au lieu de la fiction." Paul Nibelle, "La photographie et l'histoire," *La Lumière* 14 (April 22, 1854): 64.

2. Keri A. Berg also points out that early French photography of Egypt carried "the cachet of visual truth" and "offered its mid-century audience a purportedly objective image of the Orient." See her essay "The Imperialist Lens: Du Camp, Salzmann and Early French Photography," *Early Popular Visual Culture* 6, no. 1 (April 2008): 2.

3. Paul Nibelle, "La photographie et les voyages," *La Lumière* 35 (September 2, 1854): 138.

4. Derek Gregory points to the colonial function of photographic documentation, arguing that European photography of Egypt made it a "transparent space that could be fully 'known' by the colonial gaze." See his "Emperors of the Gaze: Photographic Practices and Productions of Space in Egypt, 1839–1914," in *Picturing Place: Photography and the Geographical Imagination*, edited by Joan M. Schwartz and James R. Ryan (London: I. B. Tauris, 2003), 207.

5. It is worth noting that the pages of French and British journals of photography, such as *La Lumière* and *Photographic News*, are peppered with reports of European photographers' travel and photographic activities in the region.

6. For a descriptive account of early photography of Egyptian antiquity, see Kathleen Stewart Howe, *Excursions along the Nile: The Photographic Discovery of Ancient Egypt* (Santa Barbara, CA: Santa Barbara Museum of Art, 1993).

7. For a discussion of Pragney's and other early photography of Middle Eastern antiquity, see Claire L. Lyons, John K. Papadopoulos, Lindsey S. Stewart, and

Andrew Szegedy-Maszak, *Antiquity and Photography: Early Views of Ancient Mediterranean Sites* (Los Angeles: J. Paul Getty Museum, 2005).

8. Félix Teynard was a well-known calotypist whose images of Egyptian antiquity taken during 1851–52 were viewed as perfect visual complements to *Description de l'Égypte*.

9. "Nous pouvons d'un œil sûr, que ne troublent ni la distance ni le temps, parcourir l'intérieur de ses temples, de ses pyramides, de ses palais, plonger dans la nuit de ses hypogées, lire la chronologie à demi effacée de ses Pharaons, comprendre son architecture bizarre, suivre sur la frise de ses monuments les rites de ses prêtres, et saisir la pensée de son culte ténébreux et formidable." Louis de Cormenin, "Égypte, Nubie, Palestine et Syrie: Dessins photographiques par Maxime Du Camp," *La Lumière* 27 (June 26, 1852): 98.

10. John Cramb was a Scottish professional photographer who was commissioned by a Glasgow publisher to photograph biblical sites in 1860.

11. Francis Bedford was a distinguished British photographer who in 1862 was commissioned by Queen Victoria to accompany the Prince of Wales on his tour of the Middle East and photograph monuments and sites the prince visited in the region.

12. James Graham was an amateur photographer who, having worked as a secretary of the London Society for Promoting Christianity among the Jews, visited the region from 1853 to 1857 and photographed many biblical sites.

13. Nissan N. Perez, *Focus East: Early Photography in the Near East, 1839–1885* (New York: Harry N. Abrams, 1988), 165. For an in-depth discussion of Frith's photography of the Middle East, see Douglas R. Nickel, *Francis Frith in Egypt and Palestine: A Victorian Photographer Abroad* (Princeton: Princeton University Press, 2004).

14. See Kathleen Stewart Howe, "Mapping a Sacred Geography: Photographic Surveys by the Royal Engineers in the Holy Land, 1864–68," in, *Picturing Place: Geography and the Geographical Imagination*, edited by Joan Schwartz and James Ryan (London: I. B. Tauris, 2003), 226–42.

15. Michael Bartram has also argued that "the traditional British susceptibility to landscape was combining with Protestant devotion to the Bible to view the photography of Palestine as synonymous with the word of God: to tamper with it was sacrilege" (103); see Michael Bartram, *The Pre-Raphaelite Camera* (Boston: New York Graphic Society, 1985), 103, cited in Perez, *Focus East*, 84.

16. See Yeshayahu Nir, "Cultural Predispositions in Early Photography: The Case of the Holy Land," *Journal of Communication* 35, no. 3 (Summer 1985): 35.

17. Wilhelm Hammerschmidt was a German professional photographer who moved to Cairo, where he opened a photography studio in the 1860s. He produced a large photographic collection of Egyptian antiquity and a series of views and costumes of Egypt and Syria, some of which were exhibited at the 1867 Exposition Universelle.

18. Émile Béchard, a French photographer, worked in Egypt during the 1870s–1890s and produced a large collection of photographs of "native types" and costumes, in addition to his monumental albums of archaeological sites and antiquities for which he received a gold medal at the Exposition Universelle of 1878 in Paris.

19. The Bonfils were French-born resident photographers in Beirut who from the early 1860s produced a massive number of Orientalist photographs for tourists, which they sold in their Maison Bonfils studio in Beirut.

20. Abdullah Frères was a major photographic studio in Istanbul owned by Viçen Abdullah (later known as Abdullah Şükrü) and his two brothers, Hovsep and Kevork, Armenian Catholic photographers who produced numerous images of historical sites, street types, and Turk-

ish women as well as portraits of Ottoman sultans and the Ottoman bourgeoisie during the 1870s–1900s. The winner of many photography prizes, the Abdullah brothers served as the official photographers of Sultan Abdülaziz for several years.

21. Rudolph Lehnert was a German photographer who with his business partner Ernst Heinrich Landrock created one of the most successful photography studios in North Africa. Their photography engages in an erotic and exotic form of romantic Orientalism.

22. Félix Jacques-Antoine Moulin was a Parisian commercial photographer who in 1856 traveled to Algeria, where he produced an extensive series of Orientalist photographs during his eighteen-month stay.

23. Pascal Sébah, a Christian Syrian, was the owner of a large and successful photographic studio in Istanbul. His son Jean later partnered with Policarpe Joaillier to run the business. Like Abullah Frères, he produced a large collection of photographs of Ottoman Turkey and Egypt.

24. Examples of this tendency are Engin Özendes's *Abdullah Frères: Ottoman Court Photographer* (Istanbul: İletişim Yayinlari, 1985) and *From Sébah and Joaillier to Foto Sabah: Orientalism in Photography* (Istanbul: YKY, 1999), and Carney E. S. Gavin's *The Image of the East: Nineteenth-Century Near Eastern Photographs by Bonfils from the Collections of the Harvard Semitic Museum* (Chicago: University of Chicago Press, 1982).

25. There is yet to be a comprehensive study of indigenous photography in the Middle East, and this book endeavors to address this gap. In recent years, there has begun to be more critical engagement with various indigenous archives in the region. For example, Stephen Sheehi's forthcoming book entitled *Arab Imago* offers a social history of indigenous portrait photography in the Ottoman Arab world from 1860 to 1910.

26. Issam Nassar, "Early Local Photography in Jerusalem: From the Imaginary to the Social Landscape," *History of Photography* 27, no. 4 (Winter 2003): 320–32.

27. For an example of this erroneous representation of Islam, see Maria Golia, *Photography and Egypt* (London: Reaktion, 2010).

28. See, for example, Nassar, "Early Local Photography in Jerusalem"; Nancy C. Micklewright, "Looking at the Past: Nineteenth Century Images of Constantinople as Historic Documents," *Expedition* 32, no. 1 (1990): 32; Stephen Sheehi, "A Social History of Early Arab Photography or a Prolegomenon to an Archaeology of the Lebanese Imago," *International Journal of Middle East Studies* 39 (2007): 177–208.

29. The flagship journal of the field, *History of Photography*, has occasionally published articles on photography of the Middle East, predominantly on the works of European photographers in the region and occasionally on local practices of photography, but these articles almost never offer any critical assessment or theoretical discussion of these works, instead emphasizing historical and background information about a particular photographer or group of photographers. See, for example, Orna Bar-Am and Micha Bar-Am, "The Illustrator E. M. Lilien as Photographer," *History of Photography* 19, no. 3 (Autumn 1995): 195–200; Joseph Geraci, "Lehnert & Landrock of North Africa," *History of Photography* 27, no. 4 (Winter 2003): 294–98; B. A. Henisch and H. K. Henisch, "James Robertson of Constantinople: A Chronology," *History of Photography* 14, no. 1 (January–March 1990): 23–32; Colin Osman, "Antonio Beato, Photographer of the Nile," *History of Photography* 14, no. 2 (April–June 1990): 101–11; John Tchalenko, "Persia through a Russian Lens, 1901–1914: The Photographs of Alexander Iyas," *History of Photography* 30, no. 3 (Autumn 2006): 235–44; Maria Francesca Bonetti and Alberto Prandi, "Italian Photographers in Iran, 1848–64," *History of Photography* 37, no. 1 (February 2013): 14–31; and

Khadijeh Mohammadi Nameghi and Carmen Pérez González, "From Sitters to Photographers: Women in Photography from the Qajar Era to the 1930s," *History of Photography* 37, no. 1 (February 2013): 48–73.

30. As I will discuss in chapter 2, some prominent exhibitions of Orientalist photography include "L'Orientalisme: L'orient des photographes aux XIXe siècle" in 1989, "Étranges étrangers: Photographie et exotisme, 1850–1910" in 1994, both of which appeared at the Centre National de la Photographie in Paris, "Roger Fenton: The Orientalist Suite" at the J. Paul Getty Museum in 1996, and "Sight-seeing: Photography of the Middle East and Its Audiences, 1840–1940" at Harvard's Fogg Art Museum in 2001.

31. Rosalind Krauss, "Photography's Discursive Spaces," in *The Contest of Meaning: Critical Histories of Photography*, edited by Richard Bolton (Cambridge: MIT Press, 1992), 293, 299.

32. Jülide Aker, *Sight-seeing: Photography of the Middle East and Its Audiences* (Cambridge: Harvard University Press, 2001).

33. Malek Alloula, *The Colonial Harem*, trans. Myrna Gozdich and Wald Gozdich (Minneapolis: University of Minnesota Press, 1986), 5.

34. James R. Ryan, *Picturing Empire: Photography and the Visualization of the British Empire* (Chicago: University of Chicago Press, 1997), 12, 23–24, 26.

35. Alloula, *The Colonial Harem*, 5.

36. Louis de Clercq was a French calotypist who accompanied Emmanuel-Guillaume Rey, a historian of Crusader castles, on an expedition to Syria and Asia Minor in the late 1850s that was commissioned by the French Ministry of Public Instruction.

37. Edward W. Said, *Orientalism* (New York: Vintage, 1978), 2.

38. Roland Barthes, *Camera Lucida: Reflections on Photography*, trans. Richard Howard (New York: Hill and Wang, 1981), 106.

39. Jacques Rancière, *The Future of the Image* (London: Verso, 2007), 10–11.

40. Ibid., 11.

41. Ibid., 15.

42. Christopher Pinney, *Camera Indica: The Social Life of Indian Photographs* (London: Reaktion, 1997), 8.

43. Mary Louise Pratt, *Imperial Eyes: Travel Writing and Transculturation* (New York: Routledge, 1992), 4.

44. For examples of the circulation of Pratt's ideas in this regard, see Janet Conway, "Cosmopolitan or Colonial? The World Social Forum as 'Contact Zone,'" *Third World Quarterly* 32, no. 2 (2011): 217–36; and Kate Flint, "Counter-Historicism, Contact Zones and Cultural History," *Victorian Literature and Culture* 27, no. 2 (1999): 507–11.

45. Allan Sekula, "The Body and the Archive," in *The Contest of Meaning: Critical Histories of Photography*, edited by Richard Bolton (Cambridge: MIT Press, 1992), 345.

Chapter One

1. I coin the term "visual regularities" following Michel Foucault's notion of "discursive regularities," which he posits by way of describing the relations between disparate and diverse statements made by practitioners of a particular discourse such as medicine, grammar, or political economy, relations that are marked by particular rules of formation, enunciative modalities, concepts, and strategies that govern and unite them; see *The Archaeology of Knowledge*, trans. A. M. Sheridan Smith (New York: Pantheon, 1972), 21–79.

2. See Aijaz Ahmad, *In Theory: Classes, Nations, Literatures* (London: Verso, 1992); and James Clifford, "On Orientalism," in *The Predicament of Culture: Twentieth-Century Ethnography, Literature, and Art* (Cambridge: Harvard University Press, 1988), 255–76.

3. Michelle L. Woodward, "Between Orientalist Clichès and Images of Modernization: Photographic Practice in the Late Ottoman Era," *History of Photography* 27, no. 4 (Winter 2003): 363.

4. Ibid.

5. Jill Beaulieu and Mary Roberts, "Orientalism's Interlocutors," in *Orientalism's Interlocutors: Painting, Architecture, Photography*, edited by Jill Beaulieu and Mary Roberts (Durham: Duke University Press, 2002), 3.

6. John MacKenzie, *Orientalism: History, Theory and the Arts* (Manchester: Manchester University Press, 1995), 51.

7. Ken Jacobson, *Odalisques and Arabesques: Orientalist Photography, 1839–1925* (London: Quaritch, 2007), 88.

8. I have demonstrated elsewhere, for example, that the indigenous practices of photography in the Middle East were more indebted to Orientalism's aesthetic values and ideological assumptions than to local and Islamic traditions of pictorial representation; see my essay "The Powerful Art of Qajar Photography: Orientalism and (Self)-Orientalizing in Nineteenth-Century Iran," in a special issue, "Representing the Qajars: New Research in the Study of 19th-Century Iran," edited by Layla Diba, *Journal of Iranian Studies* 34, nos. 1–4 (Fall 2001): 141–52.

9. Dominique François Arago, "Report of the Commission of the Chamber of Deputies," in *Classic Essays on Photography*, edited by Alan Trachtenberg (New Haven, CT: Leete's Island Books, 1980), 17.

10. Perez, *Focus East*, 15.

11. For an example of the first approach, see Joanna Talbot, *Francis Frith* (London: Macdonald, 1985), which was published as part of the Masters of Photography series, edited by Rosemary Eakins; and for an example of the second approach, see Claire L. Lyons, John K. Papadopoulos, Lindsey S. Stewart, and Andrew Szegedy-Maszak, *Antiquity and Photography: Early Views of Ancient Mediterranean Sites* (Los Angeles: J. Paul Getty Museum, 2005).

12. For a discussion of the commercial aspect of Frith's photographic business and his collaboration with the London-based firm of Negretti and Zambra, see Nickel, *Francis Frith in Egypt and Palestine*, 68–71.

13. Louis-Jacques-Mandé Daguerre, "Daguerrotype," in *Classic Essays on Photography*, edited by Alan Trachtenberg (New Haven, CT: Leete's Island Books, 1980), 12.

14. "The Daguerotype," *Literary Gazette and Journal of the Belles Lettres, Arts, Sciences, Etc.* 1148 (January 19, 1839): 43.

15. Alexander M. Ross, *William Henry Bartlett: Artist, Author, and Traveler* (Toronto: University of Toronto Press, 1973), 43, punctuated as in the original.

16. Théophile Gautier, *Les Beaux-Arts en Europe* (Paris: Michel Lévy Frères, Libraire-Éditeur, 1856).

17. Francis Frith, introduction to *Egypt and Palestine Photographed and Described*, vol. 1 (London: J. S. Virtue, 1858), not paginated.

18. Evelyn Waugh, *Labels: A Mediterranean Journal*, originally published in September 1930 (London: Duckworth, 1974), 140.

19. For a discussion of photography in relation to world exhibitions, see Maria Helena Souto and Ana Cardoso de Matos, "The 19th Century World Exhibitions and Their Photographic

Memories: Between Historicism, Exoticism and Innovation in Architecture," *Quaderns d'Història de l'Enginyeria* 13 (2012): 57–80.

20. For a discussion of "the desire for the Orient" versus "the Orientalist desire for knowledge," see my *Belated Travelers: Orientalism in the Age of Colonial Dissolution* (Durham: Duke University Press, 1994), 18–35.

21. "C'est donc une bonne fortune au double point de vue de l'art éternel et du voyage cursif, qu'une excursion daguerrienne, surtout quand cette excursion est entreprise dans des pays peu connus, singuliers, curieux, sur lesquels la science ne posséde que d'insuffisantes données. Aussi n'est-il pas téméraire de dire que la publication de M. Maxime Du Camp complète, sous une forme brève et compréhensible, l'ourvrage des Denon et des Champollion-Figeac, et ouvre une voie nouvelle à l'investigation des orientalistes, comme un horizon particulier aux études des artistes. L'art, à l'égal de la science, y pourra puiser de précieux, renseignements. Le movement intellectual dirigé vers l'Orient peut désormais le prendre comme le vade-mecum de ses recherches et le manuel le plus certain et le plus intelligent." *La Lumière* 27 (June 26, 1852): 98.

22. Roland Barthes, "Rhetoric of the Image," in *Classic Essays on Photography*, edited by Alan Trachtenberg (New Haven, CT: Leete's Island Books, 1980), 275.

23. Ibid.

24. Adrien Bonfils, introduction to *Nouveau Testament*, unpublished manuscript, Beirut, ca. 1898, quoted in Gavin, *The Image of the East*, 1.

25. Behdad, *Belated Travelers*.

26. "Il est temps de se dépêcher. D'ici à peu l'Orient n'existera plus. Nous sommes peut-être des derniers contemplateurs." Gustave Flaubert, *Correspondance*, vol. 1 (Paris: Bibliothèque de la Pléiade, Éditions Gallimard, 1973), 663.

27. *The Great Pyramid: Forty-Eight Slides from Direct Negatives by Professor Piazzi Smyth* (London, 1897), 2:12, cited in Julia Ballerini, "Orientalist Photography and Its 'Mistaken' Pictures," in *Picturing the Middle East: A Hundred Years of European Orientalism*, edited by Henry Krawtiz (New York: Dahesh Museum, 1995), 22–23.

28. For a discussion of how early photographers of Egyptian antiquity distilled Egyptian society to a series of monuments, see Howe, *Excursions along the Nile*.

29. Barthes, "Rhetoric of the Image," 278–79.

30. Geraci, "Lehnert & Landrock of North Africa," 297.

31. Joseph Boone has aptly described the images of Rudolf Lehnert and Ernest Landrock as examples of "ethnopornographic photography," which, in spite of their apparent "stamp of ethnographic authenticity," aim to "satisfy the predetermined fantasies of his audience"; see Joseph Allen Boone, *The Homoerotics of Orientalism* (New York: Columbia University Press, 2014), 275.

32. Rancière, *The Future of the Image*, 10.

33. Barthes, *Camera Lucida*, 28.

34. It is worth noting that to this day, the photographs of Lehnert & Landrock are sold as art objects in European galleries and exhibited in such prestigious venues as the Institut du Monde Arab in Paris and Fotographie Forum International in Frankfurt.

Chapter Two

1. Nancy Micklewright, *A Victorian Traveler in the Middle East: The Photography and Travel Writing of Annie Lady Brassey* (Aldershot, England: Ashgate Publishing, 1988), 181, 79, 111, 183.

2. Krauss has cogently argued that the concepts and categories of "view," "landscape," "art-

ist," "authorship," "career," and "oeuvre," which are drawn from aesthetic discourse, cannot be applied to the works of early nineteenth-century photographers such as Atget, Frith, and Salzmann because the subjects of early photography were "often standardized, dictated by the established categories of survey and historical documentation," and therefore overlook "the set of practices, institutions, and relationships to which nineteenth-century photography originally belonged"; see Krauss, "Photography's Discursive Spaces," 297, 298.

3. Micklewright, *A Victorian Traveler in the Middle East*, 142.

4. I use here the term "trope" in its etymological sense of a representational device altering and changing what it represents in order to produce a particular meaning—"trope" from the Greek word *tropos* is related to the root of the verb *trepein*, meaning to turn, to direct, to alter, and to change.

5. As James S. Ackerman explains, the photographic picturesque had its origin in the aesthetics of the picturesque in drawing and painting that dates back to the eighteenth century, especially as elaborated by William Gilpin (1724–1804). Gilpin, the author of many guidebooks for landscape tourists, used Joseph Addison's 1712 essays on "The Pleasures of the Imagination" as well as Edmund Burke's 1757 *A Philosophical Enquiry into the Origin of Our Ideas of the Sublime and Beautiful* to develop his notion of the picturesque. For Gilpin, as Ackerman explains, the picturesque combines "the restraint of the Beautiful with the variety, roughness, and fragmentation of the Sublime" (79). The genre of the picturesque, which was drawn to elegiac pictures of ruins, was soon applied to city views and architecture, and by the mid-nineteenth century it also became the ideal model for garden and landscape design. It is not surprising that early photography so enthusiastically embraced the genre of the picturesque; because of the technological constraints on early photographers such as long exposure times, they tended to depict "landscapes, buildings, still lifes, art works, and certain scientific subjects," as Ackerman observes. As Nochlin further explains, the genre of the picturesque was particularly appealing to Orientalist painters, and I would argue to Orientalist photographers, in that one of its functions "is to certify that the people encapsulated by it, defined by its presence, are irredeemably different from, more backward than, and culturally inferior to those who construct and consume the picturesque product (164). See, respectively, James S. Ackerman, "The Photographic Picturesque," *Artibus et Historiae* 24, no. 48 (2003): 73–94, and Linda Nochlin, "The Imaginary Orient," in *The Politics of Vision: Essays on Nineteenth-Century Art and Society* (New York: Harper and Row, 1989), 33–59.

6. Gary Sampson, "Photographer of the Picturesque: Samuel Bourne," in *India through the Lens: Photography, 1840–1911*, edited by Vidya Dehejia (Washington, DC: Smithsonian Institution, 2000), 164.

7. Esra Akcan correctly observes that panoramic photographs of the city "maintained the Orientalist myth of Istanbul as a beautiful, exotic, non-changing and non-modernizing city, without the transformative power of history—very common features of latent Orientalism, as Edward Said has characterized it"; see Esra Akcan, "Off the Frame: The Panoramic City Albums of Istanbul," in *Photography's Orientalism: New Essays on Colonial Representation*, edited by Ali Behdad and Luke Garland (Los Angeles: Getty Research Institute, 2013), 97.

8. For a brief history of Ottoman reform movements, see Stanford J. Shaw and Ezel Kural Shaw, "The Era of Modern Reform: The Tanzimat, 1839–1876," in *History of the Ottoman Empire and Modern Turkey*, vol. 2, *Reform, Revolution, and Republic: The Rise of Modern Turkey, 1808–1975* (Cambridge: Cambridge University Press, 1977), 55–171.

9. See Reinhold Schiffer, *Oriental Panorama: British Travellers in 19th-Century Turkey* (Amsterdam: Rodopi, 1999), 146.

10. John Murray, *A Handbook for Travellers in the Ionian Islands, Greece, Turkey, Asia Minor, and Constantinople* (London: John Murray, 1840), 170–71.

11. Pratt, *Imperial Eyes*, 201.

12. John Murray, *Handbook for Travellers in Constantinople, the Bosphorus, Dardanelles, Brousa and Plain of Troy with General Hints for Travellers in Turkey, Vocabularies, Etc.* (London: John Murray, 1871), 118–19.

13. Ösendes, *From Sébah & Joaillier to Foto Sabah*, 214.

14. As Bahattin Öztuncay points out, due to the Crimean War, one had to secure a permit to photograph the city because of the risk of spies, and European tourists therefore purchased their images from local professional studios in rue Pera whose photographers already had permission to take pictures; see Bahattin Öztuncay, *The Photographers of Constantinople: Pioneers, Studios and Artists from 19th Century Istanbul*, vol. 1, *Texts and Photographs* (Istanbul: Aygaz, 2003), 73.

15. Murray, *Handbook for Travellers in Constantinople*, 63.

16. Pratt, *Imperial Eyes*, 15.

17. Ibid., 30.

18. Ösendes, *From Sébah & Joaillier to Foto Sabah*, 214.

19. See Sarah Graham-Brown, *Images of Women: The Portrayal of Women in Photography of the Middle East, 1860–1950* (New York: Columbia University Press, 1988), 45.

20. Nochlin, "The Imaginary Orient," 50.

21. Robert S. Nelson, "Making a Picturesque Monument," in *Hagia Sophia, 1850–1950: Holy Wisdom Modern Monument* (Chicago: University of Chicago Press, 2004), 73–104.

22. Francis Wey, "Voyage héliographiques: Album d'Egypte de M. Maxime Du Camp," *La Lumière*, September 15, 1851, 126–27.

23. For a discussion of how professional studio photographers of Istanbul, such as Kargopoulo and Sébah, relied on the works of nineteenth-century European illustrators, see Ayshe Erdogdu, "Picturing Alterity: Representational Strategies in Victorian Type Photographs of Ottoman Men," in *Colonialist Photography: Imag(in)ing Race and Place*, edited by Eleanor M. Hight and Gary D. Sampson (New York: Routledge, 2002), 107–25.

24. It is worth noting that visual classification of people into types was not merely a phenomenon associated with the colonial or non-Western periphery. The classification of non-Western people had its counterpart in Western metropolises, especially London and Paris, in visual representations of the urban underclass. For example, Henry Mayhew's 1851 illustrated *London Labour and the London Poor*, which featured drawings of urban lower-class types made from Richard Beard's daguerreotypes, and John Thomson's photographs of street types in his 1877 *Street Life in London* both presented visual classifications of the underclass, specifically for the purpose of social reform. The iconographic affinity between these images and those of non-Western types speaks to the parallel projects of regulating the underclass at home and colonializing the racialized other abroad.

25. Ussama Makdisi, "Ottoman Orientalism," *American Historical Review* 107, no. 3 (June 2002): 769.

26. "Sont encroûtés dans une ignorance systématique"; "Ils repoussent avec entêtement toute innovation, tout progrès, toute amélioration, soit intellectuelle ou morale"; "Les mœurs et les usages de cette classe sont presque les memes qu'au moyen-âge." See Osman Hamdi Bey and Marie de Launay, *Les costumes populaires de la Turquie en 1873* (Constantinople: Imprimerie de Levant Times & Shipping Gazette, 1873), 29.

27. The discussion of Orientalist eroticism that follows focuses on images that are addressed to and indeed reflect a presumptively heterosexual male gaze. This is not at all to deny the pervasive homoerotics of Orientalism, nor even to suggest that the particular images under consideration here could not productively be analyzed otherwise. Nonetheless, it should be noted that the European albums in the Gigord Collection contain not a single example of expressly homoerotic photography. For an illuminating discussion of the "ghostly presence of … male homoeroticism that haunts many Western men's fantasies and fears of the Middle Eastern sexuality," see Boone's important *The Homoerotics of Orientalism*, xx.

28. Freud points out that "scopophilia," or the obsession with the pleasure of looking, is closely intertwined with "epistemophilia," or the compulsive pleasure of exploring the unknown. As a result he argues that there is a direct relation between the concealment of the eroticized body and sexual desire. Freud claims that the "progressive concealment of the body which goes with civilization keeps sexual curiosity awake"; see Sigmund Freud, *Three Essays on the Theory of Sexuality*, trans. James Strachey (New York: Basic Books, 1962), 22. For a discussion of these terms in the context of Orientalist representations of eroticism, see my essay "The Eroticized Orient: Images of the Harem in Montesquieu and His Precursors," *Stanford French Review* 13, nos. 2–3 (Fall–Winter 1989): 109–26.

29. Théophile Gautier, *Constantinople of To-Day*, trans. Robert Howe Gould (London: David Bogue, 1854), 195. "La première question que l'on adresse à tout voyageur qui revient d'Orient est celle-ci:—'Et les femmes?'—Chacun y répond avec un sourire plus ou moins mystérieux selon son degree de fatuité, de manière à faire sous-entendre un respectable nombre de bonnes fortunes." Théophile Gautier, *Constantinople* (Paris: Michel Lévy Frères, Libraires-Éditeurs, 1853), 195.

30. Selim Deringil, *The Well-Protected Domains: Ideology and the Legitimation of Power in the Ottoman Empire, 1876–1909* (London: I. B. Tauris, 1998), 156.

31. Öztuncay, *The Photographers of Constantinople*, 229.

32. Alloula, *The Colonial Harem*, 13, 14.

33. Albums containing erotic and nude photographs of women are to be found in many photographic archives. During my visit to Atatürk Library's photographic archive, for example, I encountered two albums titled "Souvenir de Perse" marked with the official Ottoman stamp and bound by A. Tarnawski, who is identified as the sultan's official bookbinder, clearly identifying their provenance as a gift to the court, one of which contained several images of nude women by Antoin Sevruguin (Alb. 000064/65).

34. "Dès le premier instant, j'ai eu le coup de foudre. Pendant trois jours, je visite les monuments, je parcours les rues et le Bazar, je m'enfonce dans les ruelles tortueuses escaladant les collines. Le soir venu, du haut de Galata ou du café de Pierre Loti, je contemple les derniers rayons du soleil qui dorent les minarets et les coupoles." Marie Plaisance, "Aux portes de l'Orient," *Beaux Arts* 112 (May 1993): 38.

35. "Dans les années soixante-dix, je me suis passionné pour les travaux des écrivains et des peintres voyageurs. Je recherché avant tout en Europe des oeuvres à caractéristiques topographiques, ethnographiques ou encore historiques, à travers la peinture, les estampes et les livres." *Point de Vue: Images du Monde*, February 2, 1993, 53.

36. Justification letter for the acquisition of the collection prepared by Frances Terpak, Getty Research Institute, 3.

37. Charles-Henri Favrod, "Voir les autres autrement," in *Étranges etrangers: Photographie et exotisme, 1850/1910* (Paris: Centre National de la Photographie, 1989), not paginated.

Chapter Three

1. Woodward, "Between Orientalist Clichés and Images of Modernization," 363.

2. Fredrick Bohrer, "Looking through Photographs: Sevruguin and the Persian Image," in *Sevruguin and the Persian Image: Photographs of Iran, 1870–1930*, edited by Frederick Bohrer (Washington, DC: Arthur M. Sackler Gallery, 1999), 42.

3. It is worth noting that even Perez's comprehensive "A to Z of Photographers Working in the Near East" in *Focus East* makes no reference to Sevruguin or any other resident photographer in Iran, an absence that speaks to the profound marginalization of photography in Iran by art historians.

4. Barthes, *Camera Lucida*, 97.

5. Edward W. Said, foreword to Raymond Schwab, *The Oriental Renaissance: Europe's Rediscovery of India and the East, 1680–1880*, trans. Gene Patterson-Black and Victor Reinking (New York: Columbia University Press, 1984), ix.

6. See my essay "Kontaktvision: Zur Fotografie von Antoine-Khan Sevruguin, 1870–1930" (Contact Vision: The Photography of Antoine-Khan Sevruguin, 1870–1930), in *Sevrugian: Bilder des Orients in Fotografie und Malerei, 1880–1980* (exhibition catalogue), edited by Ulrike Krasberg (Frankfurt: Societäs-Verlag, 2008), 166–85.

7. I will consider more closely this dimension of his work in the context of the politics and culture of royal portrait photography in the final chapter of this book, particularly his photographs of Nasir al-Din Shah, the "photographer king." See Mohammad Reza Tahmasbpour, *Nasir al-Din Shah Akas: Piramoon-e Tarikh-e Akasi Iran* (Nasir al-Din, the Photographer King: On the History of Photography in Iran) (Tehran: Nashr-e Tarikh-e Iran, 2002).

8. Dr. Emanuel Sevrugian, Sevruguin's grandson, to Susie Nemazee of the Arthur M. Sackler Gallery, November 5, 1990.

9. It is worth noting here that diversity of the images and subject positions is not unique to Sevruguin, and that the plurality of representations is evident among many resident photographers and professional studios across the Middle East, especially in Ottoman Turkey.

10. I borrow the notion of "contact zone" from Mary Louise Pratt, who defines it as "social spaces where disparate cultures meet, clash, and grapple with each other, often in highly asymmetrical relations of domination and subordination." Pratt, *Imperial Eyes*, 4.

11. Susan Sontag, *On Photography* (New York: Anchor, 1990), 154.

12. My notion of "(af)filiation" is informed by Edward W. Said's uses of the terms "filiation," to define the relationship of the critic to his natal culture, and "affiliation," to elaborate his or her relation with culture through critical consciousness and scholarly work; see his "Secular Criticism," in Said, *The World, the Text, and the Critic* (London: Vintage, 1983), 1–30.

13. Victor Burgin, ed., *Thinking Photography* (London: Macmillan, 1982), 144.

14. Although the images of "Oriental" eroticism in the Sackler Gallery's collections are generally less explicit, more revealing and pornographic images by Sevruguin can be found in other albums, including two albums at Atatürk Library in Istanbul (Alb. 000064/65) as well as private collections in Iran that I have consulted.

15. This point is corroborated by his grandson, who speaks of Sevruguin's "obsession" with "the idea of a synthesis of photographic documentation of a certain subject matter with an artistic view of it." See the letter of Dr. Emanuel Sevrugian to Susie Nemazee of the Arthur M. Sackler Gallery, November 5, 1990.

16. Alloula has elaborated how such forms of eroticism encourage a form of "intoxication, a loss of oneself in the other through sight." See Alloula, *The Colonial Harem*, 49.

17. Zahid R. Chaudhary, *Afterimage of Empire: Photography in Nineteenth-Century India* (Minneapolis: University of Minnesota Press, 2012), 110.

18. Johannes Fabian, *Time and the Other: How Anthropology Makes Its Object* (New York: Columbia University Press, 1983), 106.

19. For a discussion of how colonialist photography was invested in representations of primitivism, see Ryan, *Picturing Empire*, 140–82.

20. For a detailed discussion of John Thomson's "colonial gaze" and his photographic practice of racial classification, see Geoffrey Belknap, "Through the Looking Glass: Photography, Science and Imperial Motivations in John Thomson's Photographic Expeditions," *History of Science* 52, no. 1 (2014): 73–97. For a study of Felice Beato's exotic photography, see Eleanor M. Hight, "The Many Lives of Beato's 'Beauties,'" in *Colonialist Photography: Imag(in)ing Race and Place*, edited by Eleanor M. Hight and Gary D. Sampson (New York: Routledge, 2002), 126–58.

21. Barthes, *Camera Lucida*, 57.

22. See, for example, Bohrer, "Looking through Photographs," 41–44.

23. This point is corroborated by Corien J. M. Vuurman and Theo H. Martens; see their essay "Early Photography in Iran and the Career of Antoin Sevruguin," in Bohrer, *Sevruguin and the Persian Image*, 25.

24. Ibid., 25–26.

25. Percy Sykes, "Persia," in *Peoples of All Nations: Their Life Today and the Story of Their Past*, edited by J. A. Hammerton, 14 vols. (London: Fleetway House, 1922–24), 11:3985.

26. I say contradictory because women actually are working in the photograph of carpet weavers, while men are actively disciplining the pupils in the photograph of the boy receiving punishment in school.

27. Elizabeth Edwards contends that as readers we must be attentive to the social biography of a photograph, and that an understanding of a photograph's significance does not reside merely where it is produced but where it is consumed or displayed; see Elizabeth Edwards, *Anthropology and Photography, 1860–1920* (New Haven: Yale University Press, 1994).

28. This collection was studied by Theo Martens and Corien Vuurman in 1995, and they came to the conclusion that almost all of the images were taken by Sevruguin; see Wim Rosema, "The Iranian Photographs of W. L. Bosschart," in *Sevruguin's Iran: Late Nineteenth Century Photographs of Iran from the National Museum of Ethnology in Leiden, the Netherlands*, edited by L. A. Fereydoun Barjesteh and Gillian M. Vogelsang-Eastwood (Rotterdam: Barjesteh, 1999), 164–67.

29. Ibid., 165.

30. It is worth noting that, in addition to selling his photographic collections in Iran, Sevruguin also marketed his images in Europe by participating in several photographic exhibitions and colonial expositions where he showcased his images to the broader European public.

31. Julia Ballerini, "Passages: Studio to Archive to Exhibition," in Bohrer, *Sevruguin and the Persian Image*, 100.

32. Bohrer, "Looking through Photographs," 48.

33. Smith, "War Work," four-page unpaginated and undated typescript cited in Ballerini, "Passages," 106.

34. For an extensive discussion of Operation Ajax, which overthrew Mossadegh's govern-

ment, see Stephen Kinzer, *All the Shah's Men: An American Coup and the Roots of Middle East Terror* (Hoboken, NJ: John Wiley and Sons, 2003).

35. For an example of celebratory readings of hybridity as transgressive, see Aphrodite Désirée Navab, "To Be or Not to Be An Orientalist? The Ambivalent Art of Antoin Sevruguin," *Iranian Studies* 35, nos. 1–3 (Winter/Spring/Summer 2002): 113–44; in this article, the author considers Sevruguin's photography as a "complex personal narrative," problematically claiming that the artist's hybrid identity as an Armenian-Iranian (at once foreigner and native) made his images "neither dominating nor aggressive," but "transgressive and multi-directional," and as such "his art invites us to imagine an alternative practice for collective human existence which leaves coercion outside the frame," 142, 144.

Chapter Four

1. Said, *Orientalism*, 5.

2. Edward W. Said, *Culture and Imperialism* (New York: Alfred A. Knopf, 1993), xii, 213, 215–16, 212, emphasis in original.

3. Nochlin, "The Imaginary Orient," 35.

4. Alloula, *The Colonial Harem*, 4.

5. Zeynep Çelik, "Speaking Back to Orientalist Discourse at the World's Columbian Exposition," in *Noble Dreams: Orientalism in America, 1870–1930*, edited by Holly Edwards (Princeton: Princeton University Press, 2000,) 77.

6. Mary Roberts, *Intimate Outsiders: The Harem in Ottoman and Orientalist Art and Travel Literature* (Durham: Duke University, 2007), 144, 146.

7. Deringil, *The Well-Protected Domains*, 156.

8. The inconsistencies and misinformation range from inaccurate dates (for example, several images of Nasir al-Din Shah in the Sackler Collection are dated 1902–5 even though the shah died in 1896 [e.g., FSA A.4 2.12.GN.31.01]) to obviously incorrect titles—for example, a photograph (FSA A.4 2.12.GN.47.11) of the shah being treated by his European doctor is labeled "Dyeing Nasir al-din Shah's mustache"! The Gigord Collection at the Getty Research Institute includes in some cases similar images by the same photographer with different dates; the Getty librarians appear to have used the dates of albums to date the photographs within them.

9. Although Iran was not directly colonized by any European nation in the nineteenth century, it was ruled indirectly by Russia and England, as Qajar monarchs granted these and other European nations a broad range of economic and political concessions through monopolizing treaties. For a discussion of indirect imperialism in Iran, see Firuz Kazemzadeh, *Russia and Britain in Persia, 1864–1914: A Study in Imperialism* (New Haven: Yale University Press, 1968).

10. See Iraj Afshar, "Some Remarks on the Early History of Photography in Iran," in *Qajar Iran*, edited by Clifford E. Bosworth and Carole Hillenbrand (Edinburgh: Edinburgh University Press, 1983), 262, and Zoka, *Tarikh-e Akasi va Akasan Peeshgam dar Iran*, 5. It is worth noting that a reference to Richard being the first photographer in Iran appears in the third volume of the *Mirat al-buldan-i Nasiri* (1863–64), written by Etemad al-Saltaneh, also known as Sani al-Dowleh, who provided us with the first published account of how photography was introduced during Nasir al-Din Shah's reign; see Afshar, "Some Remarks on the Early History of Photography in Iran," 261–90. However, in recent years other historians such as Shahriar Adl have pointed out that the first daguerreotype depicting Crown Price Nasir al-Din Mirza was produced by a young Russian diplomat, Nikolaj Pavlov, in 1842; see Tahmasbpour, *Nasir al-Din Shah Akas*, 17.

11. For an account of the Italian mission to Iran and Montabone's photographs, see Angelo M. Piemontese, "The Photograph Album of the Italian Diplomatic Mission to Persia (Summer 1862)," *East and West* 22, nos. 3–4 (1972): 249–311.

12. This is also true of other early European photographers in Iran such as the artillery instructor August Krziz, who was associated with the Austrian embassy.

13. See, for example, the introductory remarks by Robert A. Sobieszek and Carney E. S. Gavin in *Remembrances of the Near East: The Photographs of Bonfils, 1867–1907* (Rochester, NY: International Museum of Photography at George Eastman House, 1980), unpaginated.

14. His name is also spelled Carlhié in different references to him.

15. The works of these early photographers appear in many albums of the Golestan Palace photographic archives.

16. Tahmasbpour, *Nasir al-Din Shah Akas*, 172–73. For a comprehensive account of the teaching manuals of photography in the Qajar era, see Abbas Rahimi, ed., *Qajari-e va Amozesh-e Akasi* (The Teaching of Photography in the Qajar Era) (Tehran: Farzan Press, 2012).

17. While I was conducting research at the Golestan Palace photographic archives, I came across an oversized collection of Orientalist paintings that either was presented to Nasir al-Din Shah as a gift or was purchased by him during one of his trips to Europe, a finding that provides a most concrete instance of the shah's interest in Orientalist representations. For an account of the shah's 1873 trip to Europe, see Hakim al-Mamalek, *Diary of H. M. Shah of Persia during His Tour through Europe in A.D. 1873*, trans. J. W. Redhouse (Costa Mesa, CA: Mazda Publishers, 1995); for a critical study of Nasir al-Din Shah's relation with Western powers, see Abbas Amanat, *Pivot of the Universe: Nasir al-Din Shah Qajar and the Iranian Monarch* (Berkeley: University of California Press, 1997), 259–316.

18. I borrow the notion of "grafting" from Afsaneh Najmabadi, who uses it to challenge literary critics and art historians who "treat the question of the Europeanization of Persian art largely as a matter of imitation," arguing instead that when visual icons or literary styles are copied by Iranian artists and writers, they produce different, and perhaps new, meanings; see her essays "The Erotic *Vatan* [Homeland] as Beloved and Mother: To Love, to Possess, and to Protect," *Comparative Studies in Society and History* 39, no. 3 (July 1997): 442–67, and "Reading for Gender through Qajar Painting," in *Royal Persian Paintings: The Qajar Epoch, 1785–1925*, edited by Layla Diba and Maryam Ekhtiar (London; Brooklyn, NY: I. B. Tauris in association with Brooklyn Museum of Art, 1998), 76–85.

19. As Najmabadi points out, "When a European icon is copied, or rather grafted, onto a Persian painting, it produces a different meaning—sometimes a hybrid meaning and at other times a completely new meaning. Its meaning, in other words, cannot be understood—nor its artistic success evaluated—solely in reference to the original site and meaning of that icon." See Najmabadi, "Reading for Gender through Qatar Painting," 81.

20. Arjun Appadurai, "The Colonial Backdrop," *Afterimage* 24, no. 5 (March–April 1997): 4.

21. The influence of European art on Persian art, especially during the Qajar era, has been carefully elaborated by scholars of Iranian art and culture. See, for example, B. W. Robinson, "Painting in the Post Safavid Period," in *The Arts of Persia*, edited by R. W. Ferrier (New Haven: Yale University Press, 1989); Najmabadi, "Reading for Gender through Qajar Painting"; and Layla Diba, "Persian Painting in the Eighteenth Century: Tradition and Transmission," *Muqarnas* 6 (1989): 147–60.

22. For a detailed study of the genre of fairy painting in the Victorian era, see Jane Martineau, ed., *Victorian Fairy Painting* (Seattle: University of Washington Press, 1998).

23. Mohamad Tavakoli-Targhi has elaborated the influence of traveling in Europe on the fantasy of houris and how they fantasized about European women. As he points out, "The eroticized depiction of European women by male travelers engendered a desire for that 'heaven on earth' and its uninhibited and fairy-like residents who displayed their beauty and mingled with men" (54). Tavakoli-Targhi cites the example of Mirza Abu al-Hasan Khan Ilchi who traveled to England in 1809–1810, and wrote, for example, "In the gardens and on the paths, beauteous women shine like the sun and rouse the envy of the stars, and the houris of paradise blush with shame to look upon the rose-cheeked beauties of the earth below. In absolute amazement, I said to Sir Gore Ouseley: If there be paradise on earth, It is this, oh! It is this!" (55–56) See Mohamad Tavakoli-Targhi, *Refashioning Iran: Orientalism, Occidentalism and Historiography* (New York: Palgrave Macmillan, 2001).

24. For a discussion of the term "Occidentalism" and how Iranian men viewed European women, see Tavakoli-Targhi, *Refashioning Iran.*

25. As Marianne Hirsch has elaborated in a different context, family photography is entangled with social and political ideologies because looking always entails a relationship of power. And yet, to the extent to which these are nonverbal representations, optical relations of power remain concealed and obscure. My discussion of family photography in this chapter broadens Hirsch's argument by elaborating the ways in which family photographs have implications far beyond family dynamics and domestic space, as they also engage in optical forms of subjection on cultural and societal levels. See Marianne Hirsch, *Family Frames: Photography, Narrative, and Postmemory* (Cambridge: Harvard University Press, 1997).

26. For a compelling and insightful discussion of Arab photography during the late Ottoman era and early Mandate, see Stephen Sheehi, "A Social History of Early Arab Photography or a Prolegomenon to an Archaeology of the Lebanese Imago," *International Journal of Middle East Studies* 39 (2007): 177–208.

27. An in-depth discussion of *namus* is beyond the scope of this chapter; for a discussion of the Islamic notion of *namus*, see Michael Meeker, "Meaning and Society in the Near East: Examples from the Black Sea Turks and the Levantine Arabs," *International Journal of Middle East Studies* 7, no. 2 (April 1987): 243–70; for a more specific discussion of *namus* in the context of traditional Iranian art, see Najmabadi, "The Erotic *Vatan* [Homeland] as Beloved and Mother."

28. I should note that in the mid-1940s, some professional studios employed women to photograph middle-class women without *hijab*, or Islamic dress code, that in the case of Iran included the *chador*, a large cloth that covered the entire body of a woman. The only early photographic portraits of my mother, her sisters, and grandmother without *hijab* were taken in the city of Mashad at a studio that employed a woman photographer.

29. John Tagg, *The Burden of Representation: Essays on Photographies and Histories* (Minneapolis: University of Minnesota Press, 1993), 37.

30. The practice of including objects associated with modernity was extremely common in late nineteenth-century and early twentieth-century photography in Iran and the broader Middle East. For example, Damandan's photographic collection from Isfahan and the Arab Image Foundation's photographic archives contain numerous images of mostly men posting with various instruments (such as clocks, surveying instruments, military objects, books, and photographic portraits)—see, for example, www.fai.org.lb/home.aspx.

31. Sheehi, "A Social History of Early Arab Photography," 191.

32. As Appadurai points out, colonial photography "allowed the documentary realism of the

token (the particular person or group being photographed) to be absorbed into the fiction of the general 'type,' most often an ethnological type." See Appadurai, "The Colonial Backdrop," 4.

33. Sekula, "The Body and the Archive," 345.

34. It is worth noting that the caption's use of "Mazandarani" to describe both the cow and the porter also blurs the boundary of the human and the animal, further distancing the "primitive" figure from "civilized" humanity.

35. For a descriptive discussion of photographic reportage during Nasir al-Din Shah's reign, see Tahmasbpour, *Nasir al-Din Shah Akas*, 61–110.

36. Michel Foucault, *History of Sexuality*, vol. 1, *An Introduction* (New York: Vintage, 1980), 95, 96.

37. Beaulieu and Roberts, *Orientalism's Interlocutors*, 3.

Chapter Five

1. As Geoffrey Batchen has observed, in order for photography to be restored to its own history, we must attend to vernacular photography, particularly in the context of the domestic sphere. While I agree with Batchen's insightful observation that "vernaculars insist there are many photographies, not just one, indicating a need for an equally variegated array of historical methods and rhetorics," one nonetheless must guard against the common assumption that vernacular photography necessarily operates beyond the reach of the ideological constraints of photography more generally; see Geoffrey Batchen, "Vernacular Photography," in *Each Wild Idea: Writing, Photography, History* (Cambridge: MIT Press, 2001), 59.

2. In this regard, I agree with Pinney's observation that "to view photography as a mere 'reactivator' of the Orientalist phantasm is too simplistic," and that we should not treat photography as "merely a 'screen' onto which more powerful ideologies (such as Orientalism) are projected." See Christopher Pinney, "What's Photography Got to Do with It?" in *Photography's Orientalism: New Essays on Colonial Representation*, edited by Ali Behdad and Luke Gartlan (Los Angeles: Getty Research Institute, 2013), 48–49.

3. As an example of the assertion of the autonomy of local photographic practices in the non-Western world, see Pinney, "What's Photography Got to Do with It?" Also see Christopher Pinney, "Introduction: 'How the Other Half . . . ,'" in *Photography's Other Histories*, edited by Christopher Pinney and Nicolas Peterson (Durham: Duke University Press, 2003), 1–16.

4. My discussion in this chapter is at once in dialogue with Mary Roberts's illuminating study of "Sultan Abdülaziz's use of photographic portraiture as a tool of Ottoman statecraft in the 1860s" and an attempt to broaden her argument by attending to the productive, and not merely instrumental, function of photography in Iran (54); see her insightful article "The Limits of Circumscription," in *Photography's Orientalism: New Essays on Colonial Representation*, edited by Ali Behdad and Luke Gartlan (Los Angeles: Getty Research Institute, 2013), 53–74.

5. As B. W. Robinson has elaborated, royal portraiture has a long tradition in Iran, as various monarchs since Darius the Great used it in the service of public relations by displaying themselves to their subjects in the most impressive and favorable guise possible through painting and other graphic representations; see B. W. Robinson, "Persian Royal Portraiture and the Qajars" in *Qajar Iran: Political, Social and Cultural Change, 1800–1925*, edited by Clifford E. Bosworth and Carole Hillenbrand (Edinburgh: Edinburgh University Press, 1983), 291–310.

6. See Layla Diba, "Images of Power and the Power of Images: Intention and Response in Early Qajar Painting (1785–1834), in *Royal Persian Paintings: The Qajar Epoch, 1785–1925*, edited

by Layla Diba and Maryam Ekhtiar (London; Brooklyn, NY: I. B. Tauris in association with Brooklyn Museum of Art, 1998), 31.

7. The words are Layla Diba's; see her "Images of Power and the Power of Images," 30–49. My argument here complements Diba's, as I suggest that the photographic image has replaced portrait painting to produce images of dynastic power since the mid-nineteenth century.

8. A detailed discussion of what I call "indirect colonialism" of Qajar Iran by Britain and Russia is beyond the scope of this chapter; for further elaboration, see Firuz Kazemzadeh, *Russia and Britain in Persia, 1864–1914: A Study in Imperialism* (New Haven: Yale University Press, 1968).

9. It is worth noting in passing that this phenomenon is not unique to Iran or the Middle East. For example, as Rosalind Morris has elaborated in the context of East Asia, Asia in the "photographic world-system" acts as a semi-periphery that interacts with the photographic metropole through predominantly horizontal networks, networks that also helped the forging of an "ironic solidarity between the upper classes of Europe and Asia"; see Rosalind C. Morris, ed., *Photographies East: The Camera and Its History in East and Southeast Asia* (Durham: Duke University Press, 2009), 21.

10. Inge Morath, *Portraits* (New York: Aperture, 1986); Graham Clarke, *The Photograph* (Oxford: Oxford University Press, 1997), 101.

11. I am not suggesting that European-style dress was worn solely for the purposes of the photographs. Indeed, during the reign of Nasir al-Din Shah, Western-style dress became increasingly popular among the elite classes, who used these styles in service of a broad range of political and social purposes. For a particularly illuminating discussion of dress code in the period, see Gillian Vogelsang-Eastwood, *An Introduction to Qajar Era Dress* (Rotterdam: Barjesteh Van Wallwijk van Doorn & Company's Uitgeversmaatschappij, 2002).

12. Roger Cardinal, "Nadar and the Photographic Portrait in Nineteenth-Century France," in *The Portrait in Photography*, edited by Graham Clarke (London: Reaktion, 1992), 6.

13. For a discussion of this genre of photography, see Laurie Dahlberg, *Victor Regnault and the Advance of Photography* (Princeton: Princeton University Press, 2005). I wish to thank Luke Gartlan for bringing the tradition of amateur photography to my attention.

14. Ibid., 90.

15. For a detailed discussion of portrait photography as a means of highlighting one's social status, see Tagg, *The Burden of Representation*, 34–59.

16. Although commonly referred to as the Peacock Throne, this item is not itself the original treasure that Nader Shah of the Afsharid dynasty captured during his conquest of the Mughal Empire in 1738. The throne pictured is the so-called Naderi Throne, which was built for Mohammad Shah Qajar in 1836 to resemble the original Peacock Throne captured by the legendary king. For a brief history of the Peacock Throne, see Muhammad Baqir, "The Peacock Throne: Romance and Reality," *Journal of the Research Society of Pakistan* 3 (1966): 27–32.

17. For a discussion of how royal images were used in the service of authority and power during the Qajar period by being displayed in government and other public buildings, see Diba, "Images of Power and the Power of Images," 30–49.

18. In their discussion of the photographic representations of Qajar women, Kadijeh Mohammadi Nameghi and Carmen Pérez González cite a notice of January 8, 1877, announcing the establishment of the photo studio in Dar al-Funun, stating that women's presence is prohibited in the studio; see their article "From Sitters to Photographers: Women in Photography from the Qajar Era to the 1930s," *History of Photography* 37, no. 1 (February 2013): 48–73.

19. Zoka, *Tarikh-e Akasi va Akasan Peeshgam dar Iran*, 48–53.

20. Graham Clarke, introduction to *The Portrait in Photography*, edited by Graham Clarke (London: Reaktion, 1992), 3.

Afterword

1. It is important to note at the outset that, in light of the cross-cultural and transnational nature of the Orientalist network, a taste for contemporary works by Middle Eastern artists, like the taste for traditional Orientalist painting and photography, also is in evidence among the elite classes in Middle Eastern societies today. As Roger Benjamin has remarked with regard to the purchase by rich Turkish and Arab collectors of nineteenth-century Orientalist paintings during the past decade, collectors as well as museums in the region, especially in the wealthy United Arab Emirates, have been spending fortunes to acquire both stereotypical and seemingly oppositional representations of their cultures and societies. Interestingly enough, the Qatari government has created the Orientalist Museum in Doha, which according to its website "is dedicated to Orientalism—an influential period in art history, based around western artists' first experiences and impressions of the 'oriental' East." The desire for Orientalist and contemporary Middle Eastern art underscores the global nature of what I characterize in this afterword as "neo-Orientalism." See Roger Benjamin, "Post-Colonial Taste: Non-Western Markets for Orientalist Art," in *Orientalism: Delacroix to Klee*, edited by Roger Benjamin (Sydney: Art Gallery of New South Wales, 1997), 32–40.

2. As Juliet A. Williams and I elaborate, "neo-Orientalism" is "a mode of representation that, while indebted to classical Orientalism, engenders new tropes of othering" (284); for an in-depth discussion of this term, see Ali Behdad and Juliet Williams, "Neo-Orientalism," in *Globalizing American Studies*, edited by Brian T. Edwards and Dilip Parameshwar Gaonkar (Chicago: University of Chicago Press, 2010), 283–99.

3. For a more elaborate discussion of double critique, see Juliet A. Williams, "Unholy Matrimony? Feminism, Orientalism, and the Possibility of Double Critique," *Signs* 34, no. 3 (Spring 2009): 611–32.

4. For example, in her 2012 piece *Rumia*, the Israeli artist Tal Shochat portrays a partially nude women covering her breasts with lemons and standing in front of an Ottoman fountain and a wall of colorful tiles, gazing defiantly into the camera. The photograph, which references the common trope of harem women bathing, throws into mocking relief the familiar iconography of Orientalist painting in which nude women are represented in passive and eroticized poses.

5. The meaning of women's agency, especially in the context of the Middle East, has been subject to significant analysis and contestation among feminist critics. In the 1980s, scholars such as Lila Abu-Lughod, Soraya Altorki, and Elizabeth Fernea sought to correct the Orientalist perception of Muslim and Middle Eastern women as passive and submissive by examining diverse modes of resisting religious and traditional forms of patriarchy; see Lila Abu-Lughod, *Veiled Sentiments: Honor and Poetry in a Bedouin Society* (Berkeley: University of California Press, 1986); Soraya Altorki, *Women in Saudi Arabia: Ideology and Behavior among the Elite* (New York: Columbia University Press, 1986); and Elizabeth Warnock Fernea, ed., *Women and Family in the Middle East: New Voices of Change* (Austin: University of Texas Press, 1985). While feminist scholarship that addresses Western feminists' misrecognition—if not outright dismissal—of Muslim and Middle Eastern women's voices and perspectives continues to have critical and political currency, other recent scholars have sought to problematize the very notion of agency itself in interrogating Western perspectives on women and Islam. Saba Mahmood, for example,

calls into question the unacknowledged liberal humanist foundations pervasive in Western feminist writings that have led agency to be conceived primarily in terms of resistance, or as Mahmood puts it, "the capacity to realize one's own interests against the weight of custom, tradition, transcendental will, or other obstacles" (8). Through an ethnography of the grassroots women's piety movement in the mosques of Cairo, Mahmood demonstrates that the practices of these religious women, which on the surface "may appear to be a case of deplorable passivity and docility from a progressive point of view, may actually be a form of agency—but one that can be understood only from within the discourses and structures of subordination that create the conditions of its enactment" (15). See Saba Mahmood, *Politics of Piety: The Islamic Revival and the Feminist Subject* (Princeton: Princeton University Press, 2005). In consideration of critical debates such as this, my critical interrogation of the depiction and expression of agency in the images under consideration in this chapter is presented in a self-consciously ambivalent mode. On the one hand, I highlight how contemporary Middle Eastern artists work against religious and patriarchal norms, emphasizing the readiness with which their artistic expressions have been viewed in the West as acts of resistance against forms of gender oppression presumed to be characteristic of Islamic societies. On the other hand, I contend that such analyses not only risk romanticizing resistance but also can be complicit, however inadvertently, with neo-Orientalist discourses that exoticize Muslim and Middle Eastern women.

6. For example, in his series *Police Women Academy*, the Iranian photographer Abbas Kowsari depicts female cadets all dressed in full *hijab* who are practicing martial arts, scaling walls, and carrying guns to offer an alternative view of Iranian women as active participants even in male-dominated professions such as policing.

7. Bahman Jalali, "Bahman Jalali," in *Iranian Photography Now*, edited by Rose Issa (Amsterdam: Prince Claus Fund Library, 2008), 100. Mirza Mehdi Khan Chehreh-Nama photographed many prostitutes in erotic poses; I presented two examples of such works in chapter 4 to elaborate a local form of Orientalist eroticism in Iran.

8. Shadi Ghadirian, "Shadi Ghadirian," in Issa, *Iranian Photography Now*, 48.

9. The Saudi photographer Manal Al Dowayan's series *The State of Disappearance*, for example, combines disassembled images of veiled women that are inscribed with Arabic words such as "courage" to call attention to the invisibility of women in Saudi Arabia.

10. For example, in his series *Femafia*, the Iranian artist Afshin Pirhashemi creates photorealist portraits of veiled Iranian women to critique their treatment as second-class citizens.

11. The works of the Iranian artist Parastou Forouhar are often compared to those of Shirin Neshat. Her digital drawings in her 2004 series *Schilder* (Signs) all depict faceless women in full *hijab* squeezed into small figures side by side with men who are given ample space in these pictographs.

12. *Chador* is a full-body semicircular piece of cloth that pious Iranian women wear as an outer garment. The term "chador art" was coined by the artist and curator Amirali Ghasemi, who uses it in an interview with the art historian Pamela Karimi. Karimi points out that "Afshin Pirhashemi's one such 'chador' piece was recently sold for more than $130,000 at a Christie's auction in Dubai" (294); see "When Global Art Meanders on a Magic Carpet: A Conversation on Tehran's Roaming Biennial," *Arab Studies Journal* 18, no. 1 (Spring 2010): 288–99.

13. Interview with Anne Doran, July 2, 1997, selections reprinted in Jean Stein, "Women of Allah: Secret Identities," *Grand Street* 62, "Identity" (Fall 1997): 140–45.

14. Igor Zabel, "Women in Black," *Art Journal* 60, no. 4 (Winter 2001): 22.

15. Iftikhar Dadi, "Shirin Neshat's Photographs as Postcolonial Allegories," *Signs* 34, no. 1 (Autumn 2008): 127.

16. Aphrodite Désirée Navab, "Unsaying Life Stories: The Self-Representational Art of Shirin Neshat and Ghazel," *Journal of Aesthetic Education* 41, no. 2 (Summer 2007): 57.

17. Deepanjana Pal, "An Iranian (Woman)," http://www.caravanmagazine.in/arts/iranian -woman.

18. Interview with Shirin Neshat in *Intervista*, Milan, February 1997, cited in Zabel, "Women in Black," 22.

19. Jessica Lack, "Artist of the Week: Shadi Ghadirian," *Guardian*, February 5, 2009, http:// www.guardian.co.uk/artanddesign/2009/feb/05/artist-shadi-ghadirian.

20. G. Roger Denson, "Shirin Neshat: Artist of the Decade," *Huffington Post*, December 30, 2010, http://www.huffingtonpost.com/g-roger-denson/sherin-neshat-artist-of-t_b_802050.html #s216201&title=Attributed_to_alWasiti.

21. Jan Avgikos, "Shirin Neshat, Gladstone Gallery," *Artforum*, January 2006, 220–21.

22. Amie Wallach, "Missed Signals: Nuance and the Reading of Immigrant Art," *American Art* 20, no. 2 (Summer 2006): 128.

23. Edward W. Said, preface to the 25th anniversary edition of *Orientalism: Western Conceptions of the Orient* (New York: Penguin, 2003), xix.

24. Behdad and Williams, "Neo-Orientalism," 298.

25. I am paraphrasing here Dadi's argument about Shirin Neshat's representations of Muslim womanhood, but the idea it expresses is embraced broadly by many postcolonial critics who have studied the works of contemporary Middle Eastern artists.

26. Michel Foucault, "Truth and Power," in *Power/Knowledge: Selected Interviews and Other Writings, 1972–1977*, edited by Colin Gordon (New York: Pantheon, 1980), 133.

27. Rancière, *The Future of the Image*, 17–18.

Bibliography

Abu-Lughod, Lila. *Veiled Sentiments: Honor and Poetry in a Bedouin Society.*
Berkeley: University of California Press, 1986.

Ackerman, James S. "The Photographic Picturesque." *Artibus et Historiae* 24, no.
48 (2003): 73–94.

Afshar, Iraj. "Some Remarks on the Early History of Photography in Iran." In *Qajar
Iran: Political, Social and Cultural Change, 1800–1925,* edited by Clifford E.
Bosworth and Carole Hillenbrand, 261–90. Edinburgh: Edinburgh University
Press, 1983.

Ahmad, Aijaz. *In Theory: Classes, Nations, Literatures.* London: Verso, 1992.

Akcan, Esra. "Off the Frame: The Panoramic City Albums of Istanbul." In *Photog-
raphy's Orientalism: New Essays on Colonial Representation,* edited by Ali Beh-
dad and Luke Gartlan, 93–114. Los Angeles: J. Paul Getty Museum, 2013.

Aker, Jülide. *Sight-seeing: Photography of the Middle East and Its Audiences.* Cam-
bridge: Harvard University Press, 2001.

Alloula, Malek. *The Colonial Harem.* Translated by Myrna Gozdich and Wald Goz-
dich. Minneapolis: University of Minnesota Press, 1986.

Altorki, Soraya. *Women in Saudi Arabia: Ideology and Behavior among the Elite.*
New York: Columbia University Press, 1986.

Amanat, Abbas. *Pivot of the Universe: Nasir al-Din Shah Qajar and the Iranian
Monarch.* Berkeley: University of California Press, 1997.

Appadurai, Arjun. "The Colonial Backdrop." *Afterimage* 24, no. 5 (March–April
1997): 4–7.

Arago, Dominique François. "Report of the Commission of the Chamber of Depu-

ties." In *Classic Essays on Photography*, edited by Alan Trachtenberg, 15–25. New Haven, CT: Leete's Island Books, 1980.

Armstrong, Nancy. *Fiction in the Age of Photography: The Legacy of British Realism*. Cambridge: Harvard University Press, 1999.

Avgikos, Jan. "Shirin Neshat, Gladstone Gallery." *Artforum*, January 2006, 220–21.

Ballerini, Julia. "Orientalist Photography and Its 'Mistaken' Pictures." In *Picturing the Middle East: A Hundred Years of European Orientalism*, edited by Henry Krawitz, 15–26. New York: Dahesh Museum, 1995.

———. "Passages: Studio to Archive to Exhibition." In *Sevruguin and the Persian Image: Photographs of Iran, 1870–1930*, edited by Frederick Bohrer, 99–117. Washington, DC: Arthur M. Sackler Gallery, 1999.

Baqir, Muhammad. "The Peacock Throne: Romance and Reality." *Journal of the Research Society of Pakistan* 3 (1966): 27–32.

Bar-Am, Orna, and Micha Bar-Am, "The Illustrator E. M. Lilien as Photographer." *History of Photography* 19, no. 3 (Autumn 1995): 195–200.

Barthes, Roland. *Camera Lucida: Reflections on Photography*. Translated by Richard Howard. New York: Hill and Wang, 1981.

———. "Rhetoric of the Image." In *Classic Essays on Photography*, edited by Alan Trachtenberg, 269–85. New Haven, CT: Leete's Island Books, 1980.

Bartram, Michael. *The Pre-Raphaelite Camera*. Boston: New York Graphic Society, 1985.

Batchen, Geoffrey. *Each Wild Idea: Writing, Photography, History*. Cambridge: MIT Press, 2001.

Beaulieu, Jill, and Mary Roberts, eds. *Orientalism's Interlocutors: Painting, Architecture, Photography*. Durham: Duke University Press, 2002.

Behdad, Ali. *Belated Travelers: Orientalism in the Age of Colonial Dissolution*. Durham: Duke University Press, 1994.

———. "Contact Vision: The Photography of Antoine-Khan Sevruguin, 1870–1930." In *Sevruguin: Bilder des Orients in Fotografie und Malerei, 1880–1980*, edited by Ulrike Krasberg, 166–85. Frankfurt: Societäs-Verlag, 2008.

———. "The Eroticized Orient: Images of the Harem in Montesquieu and His Precursors." *Stanford French Review* 13, nos. 2–3 (Fall–Winter 1989): 109–26.

———. "The Powerful Art of Qajar Photography: Orientalism and (Self)-Orientalizing in Nineteenth-Century Iran." In "Representing the Qajars: New Research in the Study of 19th-Century Iran," edited by Layla Diba, special issue, *Journal of Iranian Studies* 34 nos. 1–4 (Fall 2001): 141–52.

Behdad, Ali, and Juliet Williams. "Neo-Orientalism." In *Globalizing American Studies*, edited by Brian T. Edwards and Dilip Parameshwar Gaonkar, 283–99. Chicago: University of Chicago Press, 2010.

Belknap, Geoffrey. "Through the Looking Glass: Photography, Science and Imperial Motivations in John Thomson's Photographic Expeditions." *History of Science* 52, no. 1 (2014): 73–97.

Benjamin, Roger, ed. *Orientalism: Delacroix to Klee*. Sydney: Art Gallery of New South Wales, 1997.

Berg, Keri A. "The Imperialist Lens: Du Camp, Salzmann and Early French Photography." *Early Popular Visual Culture* 6, no. 1 (April 2008): 1–18.

Bohrer, Frederick. "Looking through Photographs: Sevruguin and the Persian Image." In *Sevruguin and the Persian Image: Photographs of Iran, 1870–1930*, edited by Frederick Bohrer, 33–54. Washington, DC: Arthur M. Sackler Gallery, 1999.

Bonetti, Maria Francesca, and Alberto Prandi. "Italian Photographers in Iran, 1848–64." *History of Photography* 37, no. 1 (February 2013): 14–31.

Boone, Joseph Allen. *The Homoerotics of Orientalism*. New York: Columbia University Press, 2014.

Burgin, Victor, ed. *Thinking Photography*. London: Macmillan, 1982.

Cardinal, Roger. "Nadar and the Photographic Portrait in Nineteenth-Century France." In *The Portrait in Photography*, 6–25. London: Reaktion, 1992.

Çelik, Zeynep. "Speaking Back to Orientalist Discourse at the World's Columbian Exposition." In *Noble Dreams: Orientalism in America, 1870–1930*, edited by Holly Edwards, 77–98. Princeton: Princeton University Press, 2000.

Chaudhary, Zahid R. *Afterimage of Empire: Photography in Nineteenth-Century India*. Minneapolis: University of Minnesota Press, 2012.

Clarke, Graham. *The Photograph*. Oxford: Oxford University Press, 1997.

———, ed. *The Portrait in Photography*. London: Reaktion, 1992.

Clifford, James. "On Orientalism." In *The Predicament of Culture: Twentieth-Century Ethnography, Literature, and Art*, 255–76. Cambridge: Harvard University Press, 1988.

Conway, Janet. "Cosmopolitan or Colonial? The World Social Forum as 'Contact Zone.'" *Third World Quarterly* 32, no. 2 (2011): 217–36.

Cormenin, Louis de. "Egypte, Nubie, Palestine et Syrie: Dessins photographiques par Maxime Du Camp." *La Lumière* 27 (June 26, 1852): 98–99.

Dadi, Iftikhar. "Shirin Neshat's Photographs as Postcolonial Allegories." *Signs* 34, no. 1 (Autumn 2008): 125–50.

"The Daguerotype." *Literary Gazette and Journal of the Belles Lettres, Arts, Sciences, Etc.* 1148 (January 19, 1839): 43.

Daguerre, Louis-Jacques-Mandé. "Daguerreotype." In *Classic Essays on Photography*, edited by Alan Trachtenberg, 11–13. New Haven, CT: Leete's Island Books, 1980.

Dahlberg, Laurie. *Victor Regnault and the Advance of Photography*. Princeton: Princeton University Press, 2005.

Denson, G. Roger. "Shirin Neshat: Artist of the Decade." *Huffington Post*, December 30, 2010. http://www.huffingtonpost.com/g-roger-denson/sherin-neshat-artist-of-t_b_802050.html #s216201&title=Attributed_to_alWasiti.

Deringil, Selim. *The Well-Protected Domains: Ideology and the Legitimation of Power in the Ottoman Empire, 1876–1909*. London: I. B. Tauris, 1998.

Diba, Layla. "Images of Power and the Power of Images: Intention and Response in Early Qajar Painting (1785–1834)." In *Royal Persian Paintings: The Qajar Epoch, 1785–1925*, edited by Layla Diba and Maryam Ekhtiar, 30–49. London; Brooklyn, NY: I. B. Tauris in association with Brooklyn Museum of Art, 1998.

———. "Persian Painting in the Eighteenth Century: Tradition and Transmission." *Muqarnas* 6 (1989): 147–60.

Edwards. Elizabeth. *Anthropology and Photography, 1860–1920*. New Haven: Yale University Press, 1994.

Erdogdu, Ayshe. "Picturing Alterity: Representational Strategies in Victorian Type Photographs of Ottoman Men." In *Colonialist Photography: Imag(in)ing Race and Place*, edited by Eleanor M. Hight and Gary D. Sampson, 107–25. New York: Routledge, 2002.

Fabian, Johannes. *Time and the Other: How Anthropology Makes Its Object*. New York: Columbia University Press, 2002.

Favrod, Charles-Henri. "Voir les autres autrement." In *Étranges étrangers: Photographie et exotisme, 1850/1910*, not paginated. Paris: Centre National de la Photographie, 1989.

Fernea, Elizabeth Warnock, ed. *Women and Family in the Middle East: New Voices of Change.* Austin: University of Texas Press, 1985.

Flaubert, Gustave. *Correspondance.* Vol. 1. Paris: Bibliothèque de la Pléiade, Éditions Gallimard, 1973.

Flint, Kate. "Counter-Historicism, Contact Zones, and Cultural History." *Victorian Literature and Culture* 27, no. 2 (1999): 507–11.

Foucault, Michel. *The Archaeology of Knowledge.* Translated by A. M. Sheridan Smith. New York: Pantheon, 1979.

———. *History of Sexuality*, vol. 1, *An Introduction.* Translated by Robert Hurley. New York: Vintage, 1980.

———. "Truth and Power." In *Power/Knowledge: Selected Interviews and Other Writings, 1972–1977*, edited by Colin Gordon, 109–33. New York: Pantheon, 1980.

Freud, Sigmund. *Three Essays on the Theory of Sexuality.* Translated by James Strachey. New York: Basic, 1962.

Frith, Francis. Introduction to *Egypt and Palestine Photographed and Described*, vol. 1, not paginated. London: J. S. Virtue, 1858.

Gautier, Théophile. *Les Beaux-Arts en Europe.* Paris: Michel Lévy Frères, Libraires-Éditeurs, 1856.

———. *Constantinople.* Paris: Michel Lévy Frères, Libraires-Éditeurs, 1853.

———. *Constantinople of To-Day.* Translated by Robert Howe Gould. London: David Bogue, 1854.

Gavin, Carney E. S. *The Image of the East: Nineteenth-Century Near Eastern Photographs by Bonfils from the Collection of the Harvard Semitic Museum.* Chicago: University of Chicago Press, 1982.

Geraci, Joseph. "Lehnert & Landrock of North Africa." *History of Photography* 27, no. 4 (Winter 2003): 294–98.

Golia, Maria. *Photography and Egypt.* London: Reaktion, 2010.

Graham-Brown, Sarah. *Images of Women: The Portrayal of Women in Photography of the Middle East, 1860–1950.* New York: Columbia University Press, 1988.

Gregory, Derek. "Emperors of the Gaze: Photographic Practices and Productions of Space in Egypt, 1839–1914." In *Picturing Place: Photography and the Geographical Imagination*, edited by Joan M. Schwartz and James R. Ryan, 195–225, London: I. B. Tauris, 2003.

Hakim al-Mamalek. *Diary of H. M. Shah of Persia during His Tour through Europe in A.D. 1873.* Translated by J. W. Redhouse. Costa Mesa, CA: Mazda Publishers, 1995.

Hamdi Bey, Osman, and Marie de Launay. *Les costumes populaires de la Turquie en 1873.* Constantinople: Imprimerie de Levant Times & Shipping Gazette, 1873.

Henisch, B. A., and H. K. Henisch. "James Robertson of Constantinople: A Chronology." *History of Photography* 14, no. 1 (January–March 1990): 23–32.

Hight, Eleanor M. "The Many Lives of Beato's 'Beauties.'" In *Colonialist Photography: Imag(in)ing Race and Place*, edited by Eleanor M. Hight and Gary D. Sampson, 126–58. New York: Routledge, 2002.

Hirsch, Marianne. *Family Frames: Photography, Narrative, and Postmemory.* Cambridge: Harvard University Press, 1997.

Howe, Kathleen Stewart. *Excursions along the Nile: The Photographic Discovery of Ancient Egypt.* Santa Barbara, CA: Santa Barbara Museum of Art, 1993.

———. "Mapping a Sacred Geography: Photographic Surveys by the Royal Engineers in the Holy Land, 1864–68." In *Picturing Place: Geography and the Geographical Imagination*, edited by Joan Schwartz and James Ryan, 226–42. London: I. B. Tauris, 2003.

Issa, Rose, ed. *Iranian Photography Now*. Amsterdam: Prince Claus Fund Library, 2008.

Jacobson, Ken. *Odalisques and Arabesques: Orientalist Photography, 1839–1925*. London: Quaritch, 2007.

Karimi, Pamela. "When Global Art Meanders on a Magic Carpet: A Conversation on Tehran's Roaming Biennial." *Arab Studies Journal* 18, no. 1 (Spring 2010): 288–99.

Kazemzadeh, Firuz. *Russia and Britain in Persia, 1864–1914: A Study in Imperialism*. New Haven: Yale University Press, 1968.

Kinzer, Stephen. *All the Shah's Men: An American Coup and the Roots of Middle East Terror*. Hoboken: John Wiley and Sons, 2003.

Krauss, Rosalind. "Photography's Discursive Spaces." In *The Contest of Meaning: Critical Histories of Photography*, edited by Richard Bolton, 287–302. Cambridge: MIT Press, 1992.

Lack, Jessica. "Artist of the Week: Shadi Ghadirian." *Guardian*, February 5, 2009. http://www .guardian.co.uk/artanddesign/2009/feb/05/artist-shadi-ghadirian.

Lyons, Claire L., John K. Papadopoulos, Lindsey S. Stewart, and Andrew Szegedy-Maszak. *Antiquity and Photography: Early Views of Ancient Mediterranean Sites*. Los Angeles: J. Paul Getty Museum, 2005.

MacKenzie, John. *Orientalism: History, Theory and the Arts*. Manchester: Manchester University Press, 1995.

Mahmood, Saba. *Politics of Piety: The Islamic Revival and the Feminist Subject*. Princeton: Princeton University Press, 2005.

Makdisi, Ussama. "Ottoman Orientalism." *American Historical Review* 107, no. 3 (June 2002): 768–96.

Martineau, Jane, ed. *Victorian Fairy Painting*. Seattle: University of Washington Press, 1998.

Meeker, Michael. "Meaning and Society in the Near East: Examples from the Black Sea Turks and the Levantine Arabs, parts 1 and 2." *International Journal of Middle East Studies* 7, no. 2 (April 1976): 243–70; no. 3 (July 1976): 383–422.

Micklewright, Nancy. "Looking at the Past: Nineteenth Century Images of Constantinople as Historic Documents." *Expedition* 32, no. 1 (1990): 24–32.

———. *A Victorian Traveler in the Middle East: The Photography and Travel Writing of Annie Lady Brassey*. Aldershot, England: Ashgate Publishing, 1988.

Mohammadi Nameghi, Khadijeh, and Carmen Pérez González. "From Sitters to Photographers: Women in Photography from the Qajar Era to the 1930s." *History of Photography* 37, no. 1 (February 2013): 48–73.

Morath, Inge. *Portraits*. New York: Aperture, 1986.

Morris, Rosalind C., ed. *Photographies East: The Camera and Its History in East and Southeast Asia*. Durham: Duke University Press, 2009.

Morton, Christopher, and Elizabeth Edwards, eds. *Photography, Anthropology and History: Expanding the Frame*. London: Ashgate Publishing, 2012.

Murray, John. *Handbook for Travellers in Constantinople, the Bosphorus, Dardanelles, Brousa and Plain of Troy, with General Hints for Travellers in Turkey, Vocabularies, Etc.* London: John Murray, 1871.

———. *A Handbook for Travellers in the Ionian Islands, Greece, Turkey, Asia Minor, and Constantinople*. London: John Murray, 1840.

Najmabadi, Afsaneh. "The Erotic *Vatan* [Homeland] as Beloved and Mother: To Love, to Possess, and to Protect." *Comparative Studies in Society and History* 39, no. 3 (July 1997): 442–67.

———. "Reading for Gender through Qajar Painting." In *Royal Persian Paintings: The Qajar Epoch, 1785–1925*, edited by Layla Diba and Maryam Ekhtiar, 76–89. London; Brooklyn, NY: I. B. Tauris, in association with Brooklyn Museum of Art, 1998.

Nassar, Issam. "Early Local Photography in Jerusalem: From the Imaginary to the Social Landscape." *History of Photography*. 27, no. 4 (Winter 2003): 320–32.

Navab, Aphrodite Désirée. "To Be or Not to Be an Orientalist? The Ambivalent Art of Antoin Sevruguin." *Iranian Studies* 35, nos. 1–3 (Winter/Spring/Summer 2002): 113–44.

———. "Unsaying Life Stories: The Self-Representational Art of Shirin Neshat and Ghazel." *Journal of Aesthetic Education* 41, no. 2 (Summer 2007): 39–66.

Nelson, Robert S. "Making a Picturesque Monument." In *Hagia Sophia, 1850–1950: Holy Wisdom Modern Monument*, 73–104. Chicago: University of Chicago Press, 2004.

Nibelle, Paul. "La photographie et l'histoire." *La Lumière* 14 (April 22, 1854): 63–64.

———. "La photographie et les voyages." *La Lumière* 35 (September 2, 1854): 138–39.

Nickel, Douglas R. *Francis Frith in Egypt and Palestine: A Victorian Photographer Abroad*. Princeton: Princeton University Press, 2004.

Nir, Yeshayahu. "Cultural Predispositions in Early Photography: The Case of the Holy Land." *Journal of Communication* 35, no. 3 (Summer 1985): 32–50.

Nochlin, Linda. "The Imaginary Orient." In *The Politics of Vision: Essays on Nineteenth-Century Art and Society*, 33–59. New York: Harper and Row, 1989. Originally published in *Art in America* 71, no. 5 (May 1983): 118–31.

Osman, Colin. "Antonio Beato, Photographer of the Nile." *History of Photography* 14, no. 2 (April–June 1990): 101–11.

Özendes, Engin. *Abdullah Frères: Ottoman Court Photographers*. Istanbul: İletişim Yayinlari, 1985.

———. *From Sébah and Joaillier to Foto Sabah: Orientalism in Photography*. Istanbul: YKY, 1999.

Öztuncay, Bahattin. *The Photographers of Constantinople: Pioneers, Studios and Artists from 19th Century Istanbul*, vol. 1, *Texts and Photographs*. Istanbul: Aygaz, 2003.

Pal, Deepanjana. "An Iranian (Woman)." http://www.caravanmagazine.in/arts/iranian-woman.

Perez, Nissan N. *Focus East: Early Photography in the Near East, 1839–1885*. New York: Harry N. Abrams, 1988.

Piemontese, Angelo M. "The Photograph Album of the Italian Diplomatic Mission to Persia (Summer 1862)." *East and West* 22, nos. 3–4 (1972): 249–311.

Pinney, Christopher. *Camera Indica: The Social Life of Indian Photographs*. London: Reaktion, 1997.

———. "What's Photography Got to Do with It?" In *Photography's Orientalism: New Essays on Colonial Representation*, edited by Ali Behdad and Luke Gartlan. 33–52. Los Angeles: Getty Research Institute, 2013.

Pinney, Christopher, and Nicolas Peterson, eds. *Photography's Other Histories*. Durham: Duke University Press, 2003.

Plaisance, Marie. "Aux portes de l'Orient." *Beaux Arts* 112 (May 1993): 38–40.

Pratt, Mary Louise. *Imperial Eyes: Travel Writing and Transculturation*. New York: Routledge, 1992.

Rahimi, Abbas, ed. *Qajari-e va Amozesh-e Akasi* (The Teaching of Photography in the Qajar Era). Tehran: Farzan Press, 2012.

Rancière, Jacques. *The Future of the Image*. London: Verso, 2007.

Roberts, Mary. *Intimate Outsiders: The Harem in Ottoman and Orientalist Art and Travel Literature*. Durham: Duke University Press, 2007.

Robinson, B. W. "Painting in the Post Safavid Period." In *The Arts of Persia*, edited by R. W. Ferrier, 224–31. New Haven: Yale University Press, 1989.

―――. "Persian Royal Portraiture and the Qajars." In *Qajar Iran: Political, Social and Cultural Change, 1800–1925*, edited by Carole Hillenbrand and Clifford E. Bosworth, 291–310. Edinburgh: Edinburgh University Press, 1983.

Rosema, Wim. "The Iranian Photographs of W. L. Bosschart." In *Sevruguin's Iran: Late Nineteenth Century Photographs of Iran from the National Museum of Ethnology in Leiden, the Netherlands*, edited by L. A. Fereydoun Barjesteh van Waalwijk van Doorn and Gillian M. Vogelsang-Eastwood, 164–67. Rotterdam: Barjesteh, 1999.

Ross, Alexander M. *William Henry Bartlett: Artist, Author, and Traveler*. Toronto: University of Toronto Press, 1973.

Ryan, James R. *Picturing Empire: Photography and the Visualization of the British Empire*. Chicago: University of Chicago Press, 1997.

Said, Edward W. *Culture and Imperialism*. New York: Alfred A. Knopf, 1993.

―――. Foreword to Raymond Schwab, *The Oriental Renaissance: Europe's Rediscovery of India and the East, 1680–1880*, translated by Gene Patterson-Black and Victor Reinking. New York: Columbia University Press, 1984.

―――. *Orientalism*. New York: Vintage, 1978.

―――. *Orientalism: Western Conceptions of the Orient*. New York: Penguin, 2003.

―――. *The World, the Text, and the Critic*. London: Vintage, 1983.

Sampson, Gary. "Photographer of the Picturesque: Samuel Bourne." In *India through the Lens: Photography, 1840–1911*, edited by Vidya Dehejia, 163–97. Washington, DC: Smithsonian Institution, 2000.

Schiffer, Reinhold. *Oriental Panorama: British Travellers in 19thCentury Turkey*. Amsterdam: Rodopi, 1999.

Sekula, Allan. "The Body and the Archive." In *The Contest of Meaning: Critical Histories of Photography*, edited by Richard Bolton, 343–89. Cambridge: MIT Press, 1992.

Shaw, Stanford J., and Ezel Kural Shaw. *History of the Ottoman Empire and Modern Turkey*, vol. 2, *Reform, Revolution, and Republic: The Rise of Modern Turkey, 1808–1975*. Cambridge: Cambridge University Press, 1977.

Sheehi, Stephen. "A Social History of Early Arab Photography or a Prolegomenon to an Archaeology of the Lebanese Imago." *International Journal of Middle East Studies* 39 (2007): 177–208.

Sobieszek, Robert A., and Carney E. S. Gavin. Introductory remarks to *Remembrances of the Near East: The Photographs of Bonfils, 1867–1907*. Rochester, NY: International Museum of Photography at George Eastman House, 1980.

Sontag, Susan. *On Photography*. New York: Picador, 2001.

Souto, Maria Helena, and Ana Cardoso de Matos. "The 19th Century World Exhibitions and Their Photographic Memories: Between Historicism, Exoticism and Innovation in Architecture." *Quaderns d'Història de l'Enginyeria* 13 (2012): 57–80.

Stein, Jean. "Women of Allah: Secret Identities," *Grand Street* 62, "Identity" (Fall 1997): 140–45.

Sykes, Percy. "Persia." In *Peoples of All Nations: Their Life Today and the Story of their Past*, edited by J. A. Hammerton, 11:3985–4037. 14 vols. London: Fleetway House, 1922–24.

Tagg, John. *Burden of Representation: Essays on Photographies and Histories.* Minneapolis: University of Minnesota Press, 1993.

Tahmasbpour, Mohammad Reza. *Nasir al-Din Shah Akas: Piramoon-e Tarikh-e Akasi Iran.* Tehran: Nashr-e Tarikh-e Iran, 2002.

Talbot, Joanna. *Francis Frith.* Masters of Photography series. London: Macdonald, 1985.

Tavakoli-Targhi, Mohamad. *Refashioning Iran: Orientalism, Occidentalism and Historiography.* New York: Palgrave Macmillan, 2001.

Tchalenko, John. "Persia through a Russian Lens, 1901–1914: The Photographs of Alexander Iyas." *History of Photography* 30, no. 3 (Autumn 2006): 235–44.

Vogelsang-Eastwood, Gillian. *An Introduction to Qajar Era Dress.* Rotterdam: Barjesteh Van Wallwijk van Doorn & Company's Uitgeversmaatschappij, 2002.

Vuurman, Corien J. M., and Theo H. Martens. "Early Photography in Iran and the Career of Antoin Sevruguin." In *Sevruguin and the Persian Image: Photographs of Iran, 1870–1930,* edited by Frederick Bohrer, 15–31. Washington, DC: Arthur M. Sackler Gallery, 1999.

Wallach, Amie. "Missed Signals: Nuance and the Reading of Immigrant Art." *American Art* 20, no. 2 (Summer 2006): 126–33.

Waugh, Evelyn. *Labels: A Mediterranean Journal.* Originally published in September 1930. London: Duckworth, 1974.

Wey, Francis. "Voyage héliographiques. Album d'Egypte de M. Maxime Du Camp." *La Lumière,* September 15, 1851, 126–27.

Williams, Juliet A. "Unholy Matrimony? Feminism, Orientalism, and the Possibility of Double Critique." *Signs* 34, no. 3 (Spring 2009): 611–32.

Woodward, Michelle L. "Between Orientalist Clichés and Images of Modernization: Photographic Practice in the Late Ottoman Era." *History of Photography* 27, no. 4 (Winter 2003): 363–74.

Zabel, Igor. "Women in Black." *Art Journal* 60, no. 4 (Winter 2001): 16–25.

Zoka, Yayha. *Tarikh-e Akasi va Akasan Peeshgam dar Iran.* Tehran: Offset Press, 1997.

Index

representation, and portrait painting, 136; women, subordinate status in, 160, 163. *See also* Iranian photography

Iranian Constitutional Revolution, 81, 105

Iranian photography, 105–9, 131, 155, 182n10, 183n12, 184n30; class and gender hierarchies, preserving of, 127; dynastic power, emblem of, 135–36; erotic photography, 111; and exotic images, 127; indigenous tradition of, 106; Orientalism, as style of representation, 111; Orientalism, visual and literary tropes from, 111; portrait photography in, 150–51; portraiture, transformation in, 136; representations of women in, 111–14; royal portraiture in, 134–42, 144, 185n5; unequal power relations in, engagement with, 155, 157; upper class, popular among, 106; vernacular photography in, 103–4, 114

Iranische Felsreliefs (Sarre and Herzfeld), 92

Isfahan (Iran), 155, 158, 184n30

Islahat reform movement, 48

Islam, 169

Islamic Archives, 96–98

Islamic revolution, 163

Islamic *sharia*, 167

Islamic veiling, 64–65, 85, 155, 163, 168, 188n9

Istanbul (Turkey), 27, 35, 42–47, 62–63, 68–69, 83, 89, 103, 105, 112, 127, 172–73n20, 173n23; commercial studios in, 59; European tourists, popularity with, 49–50; as modernized city, images of, 48; Orientalist myth of, 177n7; panoramic views of, 49–51, 54; as picturesque, 57; tourist's vision of, 56

Jacobson, Ken, 19

Jacotin, Charles, 111

Jalali, Bahman, 155, 157–59, 167

Jerusalem, 6, 27

Joaillerto, Policarpe, 173n23

Journal de Constantinople (journal), 7

J. Paul Getty Museum, 70

Kargopoulo, Vassilaki, 42, 47, 59, 66

Karimi, Pamela, 188n12

Ken and Jenny Jacob Orientalist Photography Collection, 70

Kermani, Mirza Reza, 131

Kesh Angels series (Hajjaj), 155

Ketab-e Aks (Photography Book) (Kazem), 107

Kinzer, Stephen, 98

Kowsari, Abbas, 155, 188n6

Krauss, Rosalind, 8, 42, 176–77n2

Krikorian, Garabed, 6

Krziz, August, 183n12

Lacretelle, Henri de, 138

Lagrange, Alexis de, 21

Landrock, Ernst Heinrich, 173n21

landscape, 46–47

Launay, Victor Marie de, 7

Lebanon, 31, 34, 105, 123

Le Gray, Gustave, 21

Lehnert, Rudolph, 173n21

Lehnert & Landrock, 4, 38, 176n31, 176n34

Lékégian, G., 25

Lewis, John Frederick, 10, 83

Light Verse, 145

Like Everyday series (Ghadirian), 159–60

Linnaeus, Carl, 56

literary studies, 102

local photography, 6, 14, 62, 102, 109, 131, 153; European aesthetic conventions, 112–14, 130; exoticist iconography, indebtedness to, 130; family portraits, 7; gendered images in, 158; "grafting" on, notion of, 111; and local consumption, 103; as marginalized, 7; Orientalism, adopted by in, 9, 130; politics of representation, as form of domination, 132; portrait photography, 7; women, representations of in, 111–13; women in, absence of, 103–5. *See also* vernacular photography

London (England), 178n24

London Labour and the London Poor (Mayhew), 178n24

London Society for Promoting Christianity among the Jews, 172n12

"L'Orientalisme" (exhibition), 70

Los Angeles (California), 75

Los Angeles County Museum of Art, 153
Loti, Pierre, 68–70
Lumière, La (journal), 171n5

MacKenzie, John, 19
Maghreb, 63, 102
Mahmood, Saba, 187–88n5
Maison Bonfils studio, 4, 35
Manuchehr Khan, 107
Martens, Theo, 181n28
Mayhew, Henry, 178n24
mediation, 27–29, 50–52, 65, 82–83, 111–12, 133–40
Micklewright, Nancy, 14, 41, 44
Middle East, 1–2, 4–5, 7–8, 10, 13–15, 18–19, 21, 32, 37, 39, 45, 54–57, 67–71, 77, 97, 131–32, 186n9; depopulating iconography in, 34; eroticism, 9; exoticism, 9; indigenous photographic archives in, 6; photographic images of, market for, 3; politics of representation in, 103; as popular site, for photography, 20; quality of light in, 2, 22–23; resident photography in, 73–74; self-orient, tendency to in, 103; stereotypical representations, challenging of, 163, 165; as visual reportage (*gozaresh-e tasviri*), 130; women, objectification of in, 159
Middle East photography, 18–19, 27, 41–42, 74, 77, 83, 96, 99, 102, 105, 109, 134, 153, 184n30; as empty space, 34; and exoticism, 15; Orientalism, indebtedness to, 133, 175n8; and possession, 15; and preservation, 15; repressive function of, 130; and *rooh al-alemin* (all-knowing spirit), 130; unequal gaze, 8
Mirat al-buldani-i Nasiri (al-Saltaneh), 182n10
Mirza Hossein Ali, 107
Mirza Kazem, 107
modernity, 33, 57, 60, 67, 80, 88, 97, 114, 116–17, 126, 128, 132, 159, 184n30
Mohammad Ali Shah, 81
Mohammad Hassan Khan Qajar, 127, 130
Mohammadi Nameghi, Kadijeh, 186n18
Mohammad Shah, 106–7, 186n16
Montabone, Luigi, 106, 137, 141
monuments: ahistorical mode of representa-

tion, 58; historical nostalgia, evoking of, 58; as mnemonic objects, 59
Morath, Inge, 137
Morris, Rosalind, 186n9
Mossadegh, Mohammad, 97–98
Moulin, Félix Jacques-Antoine, 4, 25, 173n22
Mozaffar al-Din Shah, 129, 136
Mughal Empire, 142, 186n16
Murray, John, 50–52, 55–56
Museum of Modern Art, 168
Mythologies (Barthes), 12

Nader Shah Afshar, 142; and Peacock Throne, 186n16
Najmabadi, Afsaneh, 183n18, 183n19
Napoleon, 2, 21
Nasir al-Din Shah, 78–81, 107–9, 111, 127, 129, 130–31, 147–48, 182n8, 182n10, 183n17, 186n11; artists, support of, 136; authority of, 141–42; divine power of, 149–50; as divine subject, 144–46; "dynastic image" of, 134–36; individual celebrity, cult of, 137–38, 141; monarchical power of, 142, 144, 149; Peacock Throne, 142; portraiture of, 134–42, 144–46, 149; as *rooh al-alemin* (all-knowing spirit), 141, 145; social status of, 141, 144
Nassar, Issam, 6
National Geographic (magazine), 92
National Museum of Ethnology, 96
Navab, Aphrodite Désirée, 166–67, 182n35
Nelson, Robert, 58
neocolonialism, 97–99
neo-Orientalism, 154, 167–69, 187n2, 187–88n5
Nerval, Gérard de, 28
Neshat, Shirin, 153, 163, 165–68, 188n11, 189n25
New History of Photography (Frizot), 7
Nicholas I, 106
Nochlin, Linda, 19, 57, 102, 177n5
North Africa, 3, 19, 38, 83, 173n21

Operation Ajax, 98
"Orient," 26–29, 47, 75, 89, 168; ancient and biblical world, association with, 57; and eroticism, 83; exoticism of, 94, 96; as exotic other, 18; harem scenes in, 65; and

Iranian photography, 111; nostalgic images of, 59; and "sun-pictures," 22; as timeless space, 48; Western fantasies about, 42

Orientalism, 1–2, 13, 15, 20, 25–26, 73, 75, 77–79, 92, 111, 153, 167, 173n21, 175n8, 185n2, 187n2; and art historians, 102, 106, 113, 131; as art-historical term, 19, 70; belatedness of, 32; criticism of, 18; curatorial Orientalism, 8; discourse of, 45, 62, 70, 73, 96; as discourse of power, 17, 39, 70–71, 99, 101–2, 131; exoticism, as discourse of, 51, 70–71; iconography of, 21; internalizing of, 158; local forms of, 131; as mode of representation, 27, 131–32; network theory of, 19–21; and nostalgia, 70; as "objective" discourse, 28; Ottoman form of, 62; in painting, 83; photographic representations, informing of, 10; photography, as contributing to, 9–10, 29; picturesque tradition of, 51–54; postcolonial critique of, 71; power relations, as complex network of, 133–34, 168; reproductive power of, 99; revival of, 70; scientific gloss, 10; stereotypes of, 94; and tourism, 48, 59; tourist albums, 67–68; as transhistorical and transnational phenomenon, 71; US intelligence service, and recruiting, 97–98

Orientalism (MacKenzie), 19

Orientalism (Said), 8, 18, 68, 70, 101, 168

Orientalist art, 70

Orientalist eroticism, 83, 179n27, 188n7; in contemporary photography, 155; harem scenes, indexical quality of, 65; tourist demand for, 62; veil, as crucial to, 64–65

Orientalist exoticism, 62, 70, 71, 158, 168–69; of Orient, 94, 96; and other, 18; traveler's encounters with, 52

Orientalist Museum, 187n1

Orientalist photographs, 17; collectors of, 4; and colonialism, 38; as contradictory image, 32, 33; depopulation in, 33, 34; East, lure of, 27–28; form, emphasis on, 38–39; iconic and indexical, 38; iconography of, 17; as illustrative of notions of "Orient," 19; as imaginary construct, 17–18; lower and rural classes, 129–30; "Ori-

ent," desire for, 27–28; politics of, 39; and *studium*, 38–39; textural anchorage of, 29–31

Orientalist photography, 73, 82, 102, 111; and aesthetic theory, 19; anchorage, as marked by in, 29–30, 35, 57; antagonistic gazes, 9; armchair travelers, 5; circularity in, 25–27; coded field of, 12–13; collecting, archiving, and displaying, implications of, 68–71; consumption and uses of, 42; and depopulation, 33–34; eroticism, desire for, 5; ethnology and secular temporality, 4; European tourists, as major consumers of, 5; European tourists, and nostalgia, 32; exhibitions of, 70; and exoticism, 5–6, 12, 20, 74; historical development of, and cultural contact, 14; iconographic consistency of, 43; iconography of, 4; and light, 23; light and shadow, contrast of, 24–25; local photographic representations, 6; major consumers of, 5; as marginalized, 7–8, 10; mediation in, 27–29; nostalgia, mobilization of, 32; Orientalist paintings, debt to, 25–27, 58, 102; performative function of, 13; and preservation, 31–33; representation, mode of, 7; reproductive function of, 94; staging of, 35–37; topographic images, 4; and tourism, 5–6; visual regularities of, 18; visual vocabulary of, 5–6

otherness, 19, 62, 70, 94, 102, 130, 168

Ottoman Empire, 6, 42, 45, 55, 62–63, 70

Ottoman Orientalism, hierarchical structure of, 62, 66–67

Ottoman photography, 14, 41–71, 105, 111

Ottoman Turkey, 9, 57, 123, 173n23, 180n9

Özendes, Engin, 56–57

Pahlavi, Reza Shah, 81, 105

Pahlavi period, 114, 166

Palestine, 3–4, 21, 172n15

panoramic views, 45–56

paper negative process, 2

Pardoe, Julia, 49

Paris (France), 22, 178n24

Pavlov, Nikolaj, 182n10

Peoples of All Nations (magazine), 92, 94

Perez, Nissan N., 180n3

Pérez González, Carmen, 186n18

Persepolis (Iran), 92, 97

Persia. *See* Iran

Pesce, Luigi, 106, 137

Philosophical Enquiry into the Origin of Our Ideas of the Sublime and Beautiful, A (Burke), 177n5

photographic grafting, 111, 114, 183n18; modernity, indigenous form of, 123; and transculturation, 14; Western iconography, mimicking of, 123

Photographic News (journal), 171n5

photography, 45; *camera lucida*, 11; cultural preservation, as means of, 32; dark passage (*camera obscura*), notion of, 11; disciplinary function of, 130; divine power of, 149, 150–51; documentation, as means of, 130; double system of, 14; and elites, 159; evidentiary quality of, 11; iconic and latent, relationship in, 12; indexicality of, 12–13, 15, 28, 81, 91, 141–42; intentionality, and colonial hegemony, 98; and intertexuality, 82; introverted mediation, potential for, 12; local consumption of, 127; Middle East, crucial role in, 1–2; as mode of representation, 17, 39; Orientalism, circular relationship between, 99; Orientalist representation, 10; patriarchal power, perpetuating of, 158; planetary consciousness, classificatory system of in, 56–57; privilege, as signifier of, 123; productive function of, 98; representation, technologies of, 158; self, as idealized images of, 123; social status, conferring of, 123; surveillance and social control, as tool for, 130–31; as tool of representation, 9; traditional gender roles, reaffirming of, 147–48; truth, claim to, 91; unequal gender roles, reaffirming of, 158; vocabulary, evolution of, 141–42; women, subjugation of, 158–59. *See also* amateur photography; ethnopornographic photography; family photography; harem photography; Iranian photography; Middle East photog-

raphy; picturesque photography; portrait photography; resident photography; vernacular photography

physiognomy, 91

picturesque photography, 52–54, 57–58, 79, 85; coevalness, denial of, 89; colonial picturesque, 88; elite, embrace of, 128–29; function of, 61; as ideological voyeurism, 89; origins of, 177n5; and return gaze, 61

Picturing Empire (Ryan), 8

Pierre de Gigord Collection. *See* Gigord Collection

Pinney, Christopher, 10, 13, 18, 185n2

Pirhashemi, Afshin, 163, 188n10, 188n12

planetary consciousness, as classificatory system, 56–57

"Pleasures of the Imagination, The" (Addison), 177n5

Police Women Academy (Kowsari), 188n6

portrait photography, 136, 149; amateur photography, 138–40; European traditions, indebted to, 137–38; as material object, 151; monarchical power, projections of, 142; power, image of, 141, 150–51; self-expression, as tool of, 150–51; semiotic accounts of, 150; as traditional values and unequal relations, 9

postcolonialism, 18–19, 102–3; ambivalence, notion of, 163; hybridity, notion of, 163; Manichean structure of, 131; postcolonialist critique, 41–42, 74

Prangey, Girault de, 2

Pratt, Mary Louise, 14, 56–57, 180n10

preservation, 31–33

Preziosi, Amadeo, 59

"primitive" types, 89, 96, 128–29

Qajar dynasty, 78–80, 113–14, 127, 128, 161; female family members, absence of, 146–48; homosociality in, 147; male-centered nature of, 146; photographs of, 106–7, 111, 129–31, 134–37, 158–59; power, attentiveness to, 142; royal portraiture during, 144, 146, 150–51; traditional gender roles in, 147

Qajar series (Ghadirian), 155, 159–60, 167–68

Raad, Khalil, 6
racial taxonomy, 59
Rancière, Jacques, 11–12, 38, 169
Reclining Odalisque (Essaydi), 154
Regnault, Victor, 138–40
resident photography, 73–74
Rey, Emmanuel-Guillaume, 174n36
Richard, Jules, 106–7, 182n10
Roberts, David, 25
Roberts, Mary, 14, 18, 34, 102, 131, 185n4
Robertson, James, 27, 55, 58
Robinson, B. W., 185n5
"Roger Fenton" (exhibition), 70
Royal Dutch Geographical Society, 96
Royal Engineers, 3
Royal Geographical Society, 9
royal portraiture, 136–42, 145, 147–48; as
 divine status, 146; domination, ideologies
 of, 134; European influences, as reflection
 of, 134; European notion of, 146; power,
 symbol of, 134–35, 144; statecraft, as tool
 of, 134, 149; as valuable material objects,
 144
Rumia (Shochat), 187n4
Russia, 106, 113, 142, 182n9
Ryan, James, 8–9

Saatchi Gallery, 153, 167
Sabunji, Sirjis, 6
Sabzevar (Iran), 148
Sabzevari, Haji Mulla Hadi, 148–49, 151
Safavid period, 113, 134, 142
Saffarzadeh, Tahereh, 166
Said, Edward, 8, 10, 18, 25–26, 68, 70–71, 77,
 101–2, 131, 168, 180n12
Salzmann, Auguste, 3, 21, 25, 27, 176–77n2
Sami Bey, Ali, 6
Sampson, Gary, 46
Sarrafian brothers, 6
Sarre, Friedrich, 92, 98
Sassanid dynasty, 134
Saudi Arabia, 188n9
scènes et types, 6, 89, 94, 97; indexical quality
 of, 127; realism, illusion of, 127–28; visual
 classification of, 178n24

Schilder (Signs) (Neshat), 188n11
Schmeltz, J. D. E., 96, 98
Schoeberl, Frederic, 59
Schwab, Raymond, 77
Sébah, Jean, 173n23
Sébah, Pascal, 4, 7, 25, 42, 47, 59, 63–64, 66,
 74, 173n23
Sébah family, 73
Sébah & Joaillier, 5–6, 35, 42, 56, 57, 73–74, 112
Sekula, Allan, 14, 128
Servet-i-Fünun (journal), 63
Sevruguin, Antoin, 73–74, 142, 179n33, 180n3,
 180n9, 180n14, 180n15, 181n28, 181n30,
 182n35; categorizing gaze, avoidance of,
 79–80; categorizing tendencies of, 91;
 exoticist tendencies of, 91, 98; historical
 knowledge, traces of, 81; mode of repre-
 sentation, 77, 80, 83; (neo)colonial uses
 of, 82, 91–92, 94, 96–99; and nostalgia,
 89; and Orientalism, 82–83, 85, 88–90,
 98; as *orienteur*, 77–81; "Orient" trope,
 83, 85; as participating photographer, 78;
 photographie artistique, 83; picturesque
 tradition, 79, 85, 88–89; plurality of, 78,
 81; *scènes et types*, genre of, 89; *shahreh
 farang*, photos of, 75, 79–80; street scenes,
 97; street types, 94
Sevruguin, Emanuel, 92
Sevruguin, Vassil de, 83
Shahbazi, Shirana, 153
Sheehi, Stephen, 123, 173n25
Shochat, Tal, 154, 187n4
"Sight-seeing" (exhibition), 70
Simmons, John, 113
Smith, Albert, 26, 50
Smith, Myron Bement, 92, 96–98
Smyth, Charles Piazzi, 33
Société Asiatique, 107
Société Française de Photographie, 4
Société Orientale, 21
Sontag, Susan, 81
South America, 56
staging, 59–62, 89–90; of "Oriental" types,
 36–37; performative function of, 36; and
 typification, 35

Printed and bound by CPI Group (UK) Ltd, Croydon, CR0 4YY

09/06/2025

14685767-0001